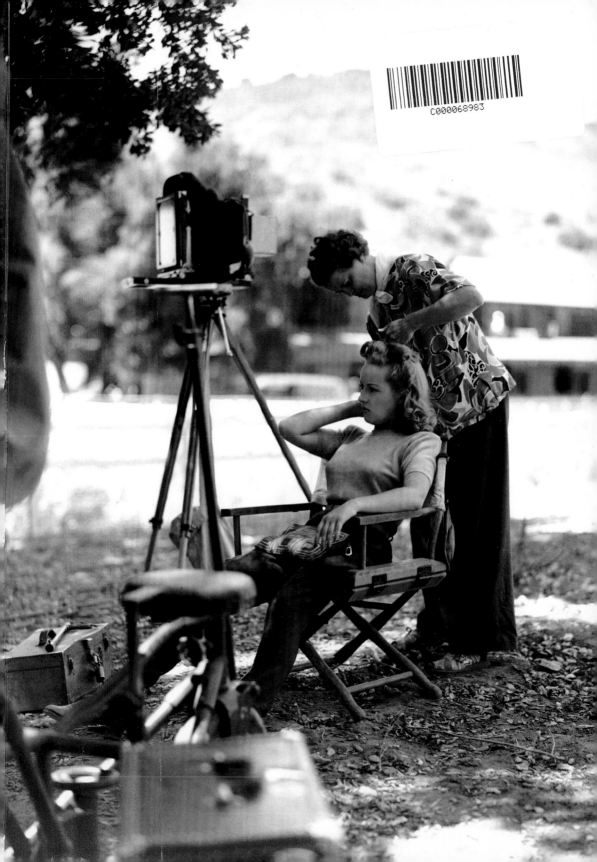

MENS — WARDROBE
PICT.* A-131 DATE
TITLE
DIRECTOR Dmytryk
ACTOR C GABLE
CHARACTER H.LEE
CHANGE fans
SET Spotted
SCENE
COLOR 8X10

STYLING *the* STARS

Lost Treasures *from the* Twentieth Century Fox Archive

By Angela Cartwright *and* Tom McLaren

Foreword by Maureen O'Hara

INSIGHT EDITIONS

San Rafael, California

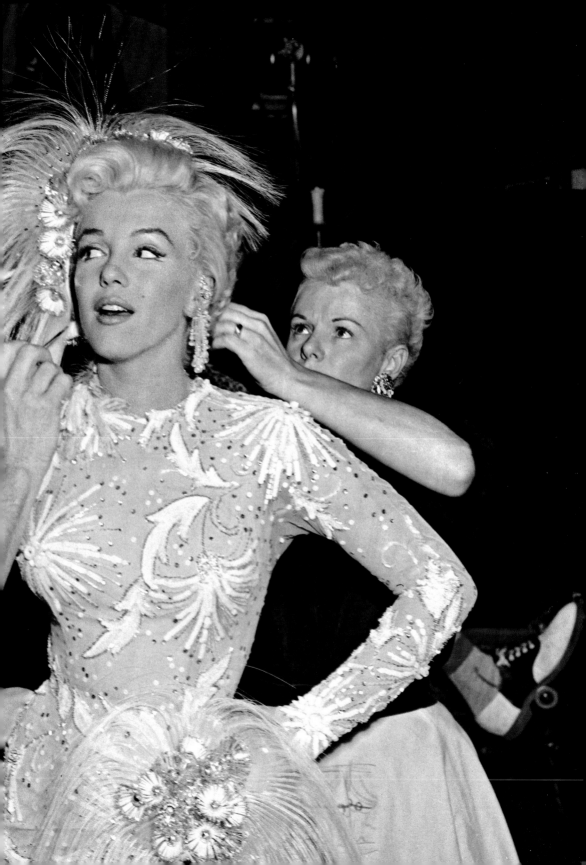

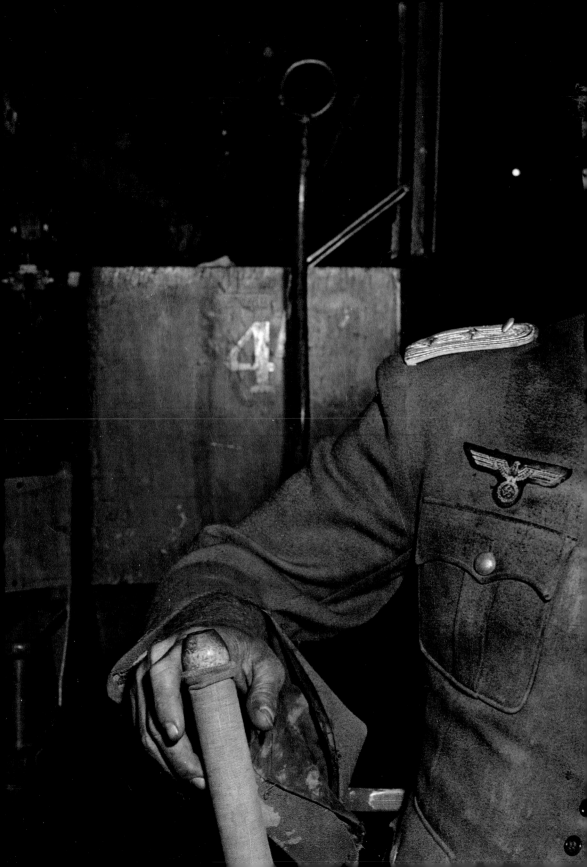

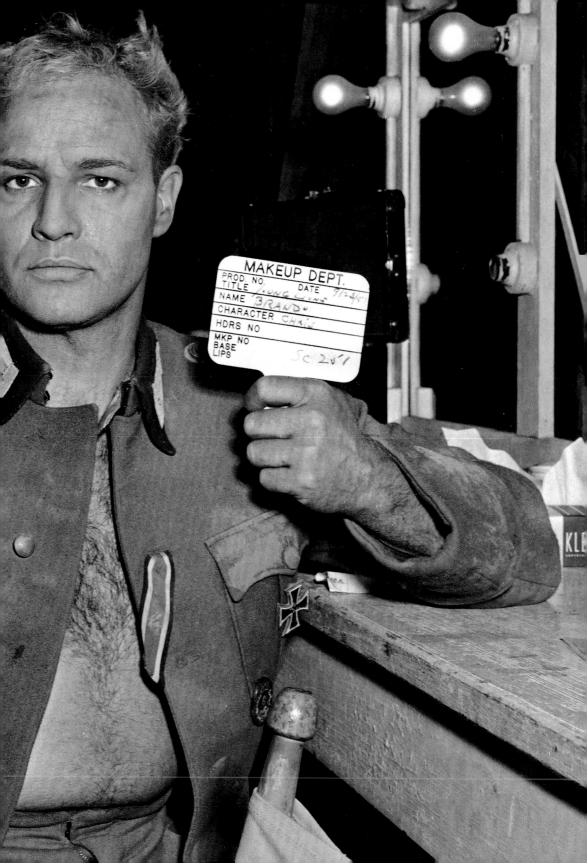

MAKEUP DEPT.
PROD. NO. DATE 9/24/?
TITLE YOUNG LIONS
NAME BRANDO
CHARACTER CHRIS
HDRS NO
MKP NO
BASE
LIPS SC 201

CONTENTS

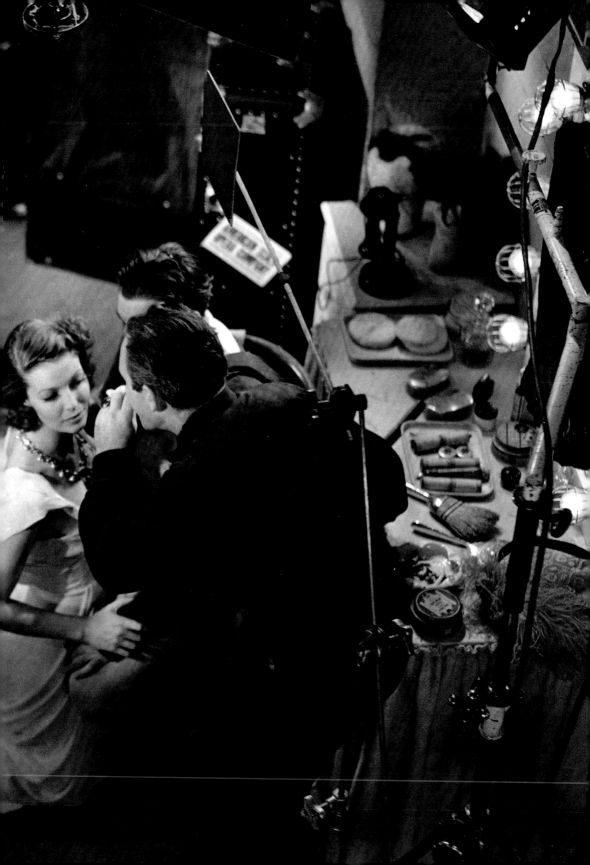

Maureen O'Hara

I came under contract to Twentieth Century Fox as part of a backroom deal. John Ford offered me the role of Angharad in *How Green Was My Valley*, but Fox refused to cast me unless it owned part of my contract. It was one of the luckiest breaks of my career. It not only led to my being cast in *Miracle on 34th Street*, it also taught me the business behind making motion pictures. I can still hear Mr. Darryl Zanuck saying, "Time is money!" He demanded we actors be camera ready—hair, makeup, and wardrobe—so that we never kept a busy set waiting. *Miracle on 34th Street* is one of the all-time favorite films I made. I love it so much because it's warm, it's overly sentimental, and it captures the spirit of Christmas. Seeing all these rare behind-the-scenes photos is a thrill and brings back so many memories. It's like being right back on set with John Payne, Natalie Wood, and Edmund Gwenn, who played Kris Kringle. Believe me, we all thought he really *was* Santa.

We spent the first week in wardrobe with our costume designer, Kay Nelson, being fitted for all the gorgeous clothes we got to wear in the picture. I remember how Natalie Wood enjoyed that part of making the movie, and she and I worked with Kay again later in *Father Was a Fullback*.

Being camera ready allowed me to bring Doris Walker to life in a more textured way. If you don't look and feel right in the story, it can pull you out of character and hurt your performance. When those elements came together as nicely as they did on *Miracle*, I was able to offer more about Doris through style and movement. It is very freeing when everything fits and works. It allows an English gentleman like Edmund to grow a white beard, sink into a soft red suit, and summon a magic twinkle in his eye.

Maureen O'Hara, *Do You Love Me*, 1946

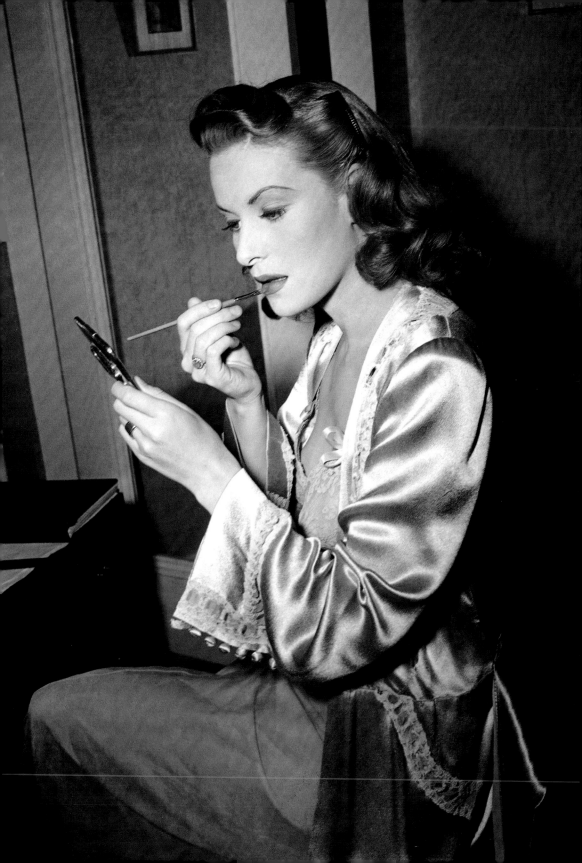

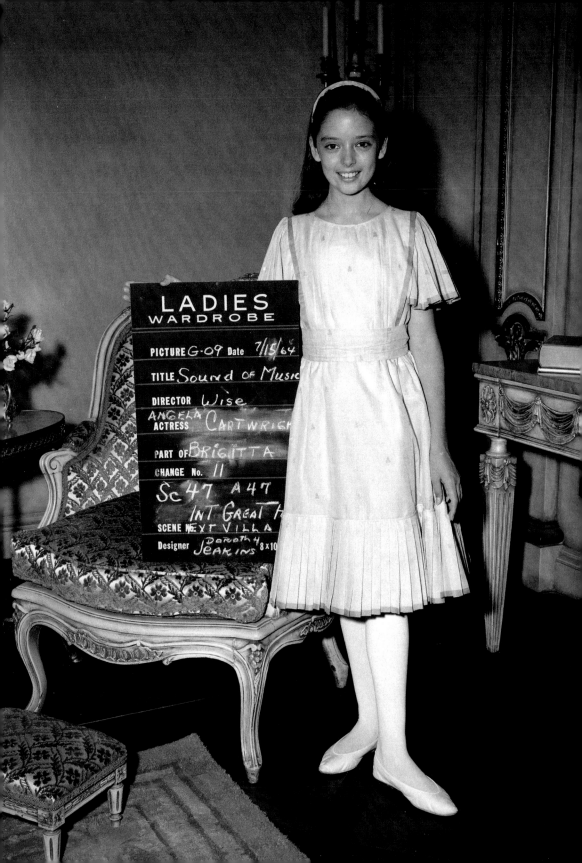

LADIES
WARDROBE

PICTURE G-09 Date 7/15/64

TITLE Sound of Music

DIRECTOR Wise

ANGELA
ACTRESS Cartwright

PART OF Brigitta

CHANGE No. 11

Sc 47 A47

INT Great H

SCENE NEXT VILLA

Designer Dorothy Jeakins 8x10

Angela Cartwright

When I was three years old, the word *action* became an unlimited license to pretend. Pretend that Paul Newman was my father . . . pretend I was the daughter of a famous New York comedian . . . pretend to be a genius lost in outer space . . . pretend to be learning how to sing "Do Re Mi" from an Austrian nun.

I have distinct memories of arriving on the Fox studio lot in 1964, and heading to my dressing room while filming the movie *The Sound of Music*. My cleaned and pressed wardrobe was hanging in the closet, my tights and socks neatly laid out next to the shoes I was to wear that day. After slipping into my costume, I made my way to the stage where the all-important ritual of getting camera ready would begin. *Camera ready* meant that hair, makeup, and wardrobe were ready for the day's shoot.

In the makeup room (which could be a honeywagon or a more permanent area on the soundstage), tissues were placed around my collar to protect my costume from the thick pancake makeup being applied to my face and neck. For the purpose of continuity, a photograph was taken of me so that my hair, makeup, and wardrobe would match the next day's shoot. In the photo I held a placard that indicated the scene number we were shooting that day, so the hairdresser and makeup artists could match everything exactly—in film and television, continuity is key! Once I was camera ready I would either head to the classroom to start my mandatory three hours of daily schooling, or I went straight to the set to begin working.

"Angela, we need you in five . . . camera ready." These were some of the first words I remember hearing, because my childhood began on a soundstage. Last-minute touch-ups were done so that I would be ready to hit my mark and perform my scene in five minutes' time.

From where I stood on the set, I could see and hear adults scurrying around me, adjusting lights, and yelling orders back and forth over the ever-present hum of electric energy. Small groups of people in serious discussions occasionally glanced over their shoulders. A woman with a stopwatch wrote frantically in shorthand on a steno pad. People with pockets full of pins, scissors, brushes, and combs straightened my hair and adjusted my wardrobe. With a tape measure, a cameraman measured the distance from his camera lens to the tip of my nose while lights were shifted around the floor and words like *key light* and *arc light* rang in my ears.

The intoxicating fumes of hair spray, fresh-cut wood, oily cables, cigarettes, and cologne mingled to form an inimitable bouquet. I heard a still photographer

Angela Cartwright, *The Sound of Music*, 1965

incessantly firing the shutter of his camera. I squinted as the heat from the lights intensified. The murmur of dialogue merged until one voice rose above the others and yelled the two simple words capable of bringing all of the chaos to an immediate halt: "Settle, please." And in that instant, silence dropped like a curtain, and the magic began.

Growing up on the Twentieth Century Fox lot was like being plopped in the middle of a small city. There was an art department that could draw anything and a mill that could build anything. There was a theater, a publicity department, and a portrait studio complete with a darkroom. The commissary served breakfast, lunch, and dinner, while at the infirmary an on-staff doctor and nurse administered aspirin and flu shots. The Old Writers Building hummed with the sound of typewriters; it overlooked the permanent schoolhouse, where wooden school desks bore the hand-carved signatures of students like Elizabeth Taylor and Roddy McDowall. The post office, bank, and dry cleaner were there for everyone's convenience, while the executive building contained a pool and sauna in the basement for the execs. The old-fashioned barbershop was in service all day, and there was a shoe shiner who made daily rounds.

From the crack of dawn until late in the evening, golf carts laden with new script pages, set drawings, or urgent messages would weave through the studio lot to the different productions. Besides walking, the golf cart or bicycle was, and still is, the primary choice of transportation.

In those magical years on the Twentieth Century Fox lot, the men's and women's wardrobe buildings were lined with racks of suits, dresses, and costumes. Containers were bursting with shoes in every size. There were drawers lined with jewelry, men's ties of every shape, belts of every dimension, and hats for all seasons. All items were methodically tagged and labeled so that any clothing or accessory could be located immediately. The wardrobe department was also complete with salons where swatches of fabric were scrutinized and meetings about a designer's sketches were held. Fitting rooms were flanked by seamstresses wearing bracelets of straight pins, patiently waiting for an outfit to pin. In another large section of the wardrobe department, among bolts of fabric and spools of thread, you'd hear the constant buzz of sewing machines.

The hair department housed an impressive stash of wigs to bring to life any character a production might need. Stacks of hair dye in every conceivable color and a plethora of brushes, combs, curlers, and bobby pins filled the cupboards. In the hair salon, a star's locks were switched or styled in an instant for a role, and renegade gray hairs were meticulously covered daily. Manicurists were on call at a moment's notice. Glamour was a full-time job.

The makeup building had a large array of makeup tables surrounded by lightbulbs and heaped with canisters of makeup in every shade imaginable. Amid the eyelashes and mustaches of every size and shape were large casks of blood, mud, and tea-stain dye.

In this environment, the magic never seemed to dissipate. The transformation of an actor through hair, makeup, and wardrobe continues to fascinate me. It was this fascination with the behind-the-scenes moviemaking dance that prompted me to approach my friend, Tom McLaren, with an ambitious book idea. What if we could gain access to the Twentieth Century Fox archives? What if we could uncover the many continuity photographs that no one has ever seen? Depending on the budget of the film and the complexity of the wardrobe, there would have been time set aside for formal photographs to be taken of every costume and hairstyle being worn by a particular actor before production began.

In addition to photos taken in the official portrait studio, more images would have been snapped on the set between takes as quick references for the wardrobe and hair departments. These important images were sent to the photography lab, where they were developed immediately, printed, and delivered back to the correct department.

The stills would largely consist of an actor standing next to a placard. Upon the placard, the movie title, actor name, character name, and scene number were hastily scribbled down. Some photographs were shot on the fly, with the crew milling about in the background. Sometimes wardrobe personnel would hold the placard while the actor held a cup of steaming coffee or smoked a cigarette on a break during filming. You may notice within these pages some photographs in which the actor is holding a brush, comb, or powder puff. This was merely to designate which department would receive the images once they were developed. If a brush or comb (or sometimes even a broom) was present the image went to hair; if a powder puff was present or the image showed an actor with downturned or closed eyes to reveal nuances of eye makeup, the image went to makeup. A movie such as *Cleopatra* or *Star!* with an inordinate amount of changes would have to be meticulously recorded to prevent errors in hairdos, accessories, makeup, and clothing.

Because these were not promotional shots, the actors wore a variety of expressions that often showed their personalities. Some were very serious, some clowned around, some posed like models, and some paid little attention at all, showing that it was merely a mundane part of the job. These photos often show the actor in a truly candid moment.

These were the shots I hoped to find, for they would be far more revealing than the posed publicity photos used in magazines and for advertising purposes. I knew there had to be thousands of these photographs, because they were taken on every movie ever filmed. What had happened to them? Where were they now?

It would be several years from the time I proposed the book idea to when Tom and I were actually granted access to the archives. We were armed with our wish list of actors who had performed in movies at Twentieth Century Fox studios. Would we find images of the greats of Hollywood? Would we discover photographs of John Wayne, Clark Gable, Marilyn Monroe, Ann-Margret?

Though numerous photographs have been lost, misplaced, or even stolen over time, we still uncovered plenty of pristine negatives from the treasured past. Many of

these finds gave us goose bumps when we uncovered images we knew had not been viewed in decades. We marveled at the impressive high-quality negatives taken by the Fox studio photographers. We were relieved to find many of these crucial pieces of movie history receiving the respect they deserved, carefully maintained in a state-of-the-art facility deep in the cool underbelly of the studio.

This had not always been the case. For years these continuity photographs were stored throughout various departments, where they were kept in tins and old Kodak cardboard photo-paper boxes labeled with the film's title. Over time, so many boxes were created that the studio began running out of room to store them. With the wardrobe, makeup, and hair departments bursting at the seams, and needing more space for clothing and wig storage, they began storing these photos wherever they could around the studio. Many of the images were delivered to the publicity department, which in turn stored hundreds of boxes in the basement of the administration building, in a shed on the lot, on a soundstage, and in a place called "The Barn." The overflow of continuity photographs was clearly out of control. Over the years, the boxes were unsupervised, often compromised and opened, and many of the photographs just went missing.

Fox has always maintained a complete script library dating back to the 1920s, but many of the boxes filled with continuity photographs were thrown out. In the early 1970s, when the hair and makeup departments were downsized, dumpsters were filled with scripts, old contracts, and photographs, though no one has been able to confirm if these items were duplicates or originals.

Ultimately, Twentieth Century Fox realized that if action wasn't taken to preserve such important movie history, everything would be junked due to a lack of storage space. Various individuals rallied to keep the memorable items secure, knowing that many of the photos would be used for future television syndication. With the support of the television and international departments, a deal was struck with UCLA in 1973. In exchange for storage, the studio allowed the university's film department to use the images for educational purposes, opening the archive to film students. Minimal filing was performed at the university, however, and many of these boxes were left untouched for years. The 6,500 precious boxes of movie history were eventually returned to the studio lot for preservation, and in 1997 the Twentieth Century Fox Photo Archive was created.

It was in these archives that we found continuity shots for many of the classic movies. We spotlighted such films as *The Sound of Music, The Poseidon Adventure, Butch Cassidy and the Sundance Kid, The Pleasure Seekers,* and *Valley of the Dolls* because there was an abundance of photographs to choose from. The majority of these pristine photos were from the mid-1950s to the mid-1970s, but we also found rare early treasures from the 1930s and 1940s.

We imagined the paths these photographs must have taken—meticulously scrutinized by the director, the costume designer, and hair and wardrobe personnel

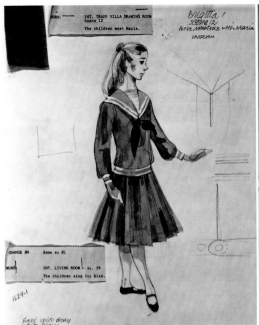
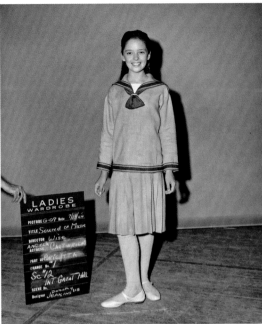

in a group effort to make sure each department properly portrayed the essence of the character in the movie: a simple continuity shot of Deborah Kerr taken during the production of *The King and I* carefully reviewed by Director Walter Lang and Costume Designer Irene Sharaff . . . a photograph of Faye Dunaway passed among Director John Guillermin, Producer Irwin Allen, and Costume Designer Paul Zastupnevich before making its way to the hair and wardrobe personnel . . . photos of Paul Newman and Robert Redford holding their gun belts reviewed by Costume Designer Edith Head and Director George Roy Hill before he called, "Action!"

This important element of the studio process is one of the many pieces connecting the actor to the role he or she plays. The continuity photograph highlights the collaborative effort it takes to bring a character to life. When all the pieces of this cinematic puzzle fall together in synchronicity, magic is created.

The hours we spent treasure hunting in the vault yielded a true time capsule of some of the greatest moments in movie history. Each photograph reveals the raw essence of Hollywood moviemaking, a glimpse into a process never intended for the public eye. Here, together, we truly sneak a peek behind the scenes.

FOLLOWING PAGES (FROM LEFT TO RIGHT): Kym Karath, Debbie Turner, Julie Andrews, Angela Cartwright, Christopher Plummer, Duane Chase, Heather Menzies, Nicholas Hammond, and Charmian Carr, *The Sound of Music*, 1965

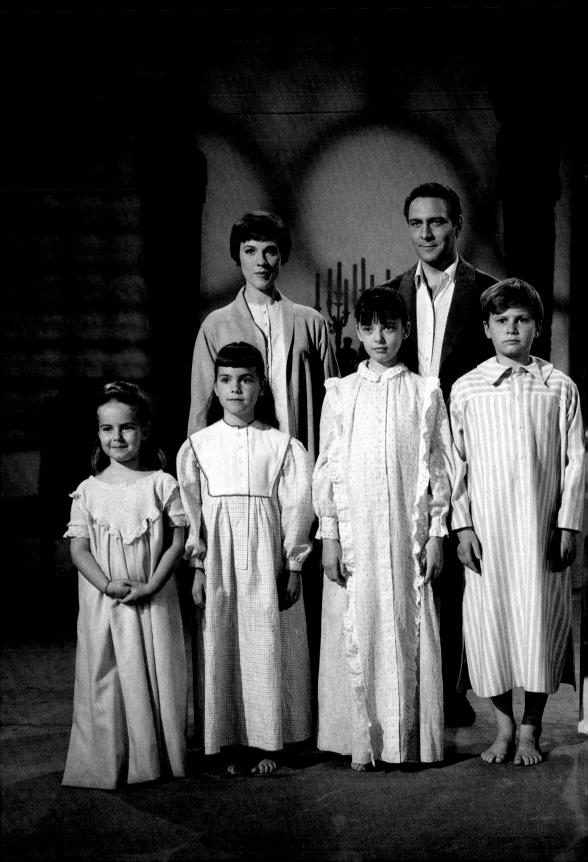

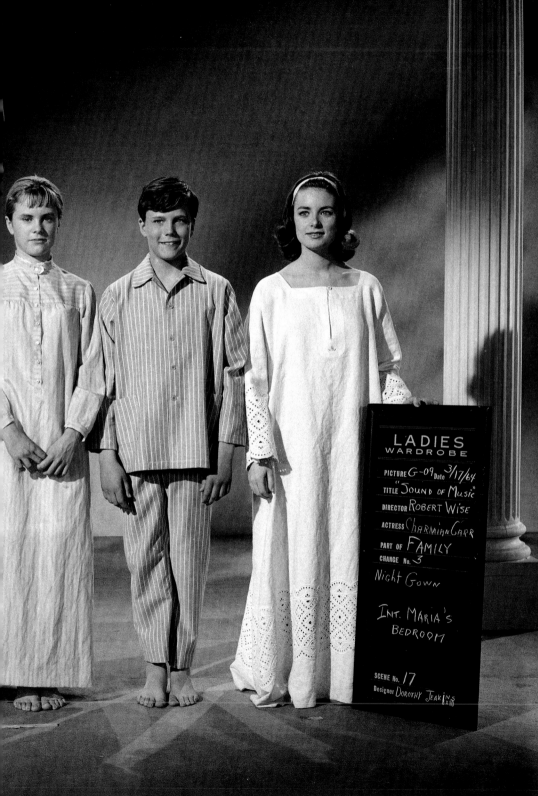

LADIES
WARDROBE

PICTURE G-09 Date 3/17/64
TITLE "Sound of Music"
DIRECTOR Robert Wise
ACTRESS Charmian Carr
PART OF FAMILY
CHANGE No. 3

Night Gown

Int. Maria's
Bedroom

SCENE No. 17
Designer Dorothy Jeakins

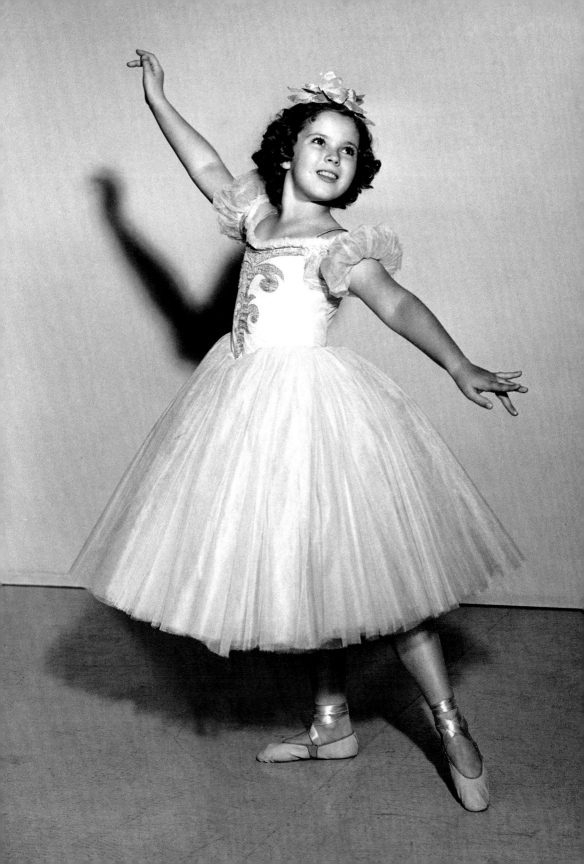

Part One

THE GOLDEN AGE OF HOLLYWOOD

THE GOLDEN AGE OF HOLLYWOOD, which extended from 1927 to 1963, saw the rise of Hollywood's most iconic and enduring stars. With narratives built around unique, distinctive characters, and cinematic techniques grounded in medium-long and medium shots focused on gestures and facial expressions, it's not surprising that the actors from classical Hollywood cinema—from Shirley Temple to Paul Newman—remain figureheads of film. Continuity editing—a style designed so that the camera would never draw attention to itself—defined cinematography during the Golden Age; therefore, a piece of hair or wardrobe out of place would spoil the continuity of the film and derail the viewer's suspension of disbelief.

With the dominance of this style, the use of continuity photographs to document the precise look of an actor's hair, makeup, and costume so it could be exactly replicated day after day during the shooting of a film was crucial. Seemingly simple alterations would be magnified on the big screen to glaring mistakes, dispelling the audience's sense of illusion. No one wanted to be responsible for explaining to Studio Chief Darryl Zanuck why Tyrone Power's mask in *The Mark of Zorro* was tied two different ways in the same scene on film. Certainly there were film flubs, but they were few and far between thanks to the continuity shots.

Continuity photographs and behind-the-scenes stills featured throughout this section showcase the sophisticated yet conservative style of the Golden Age wardrobe. Gene Tierney, Lauren Bacall, and Ava Gardner—with their hats, high heels, and high-neckline blouses—represented (and helped define) the era. This wardrobe was a reflection of the strict rules of moral censorship developed from the Hays Code (a motion picture production code followed by most studio films made through 1968). But the Hays Code did not determine the style or the evolutions in dress—steadily leaning toward the more adult as the decades unfold—which are readily apparent in these photographs spanning thirty years. The Hays Code dictated the covering of Carmen Miranda's belly button in *If I'm Lucky*, but it could not prevent Marilyn Monroe's seductive sway in stiletto heels from appearing on-screen.

The earliest images in the archive document Hollywood's emphasis on wholesomeness. In 1933, Twentieth Century Fox signed Shirley Temple, and she became its first superstar. From 1935 to 1938, Temple was the number-one box office attraction in the world, outranking even Greta Garbo and Clark Gable. Temple was also the first in a long string of child stars at Twentieth Century Fox, which continued with Jane Withers and Natalie Wood.

The revenue from Temple's films saved the studio from bankruptcy during the Great Depression and allowed it to develop other adult stars such as Alice Faye, Henry Fonda, and Loretta Young. It wasn't until 1935, when Fox merged with Twentieth Century Productions and Darryl Zanuck took over as studio head, that a recognizable style began to emerge at the studio.

Shirley Temple, *The Little Princess*, 1939

Zanuck organized the various departments—including wardrobe, hair, and makeup—streamlining production. When Costume Designer Charles LeMaire was hired in 1943, he further refined the system by hiring a squad of designers, each with a different specialty. Yvonne Wood worked with Carmen Miranda to develop her signature Technicolor® tutti-frutti look, while René Hubert's area was period films such as *Forever Amber* and *Centennial Summer*, although he also designed modern dress for *State Fair* (1945).

The best-known Fox designer from the Golden Age was another LeMaire hire, William Travilla. Travilla was originally brought to Fox to design for its male stars based on his Academy Award®–winning work for Errol Flynn at Warner Bros. Travilla's costumes for Betty Grable in *Meet Me After the Show* were so successful, though, that he became renowned for his over-the-top showgirl costumes. It was natural that he be assigned to the studio's latest sex symbol, Marilyn Monroe. Travilla's partnership with Monroe generated some of Hollywood's most iconic moments, from the white halter dress in *The Seven Year Itch* to the hot-pink gown she wore while singing "Diamonds Are a Girl's Best Friend" in *Gentlemen Prefer Blondes*. This section offers a rare look at the original costume for the number, which the censors vetoed.

Whether glamorous romances, colorful musicals, historical epics, or mundane westerns, all films required continuity photographs. The creativity as well as the productivity of the studio is evident through these snapshots of the Golden Age. On any given day, a seamstress could be sewing a satin evening gown, a suit for an alien, or a monk's robe. Certain films contained such a large variety of images—capturing actors in multiple costume changes, hair and makeup tests, and other behind-the-scenes moments—that they have been highlighted as "spotlight films." Other unique photos are sprinkled among these spotlights: Cary Grant suited up for a swim in *An Affair to Remember*, and Bette Davis in full royal regalia as Elizabeth I of England in *The Virgin Queen*.

Although continuity images are still necessary in film today, they lack the same craftsmanship as the images seen here. Even though the photographers' work was never intended to be viewed publicly in most cases, their talent is readily apparent. Enjoy this glimpse of hidden Hollywood. From glamour to grit, the following pages present a revelatory look into Hollywood's Golden Age.

OPPOSITE: Shirley Temple, *Dimples*, 1936, TOP: Shirley Temple, *Rebecca of Sunnybrook Farm*, 1938 FOLLOWING PAGES: Shirley Temple combs her famous locks in one of her personal dressing rooms.

Hulda Anderson (nicknamed "Andy") was Shirley Temple's private seamstress, creating her costumes for all of her films and assisting Shirley with her wardrobe changes between scenes. Additionally, she taught Shirley to sew. It has been rumored that only Shirley's mother, Gertrude, was allowed to style the moppet's famous ringlets for each movie. Shirley had three spaces for her exclusive use: a permanent dressing room, which is now Building 86, directly across from the studio's commissary; Bungalow 42, which is now *The Simpsons'* production office; and a mobile honeywagon on the set.

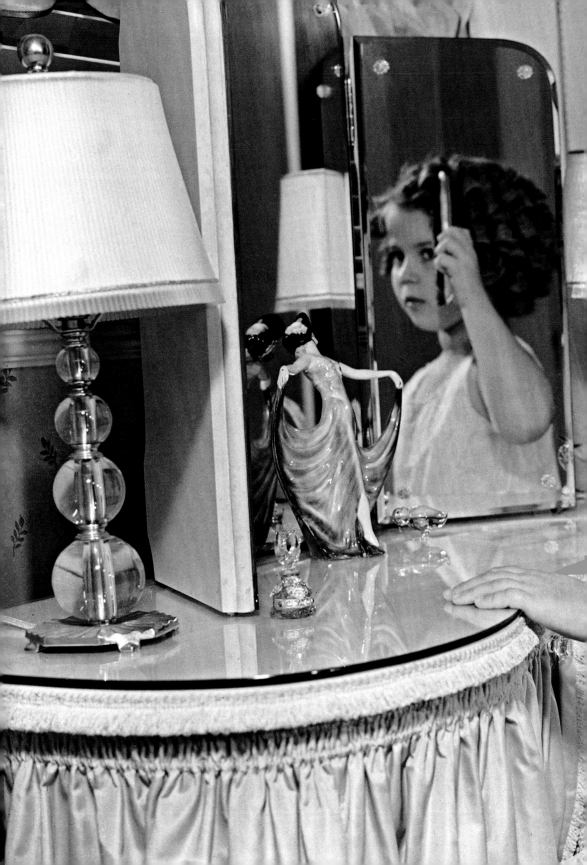

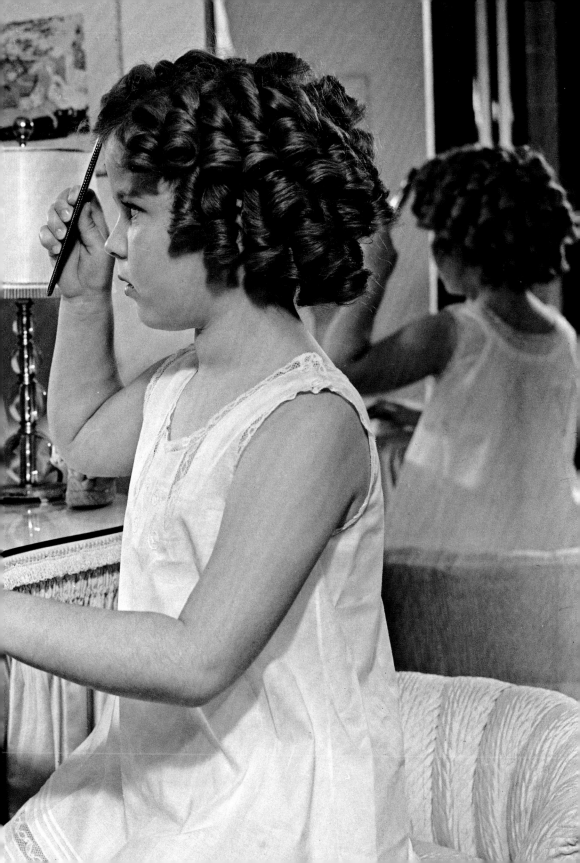

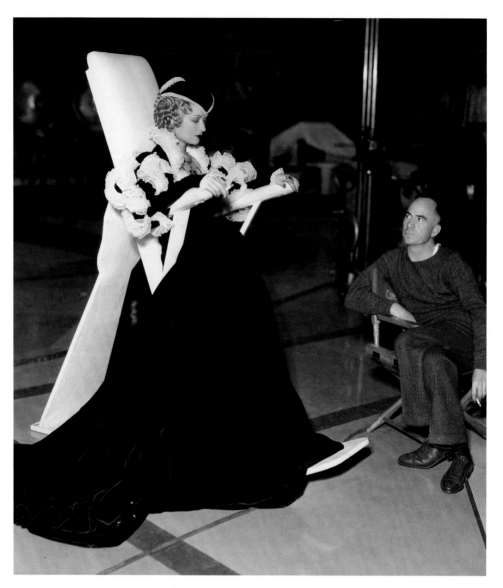

Constance Bennett, *The Affairs of Cellini*, 1934

The slanted board created for the film *The Affairs of Cellini* allowed Constance Bennett and Frank Morgan relief from the weight of their costumes, which weighed more than forty pounds. Since sitting or standing between takes was nearly impossible, a heavily padded leaning board with sturdy armrests was built in the studio's carpentry shop. The slanted board became a common fixture for stars to use on productions featuring heavy costumes or skintight outfits, to prevent the fabric from wrinkling and to provide a comfortable place to rest between takes.

Frank Morgan, *The Affairs of Cellini*, 1934

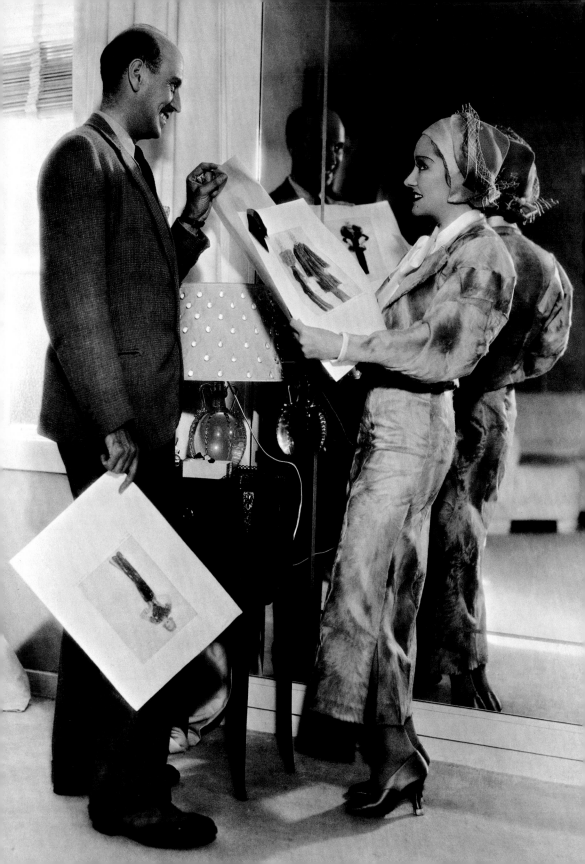

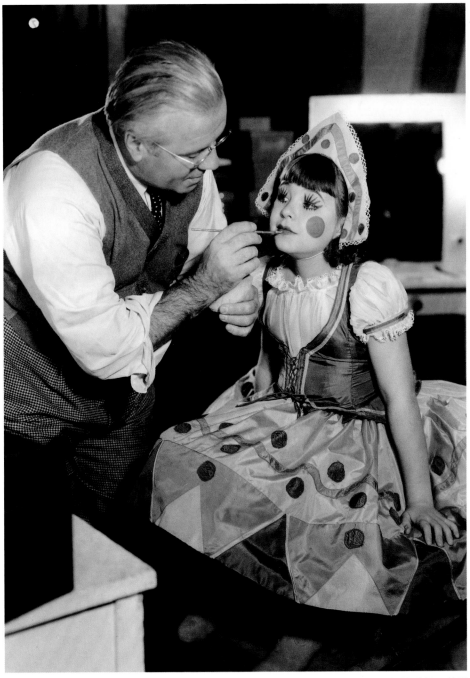

Jane Withers, *Paddy O'Day*, 1935

Gloria Swanson (right) and Costume Designer René Hubert, *Music in the Air*, 1934

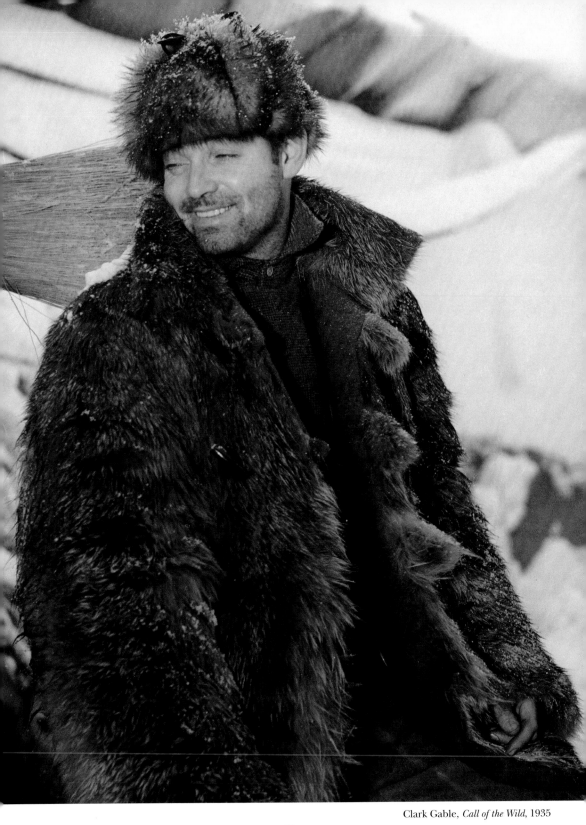

Clark Gable, *Call of the Wild*, 1935

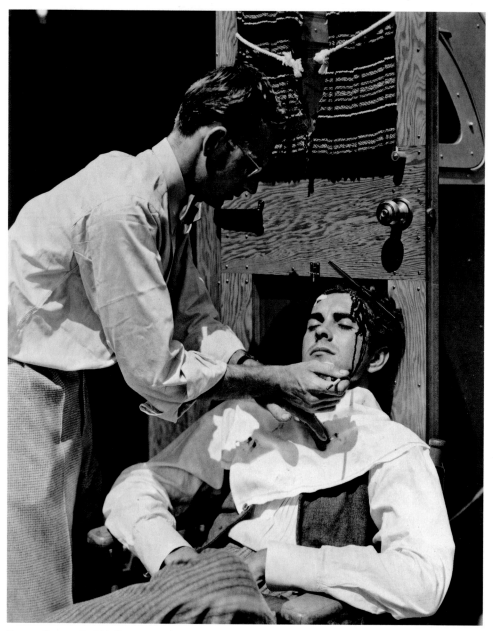

Tyrone Power, *In Old Chicago*, 1937

Tissue is always placed around the collar of an actor during rehearsals to keep makeup off the actor's wardrobe. In this image, fake blood is being applied to Tyrone Power, who was often called "The King of Twentieth Century Fox." He became one of the studio's most successful leading men during the Golden Age.

Loretta Young, *Ramona*, 1936

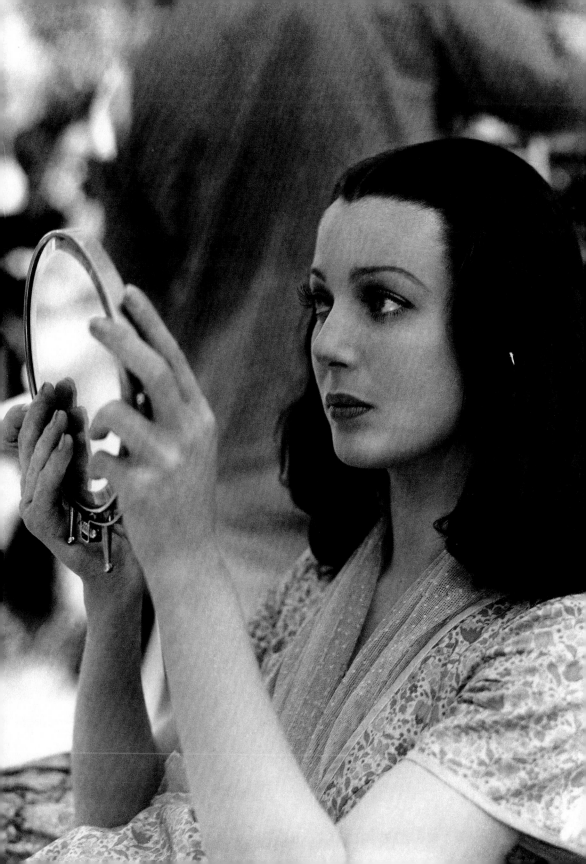

John Carradine, *Drums Along the Mohawk*, 1939

Sonja Henie, *Iceland*, 1942

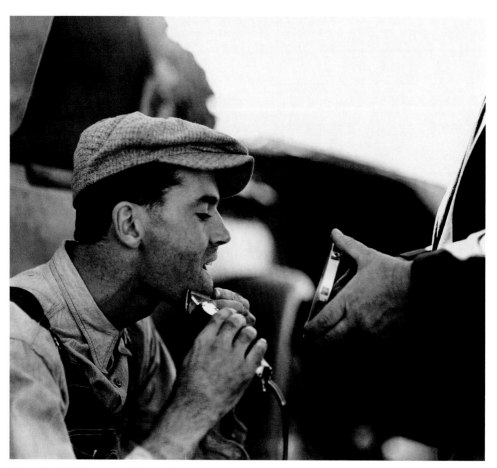

Henry Fonda, *The Grapes of Wrath*, 1940

Alice Faye, *Tin Pan Alley*, 1940

Images from the early Golden Age featuring the wardrobe placard are rare. This image of Alice Faye from *Tin Pan Alley* was one such occurrence. Faye became one of Fox's most successful leading ladies, starring in thirty-two films between 1934 and 1945.

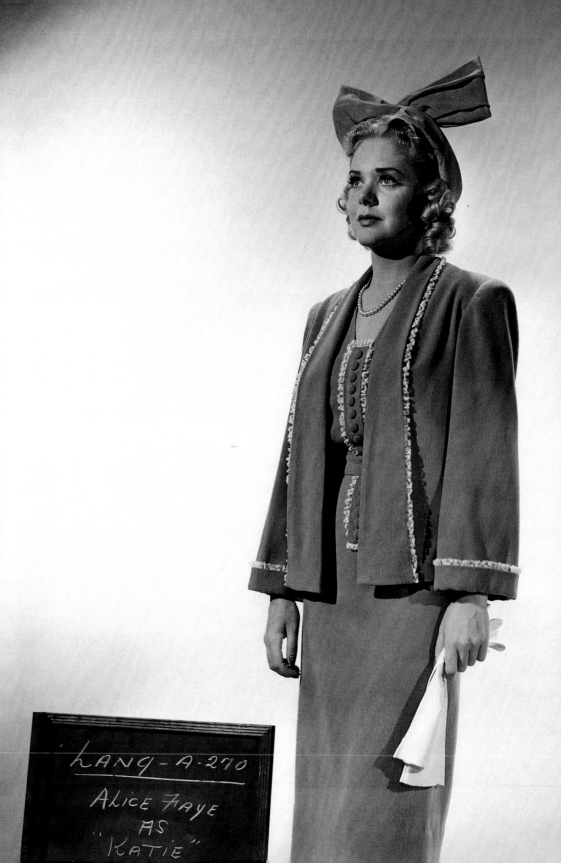

'LANG-A-270
ALICE FAYE
AS
"KATIE"

Linda Darnell, *The Mark of Zorro*, 1940

Tyrone Power, *The Mark of Zorro*, 1940

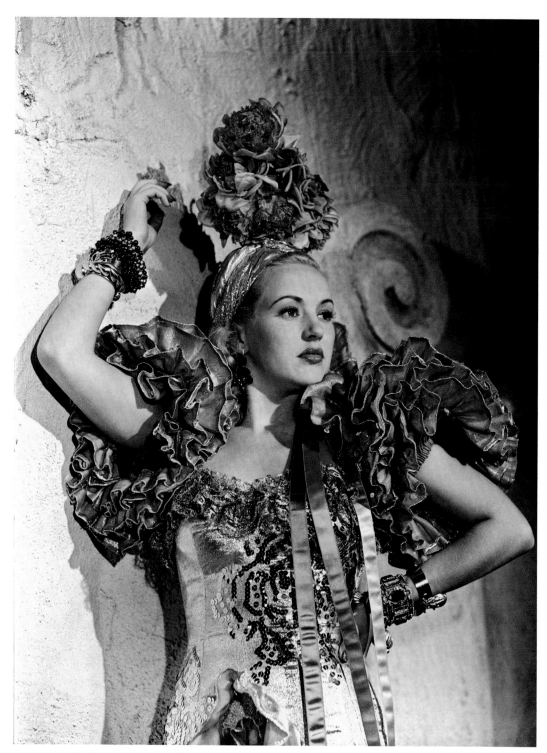

ABOVE: Betty Grable, *Down Argentine Way*, 1940, OPPOSITE: Betty Grable, *Moon Over Miami*, 1941

Gene Tierney, *Leave Her to Heaven*, 1945

Body makeup is applied to even out the skin tone of Gene Tierney as she's made camera ready for *Leave Her to Heaven*. The music for this film was composed by Alfred Newman, who also composed the original "Fox fanfare" in 1935, heard to this day at the beginning of Twentieth Century Fox films while the searchlights beam into the sky.

Gene Tierney, *Laura*, 1944

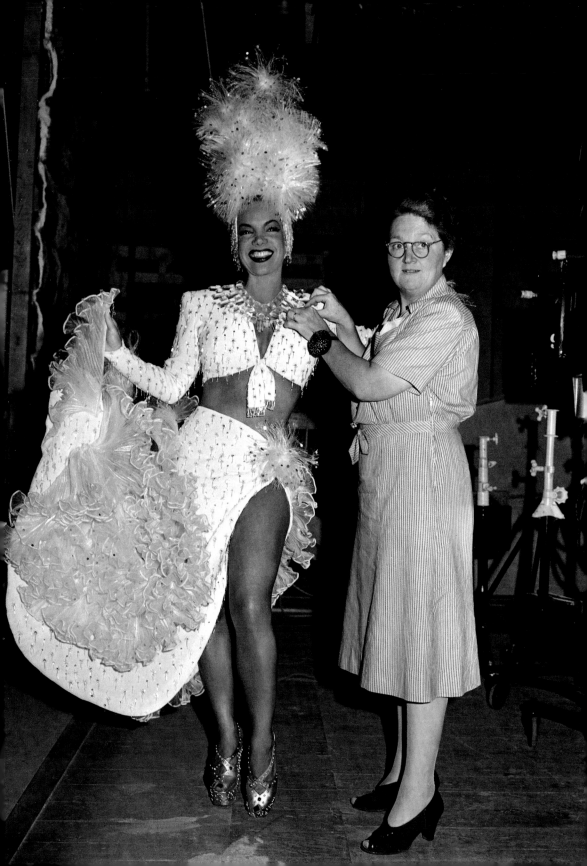

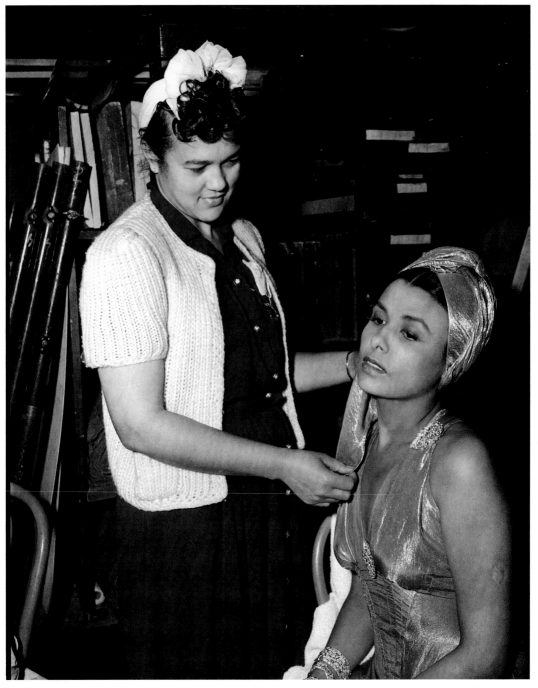

Lena Horne, *Stormy Weather*, 1943

Carmen Miranda, *If I'm Lucky*, 1946

Miracle on 34th Street

1947

Ironically, *Miracle on 34th Street* was released in May 1947 because Studio Executive Darryl Zanuck believed more people attended movies during the summer months. Despite its original release date, it has become one of the most famous Christmas movies of all time. Nominated for four Academy Awards, including Best Picture, the movie won three awards, including Best Supporting Actor for Edmund Gwenn for his role as the charismatic Kris Kringle.

Shooting included not only filming on location in New York City at the actual Macy's store on 34th Street but also filming at the annual Macy's Thanksgiving Day Parade. Director George Seaton wanted authentic footage of the parade itself, so Gwenn actually played Santa Claus in the parade on November 28, 1946—a fact that many parade watchers were unaware of at the time.

Maureen O'Hara and John Payne were the romantic leads. The vivacious eight-year-old Natalie Wood, in one of her first films, plays matchmaker to the couple, with a little assist from Kris Kringle. Like most Fox films released during Zanuck's tenure, the emphasis was on substance rather than style. Zanuck was interested in plot-driven films rather than glamour.

Edmund Gwenn, *Miracle on 34th Street*, 1947

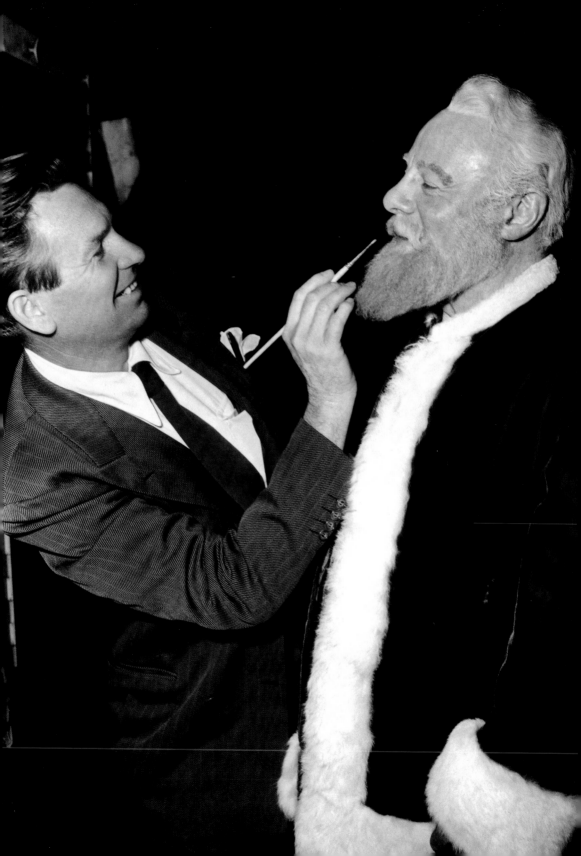

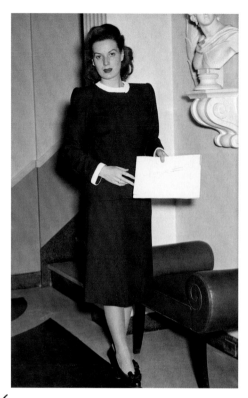

"My favorite memories on set are the ones with Natalie Wood. I have costarred with almost forty children in movies, but I have always had a special place in my heart for her. She called me Mama Maureen, and I called her my little Natasha, the name her parents gave her. She loved making little ceramics on the weekends and used to bring me lovely painted animals and people as gifts. When Natalie and I shot all the scenes in Macy's, we had to do them at night because the store was full of people doing their Christmas shopping during the day. Natalie loved this because she was allowed to stay up late and didn't have to go to bed. I remembered all the tricks we pulled as kids in our house, trying to stay up past bedtime, and so I really enjoyed this time with her. We loved to walk through the quiet closed store together and look at all the beautiful girls' dresses and shoes. She was even more darling in life than she was on-screen.

"I am very proud to have been part of a film that has been continuously shown and loved all over the world for so many years. I never tire of children asking me, 'Are you the lady who knows Santa Claus?' I always answer, 'Yes, I am. What would you like me to tell him?'"

—MAUREEN O'HARA

TOP: Maureen O'Hara, *Miracle on 34th Street*, 1947, OPPOSITE: Maureen O'Hara, Natalie Wood, and John Payne, *Miracle on 34th Street*, 1947

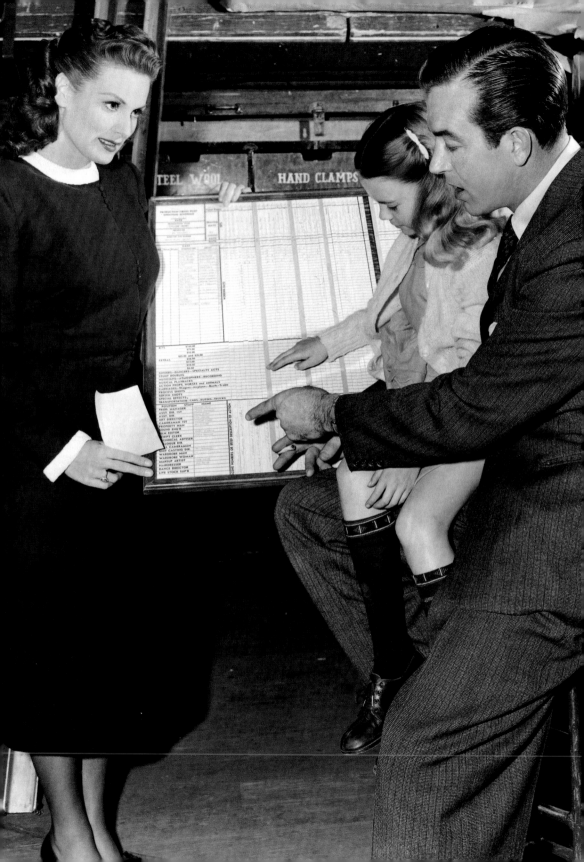

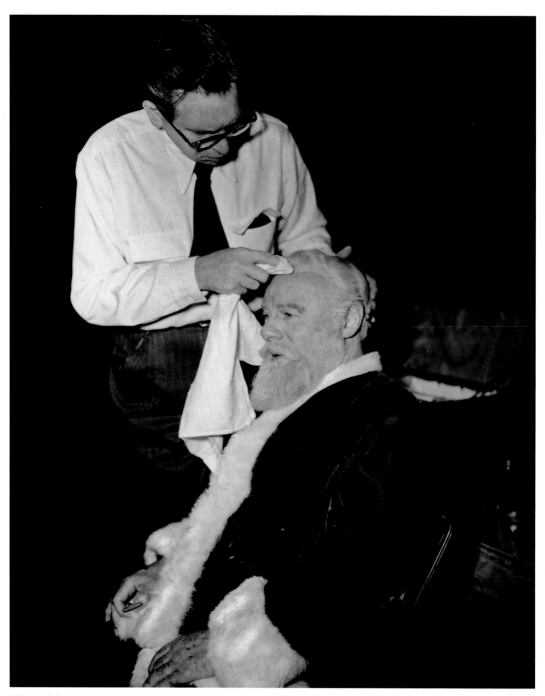

Edmund Gwenn, *Miracle on 34th Street*, 1947

Natalie Wood and John Payne, *Miracle on 34th Street*, 1947

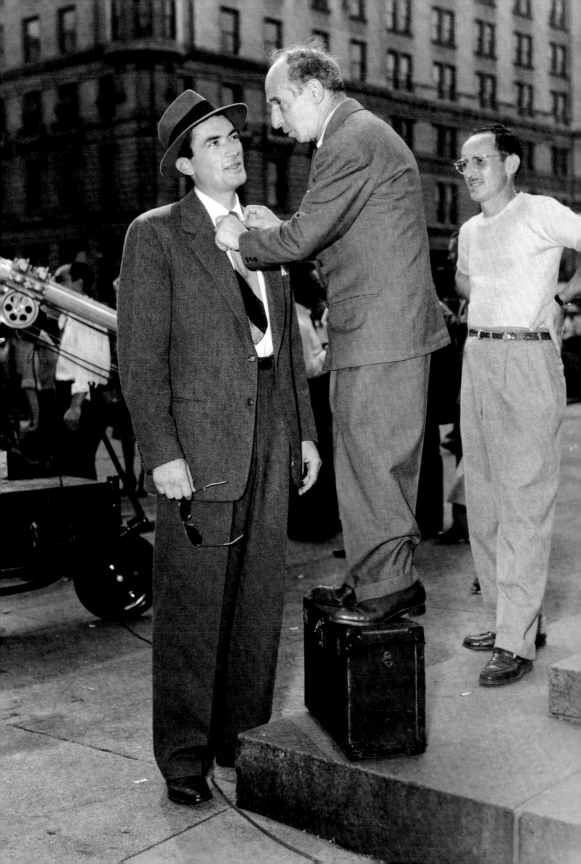

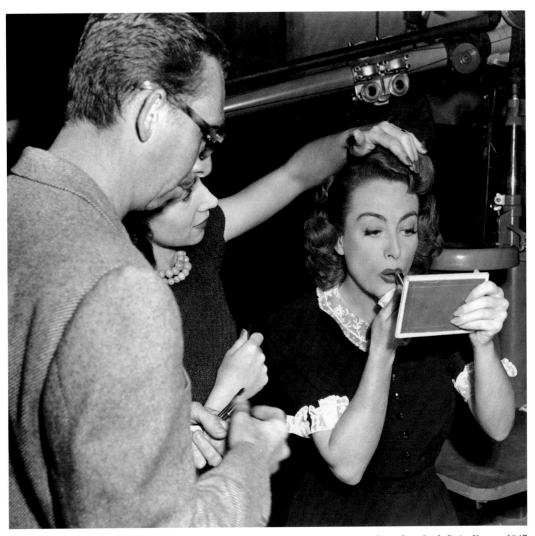

Joan Crawford, *Daisy Kenyon*, 1947

Gregory Peck, *Gentleman's Agreement*, 1947

Gene Tierney, *The Ghost and Mrs. Muir*, 1947

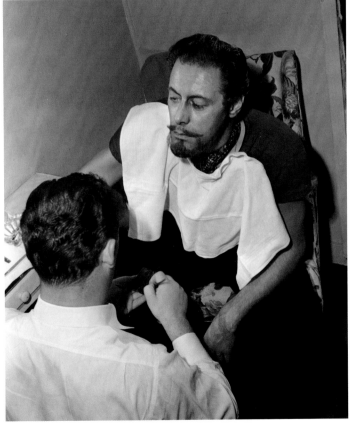

TOP: Natalie Wood, *The Ghost and Mrs. Muir*, 1947
ABOVE: Rex Harrison, *The Ghost and Mrs. Muir*, 1947

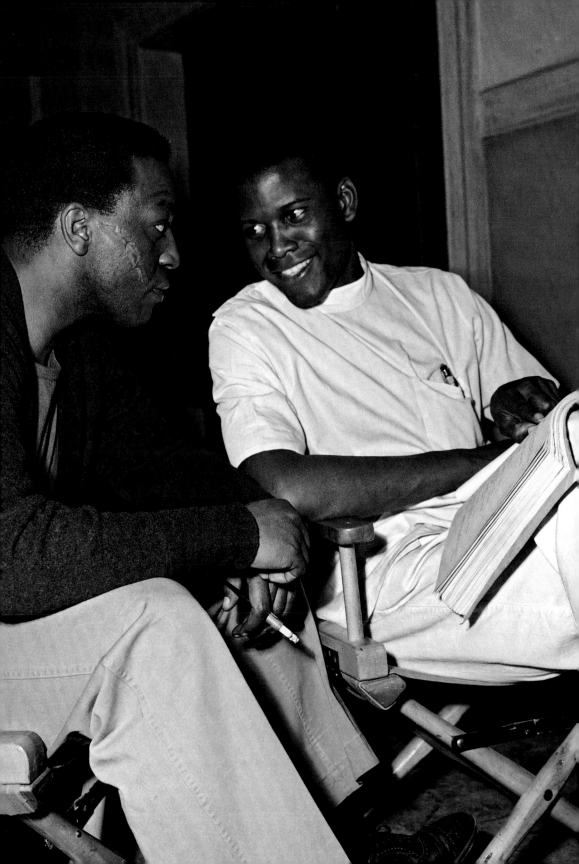

James Cagney, *13 Rue Madeleine*, 1947

James Cagney stands with and without his shirt for his wardrobe continuity photographs. Cagney had a long history with Warner Bros. but starred in *13 Rue Madeleine* for Fox during his independent years.

Sidney Poitier (right), *No Way Out*, 1950

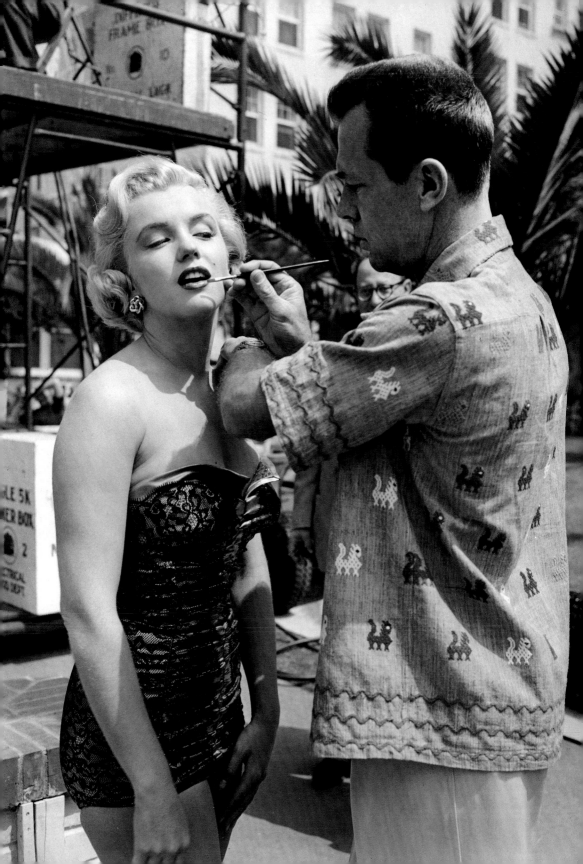

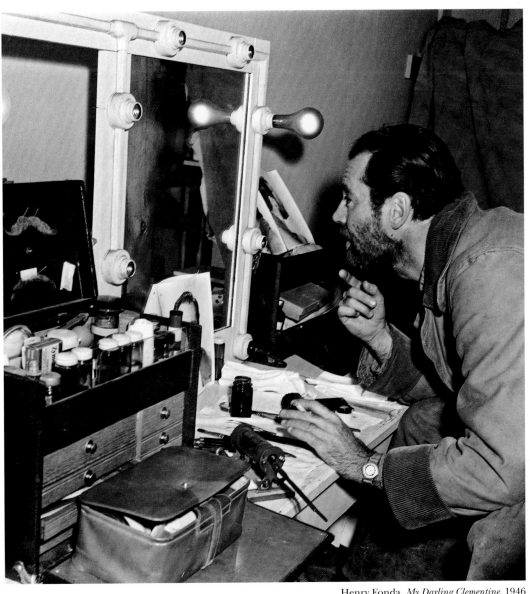

Henry Fonda, *My Darling Clementine*, 1946
FOLLOWING PAGES: Betty Grable, *Meet Me After the Show*, 1951

Marilyn Monroe, *Let's Make It Legal*, 1951

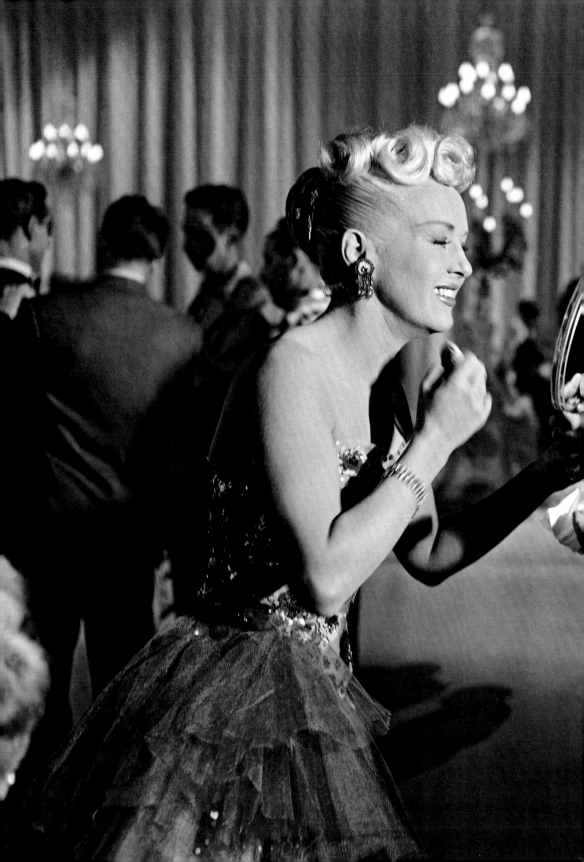

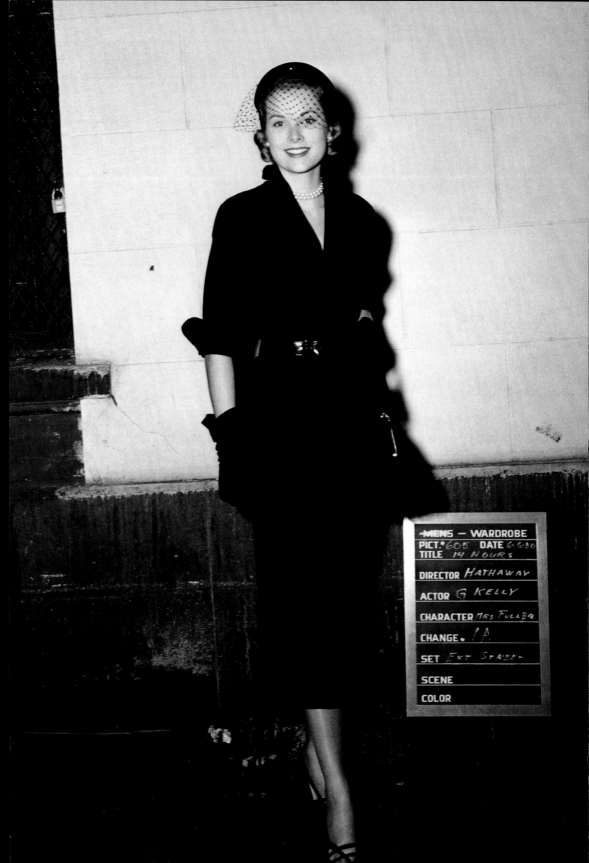

MENS — WARDROBE
PICT.* 605 DATE 6-5-90
TITLE 14 HOURS
DIRECTOR Hathaway
ACTOR G KELLY
CHARACTER Mrs Fuller
CHANGE. 1A
SET Ext Street
SCENE
COLOR

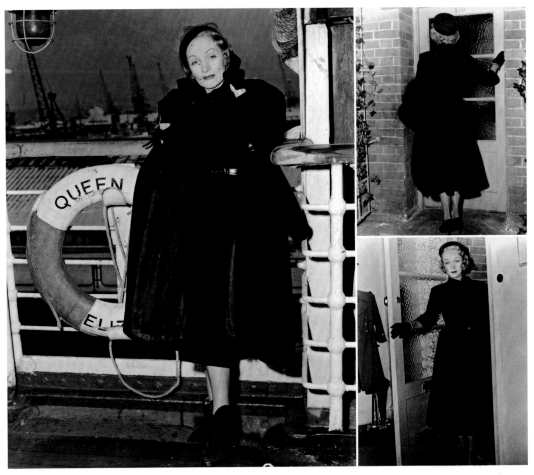

Marlene Dietrich, *No Highway in the Sky*, 1951

Grace Kelly, *Fourteen Hours*, 1951

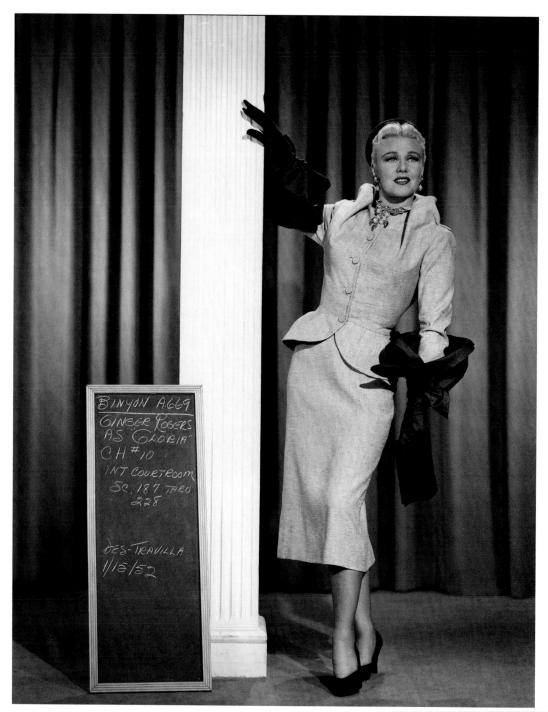

Ginger Rogers, *Dreamboat*, 1952

Ginger Rogers, *Black Widow*, 1954

Tommy Noonan, *Gentlemen Prefer Blondes*, 1953

Marilyn Monroe, *Gentlemen Prefer Blondes*, 1953

After this wardrobe shot was taken, Marilyn Monroe's costume was reportedly deemed too risqué for the infamous "Diamonds Are a Girl's Best Friend" musical number from *Gentlemen Prefer Blondes*. Costume Designer William Travilla's memorable pink gown was the last-minute replacement. Travilla and Monroe were close friends, and he enjoyed creating costumes for her many Fox films.

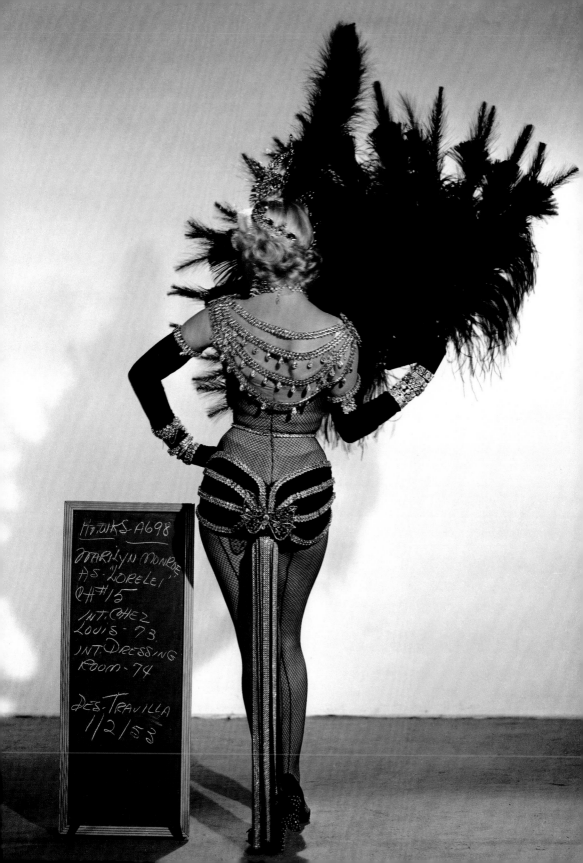

MR. WKS A698
MARILYN MONROE
AS "LORELEI"
PH #15
INT. CHEZ
LOUIS - 73.
INT. DRESSING
ROOM - 74

DES. TRAVILLA
1/2/53

JONES A-708
ANNE BANCROFT
AS "MARIAN"
SH #7
INT. WHACKER'S
OFFICE
SC. 172

DES·JENKINS
3/4/'53

Vivien Leigh, *The Deep Blue Sea*, 1955

Anne Bancroft, *The Kid from Left Field*, 1953

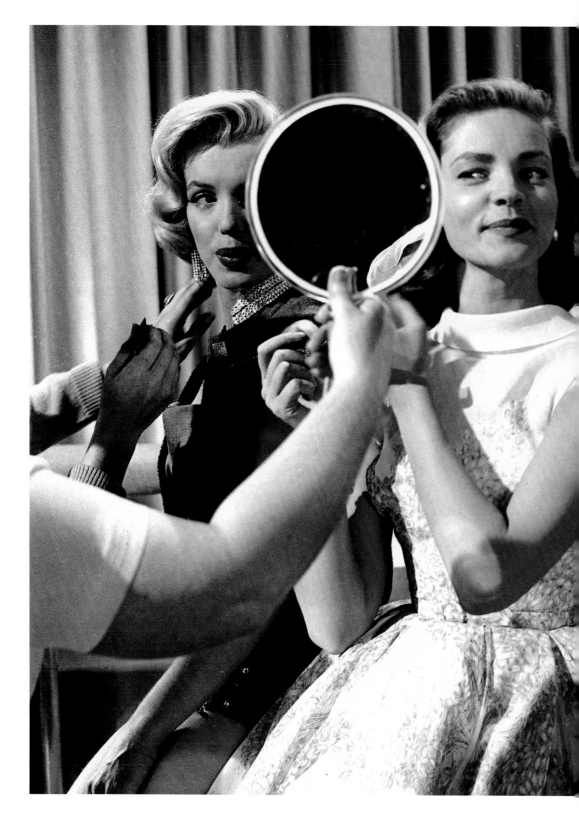

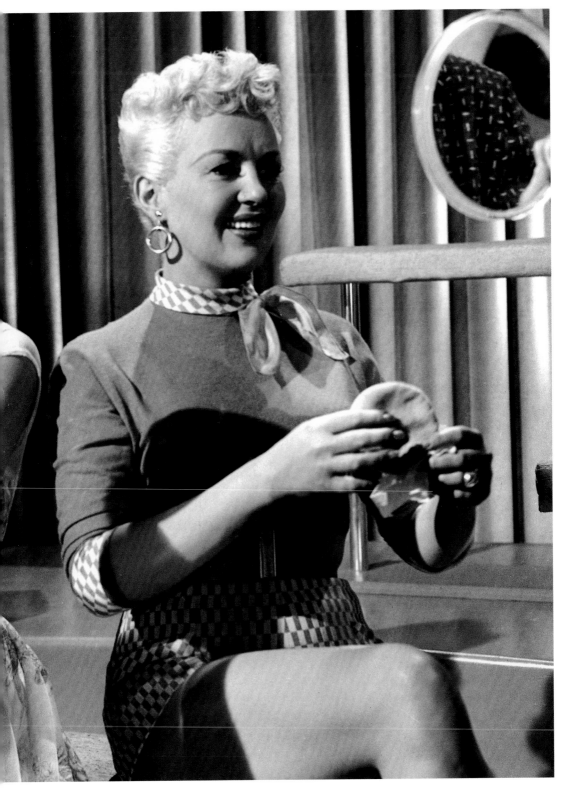

Marilyn Monroe, Lauren Bacall, and Betty Grable, *How to Marry a Millionaire*, 1953

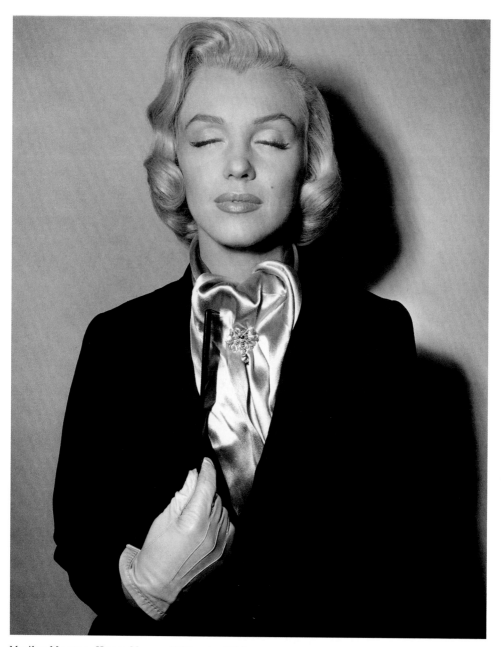

Marilyn Monroe, *How to Marry a Millionaire*, 1953

Norma Jeane Dougherty signed her first studio contract in 1946 with Twentieth Century Fox. She changed her stage name to Marilyn Monroe at that time. Although the first contract expired one year later, she returned to Fox in 1950 by signing a seven-year deal. Based on the phenomenal success of her first major films, she renegotiated in 1955 and signed her final Fox contract (a four-film, seven-year deal). The third of these films would be the unfinished *Something's Got to Give* in 1962, the year of her death.

Titanic

1953

Long before James Cameron's record-breaking 1997 version, Fox released the original *Titanic* in 1953—approximately forty years after the real-life tragedy claimed the lives of more than 1,500 people. Filmed entirely on the Fox lot, the film starred Barbara Stanwyck and Clifton Webb, with Audrey Dalton as their daughter. A young Robert Wagner served as Dalton's love interest, with Frances Bergen (Candice's mother) as Mrs. John Jacob Astor, and Thelma Ritter as Maude Young (clearly patterned after the "Unsinkable" Molly Brown).

The extravagant costumes with their fur trim, and the ladies' elaborate upswept hairdos, emphasize the wealth and glamour of the first class on the luxury liner. The costumes were designed by Dorothy Jeakins, who provided clothing from the "skin out"—underwear to fine wear. The women in the cast wore modified corsets and other period undergarments to ensure their Edwardian gowns would hang properly. Jeakins dressed her charges in the heavy clothing appropriate for a night outdoors in the North Atlantic, but the film was shot indoors under the blazing studio lights, which caused difficulties on the set. Audrey Dalton became so overheated in her costume and perspired so heavily that she was issued salt pills.

Jeakins was also tasked with the responsibility of having to visually indicate in a brief moment an actor's fate in *Titanic*. Extensive continuity shots were taken of the principals and extras to verify that audiences would be able to tell at a glance whether they were looking at a first- or third-class passenger.

Robert Wagner, *Titanic*, 1953

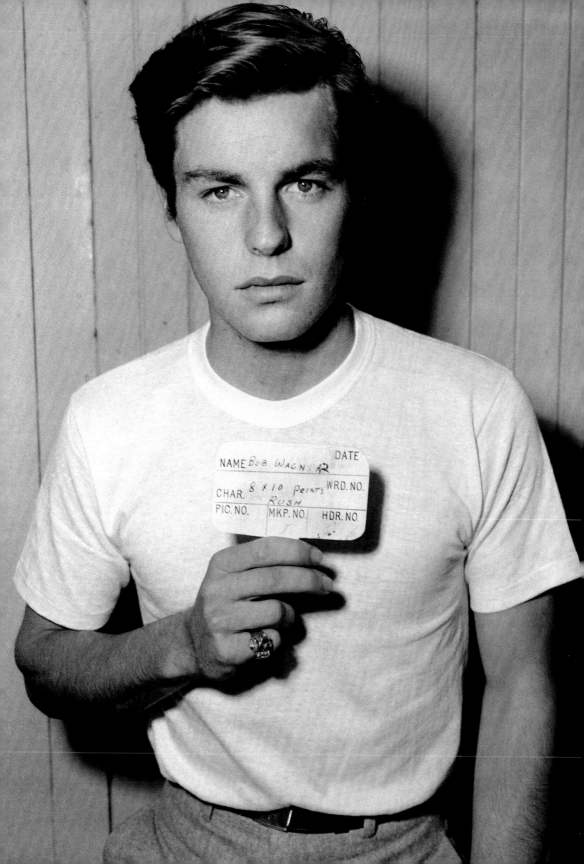

NAME Bob Wagner DATE

CHAR. 8 x 10 Prints WRD. NO.

Rush

PIC. NO. MKP. NO. HDR. NO.

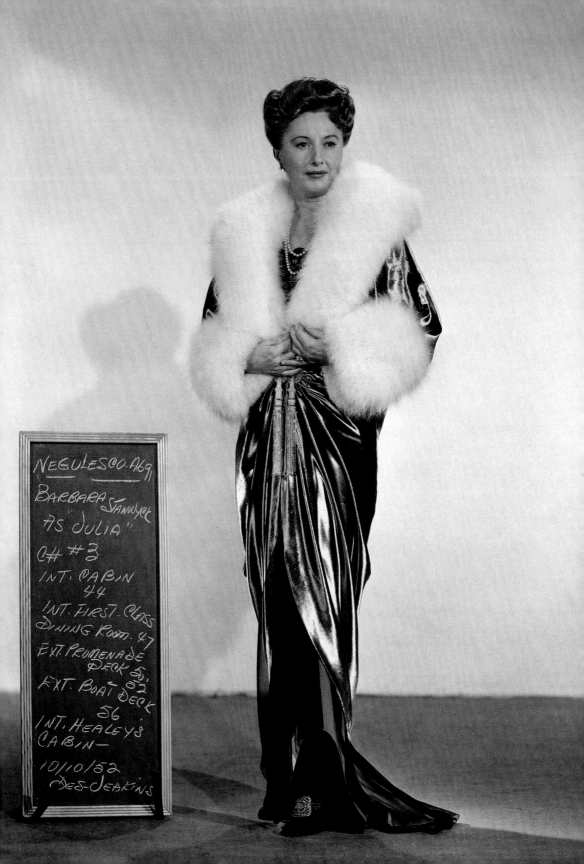

NEGULESCO.A69
BARBARA STANWYCK
AS "JULIA"
C# #3
INT. CABIN
44
INT. FIRST CLASS
DINING ROOM. 47
EXT. PROMENADE
DECK 50.
52
EXT. BOAT DECK
56
INT. HEALEY'S
CABIN—
10/10/52
DES-JEAKINS

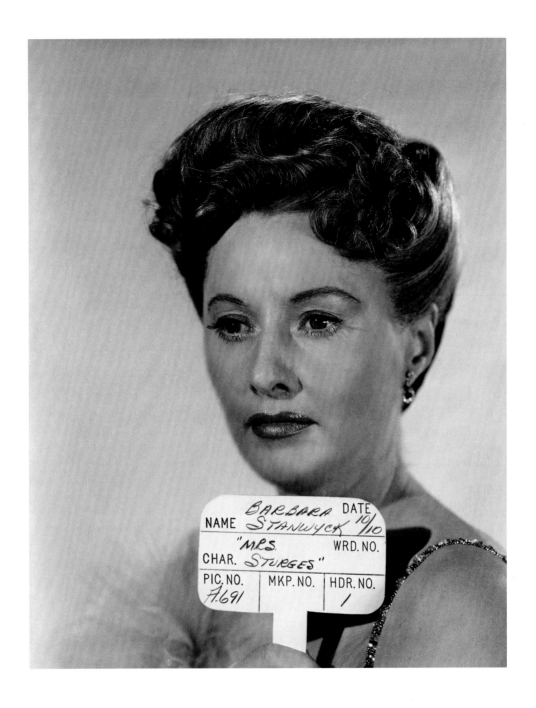

Barbara Stanwyck, *Titanic*, 1953

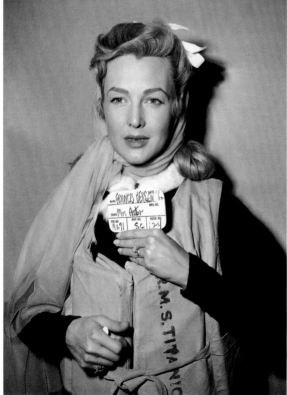

TOP: Thelma Ritter, *Titanic*, 1953
LEFT AND OPPOSITE: Frances Bergen, *Titanic*, 1953

Frances Bergen made her film debut in 1953's
Titanic. Her final acting appearance was a guest role
in her daughter Candice Bergen's television series
Murphy Brown.

NEGULESCO PGG
FRANCES
BERGEN
AS "MRS. ASTOR"
CH #1
EXT. TENDER
SC 11,12

EXT. STAIRWAY
TO PARCEL
RECEIVING
ROOM - A14

DES - JEAKINS
10/21/52

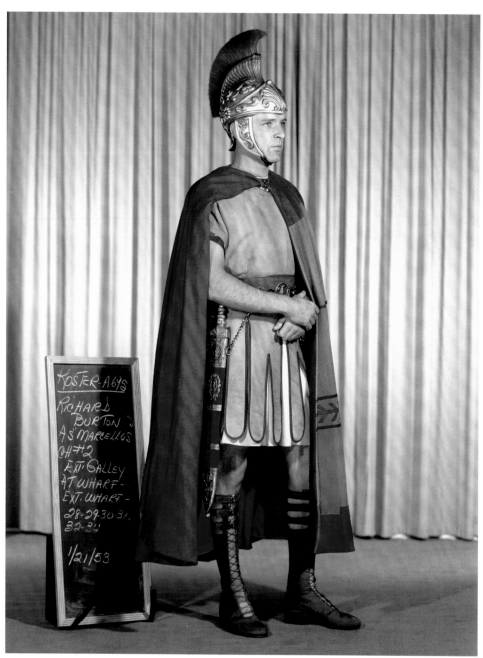

The blackboard reads:

KOSTER - A-695
RICHARD
BURTON
AS "MARCELLOS"
CH #2
EXT GALLEY
AT WHARF -
EXT. WHARF -
28-29-30-31-
32-34

1/21/53

Richard Burton, *The Robe*, 1953

Victor Mature, *The Robe*, 1953

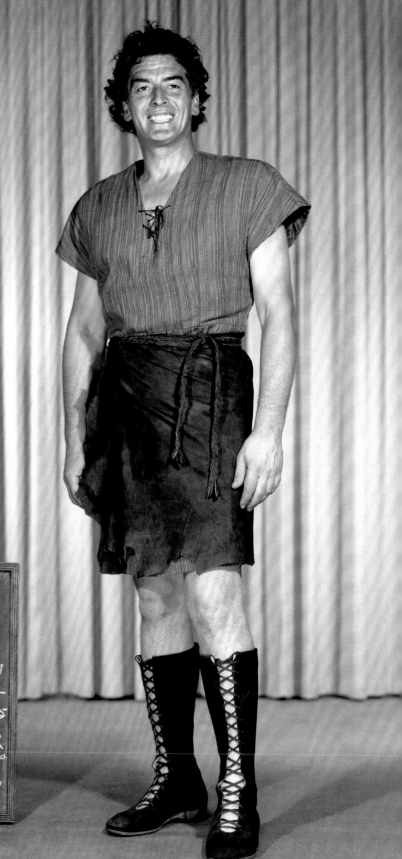

KOSTER-A-695
VIC MATURE AS
"DEMETRIUS"
C#6
INT. DEMETRIUS' ROOM
153·155·156·158
EXT. MARKET PLACE
159·161·162·168·170·173·175
SH#7
INT. TORTURE CHAMBER
182·183·184·186·187·190
200·220·223·225·230
INT. GALLIO ATRIUM
240
1/26/3

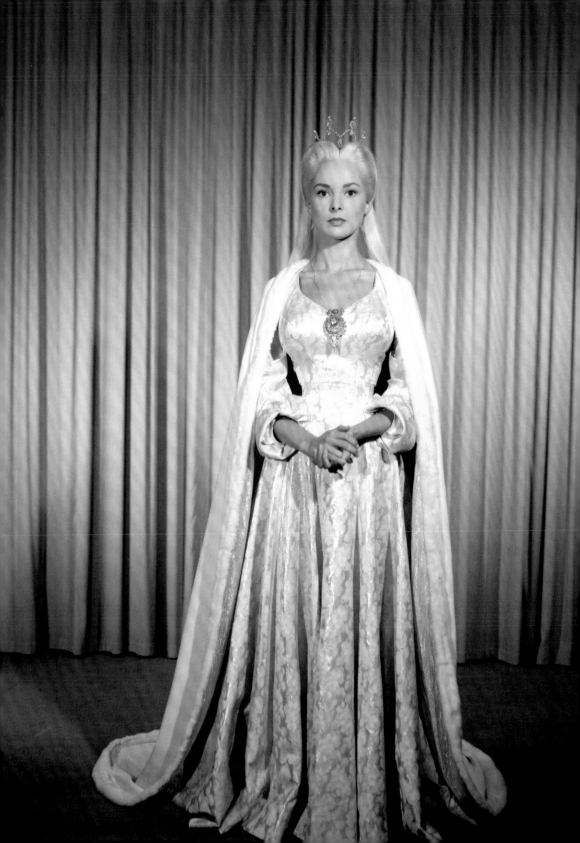

Janet Leigh, *Prince Valiant*, 1954

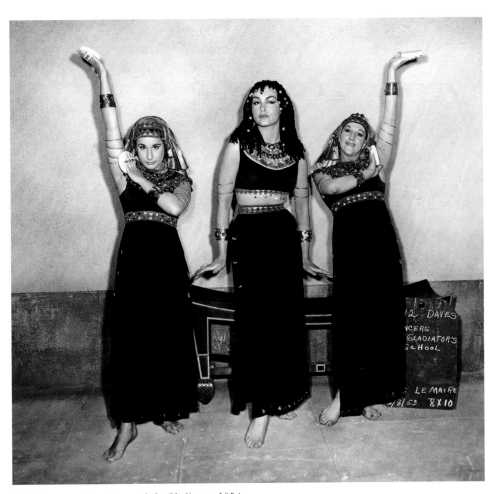

Julie Newmar, *Demetrius and the Gladiators*, 1954

Julie Newmar (above, center) was a featured dancer in *Demetrius and the Gladiators* just prior to landing her first principal role in *Seven Brides for Seven Brothers*. Featured dancers are similar to background players (extras), but they are hired for their dancing talent and not just their look.

Anne Bancroft, *Demetrius and the Gladiators*, 1954

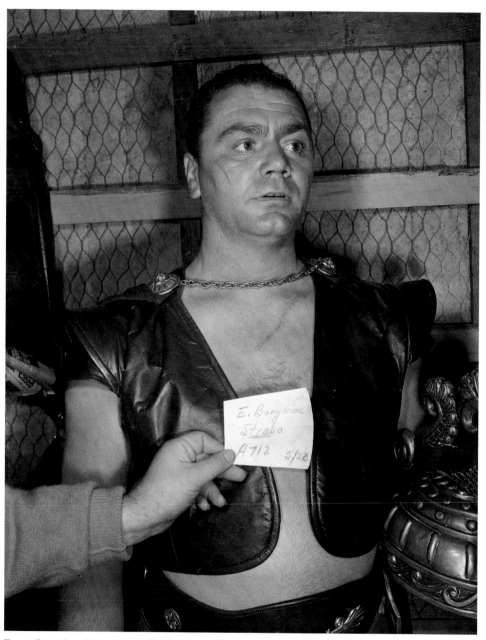

Ernest Borgnine, *Demetrius and the Gladiators*, 1954

Susan Hayward, *Demetrius and the Gladiators*, 1954

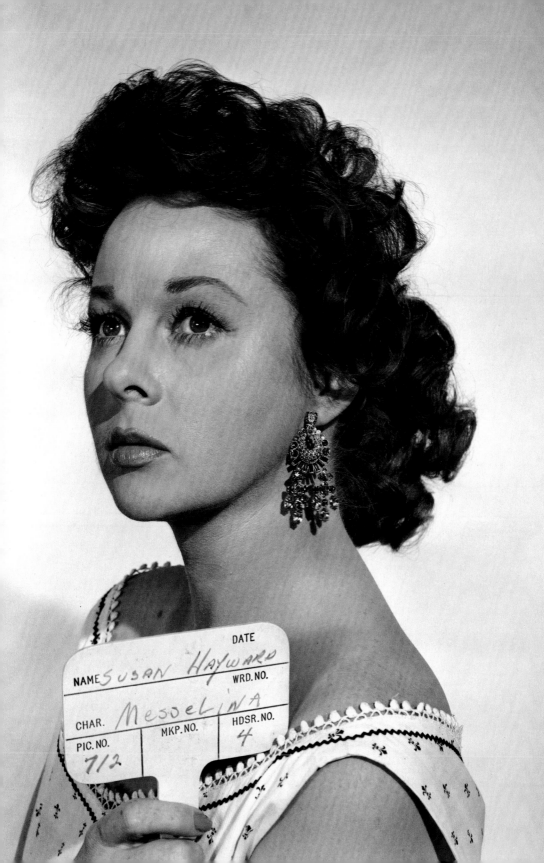

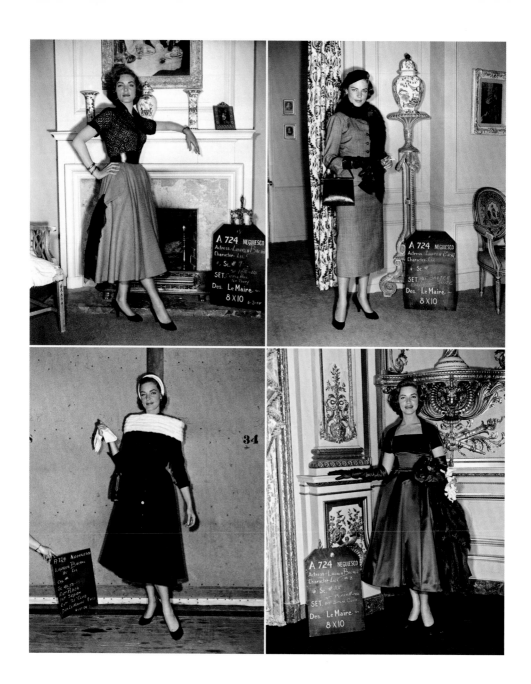

Lauren Bacall, *Woman's World*, 1954

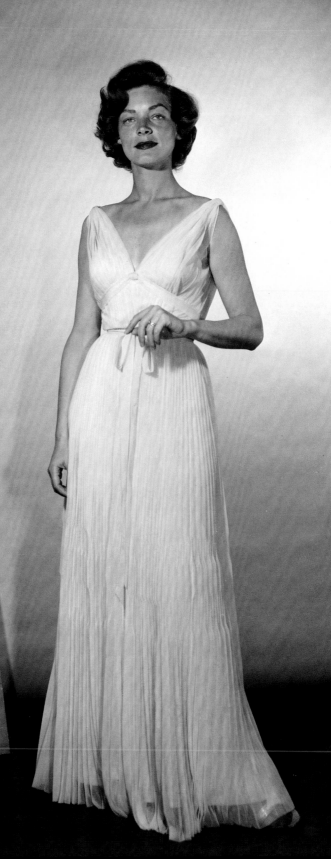

LADIES - WARDROBE
PICT.*
TITLE F 724 DATE 5/5/54
DIRECTOR Neglesco
ACTOR Lauren Bacall
CHARACTER Liz
CHANGE # 3
SET INT. Burn's Suite
SCENE 37
COLOR 8x10 DES. LeMaire

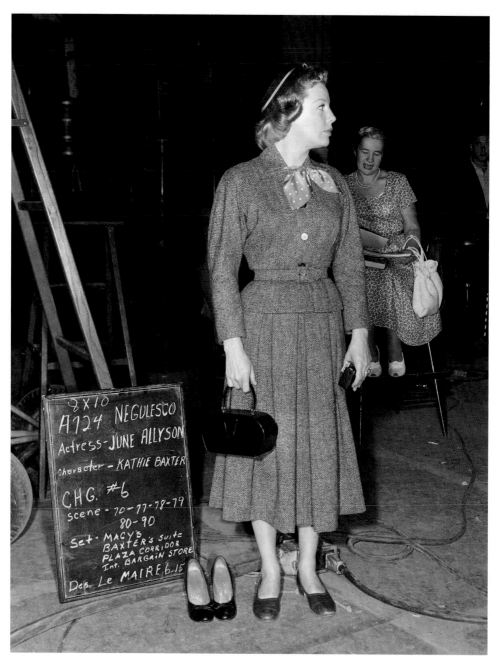

June Allyson, *Woman's World*, 1954

Arlene Dahl, *Woman's World*, 1954

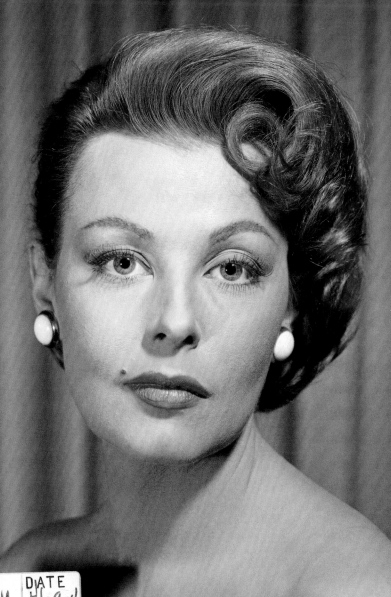

NAME **ARLENE DAHL** DATE 4/29/54
CHAR. **CAROL** PIC. NO.
MKP. NO. HRD. NO. 2

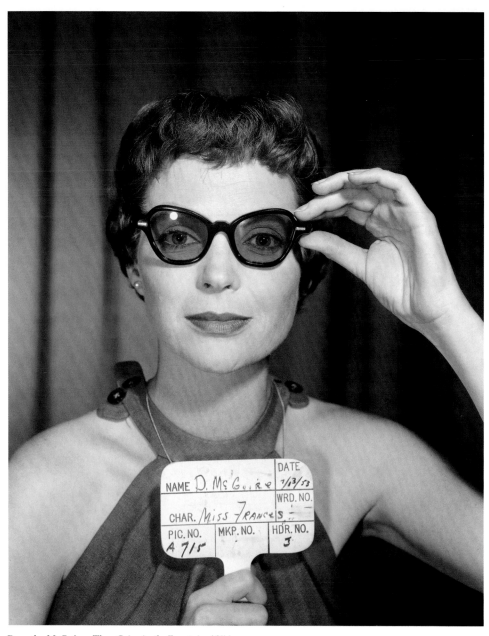

Dorothy McGuire, *Three Coins in the Fountain*, 1954

Louis Jourdan, *Three Coins in the Fountain*, 1954

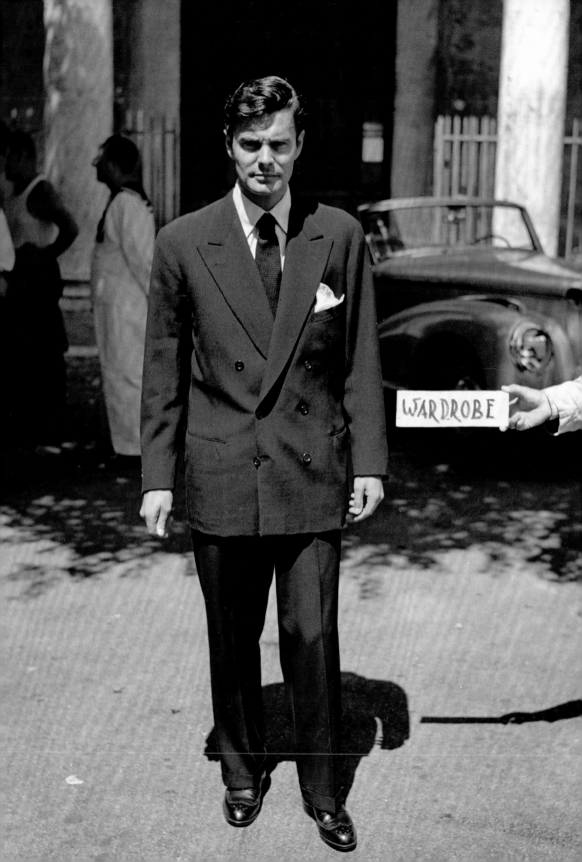

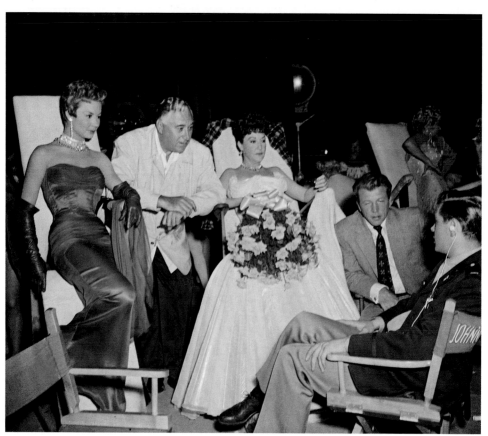

Mitzi Gaynor, Ethel Merman, and Marilyn Monroe (far right),
There's No Business Like Show Business, 1954

Marilyn Monroe, *There's No Business Like Show Business*, 1954

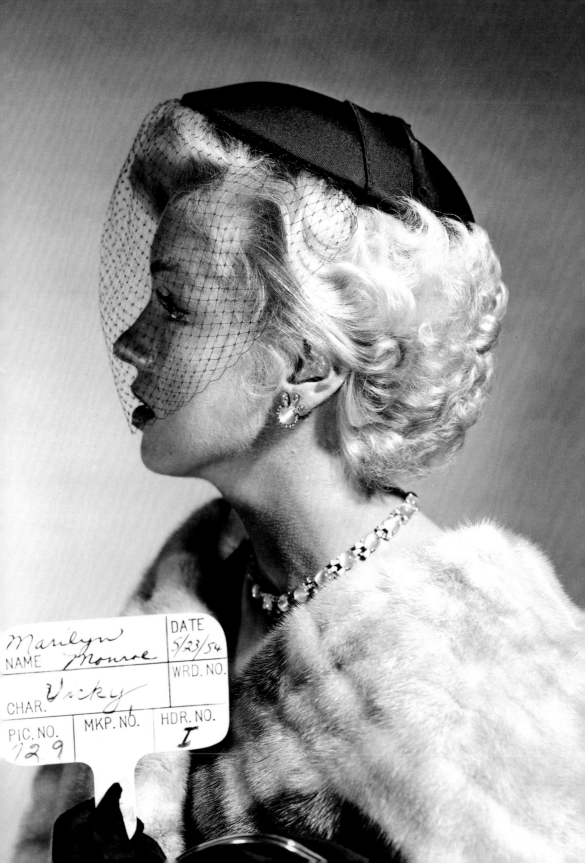

NAME Marilyn Monroe DATE 5/23/54
CHAR. Vicky WRD. NO.
PIC. NO. 729 MKP. NO. HDR. NO. I

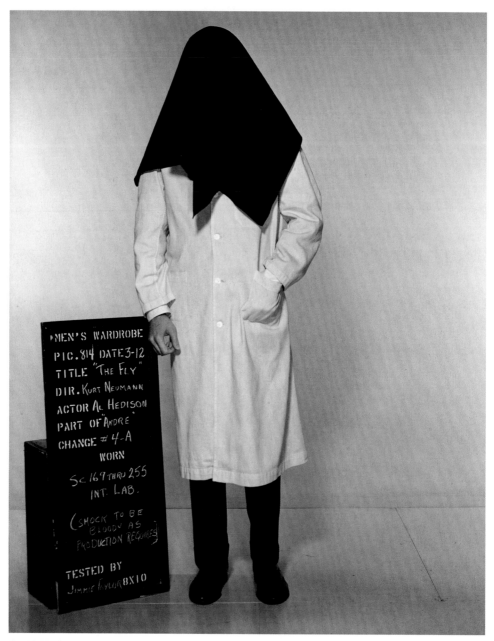

David Hedison, *The Fly*, 1958

Prior to donning his frightening fly-head mask, David Hedison posed for a most unusual continuity shot. In the film, Hedison's character initially conceals his monstrous face from his wife by wearing this black cloth. He also conceals his deformed hand.

Patricia Neal, *The Day the Earth Stood Still*, 1951

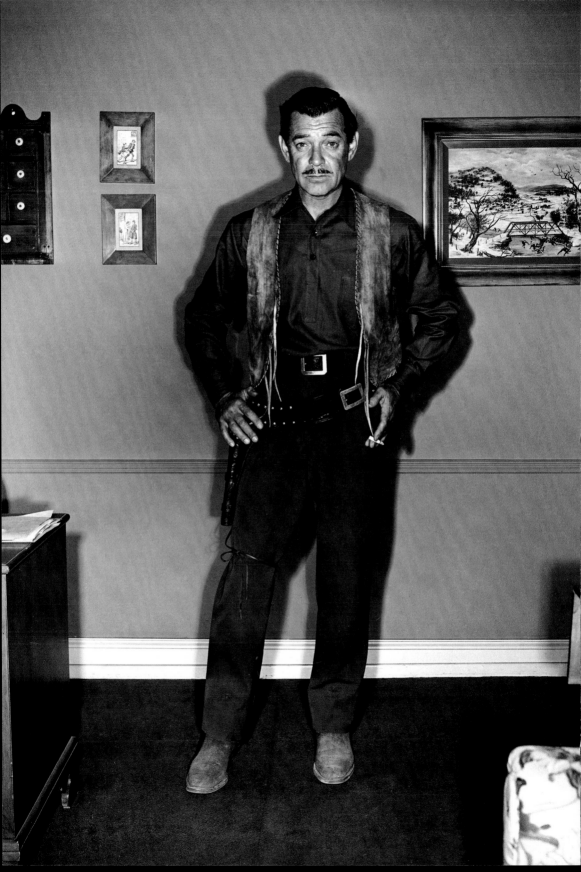

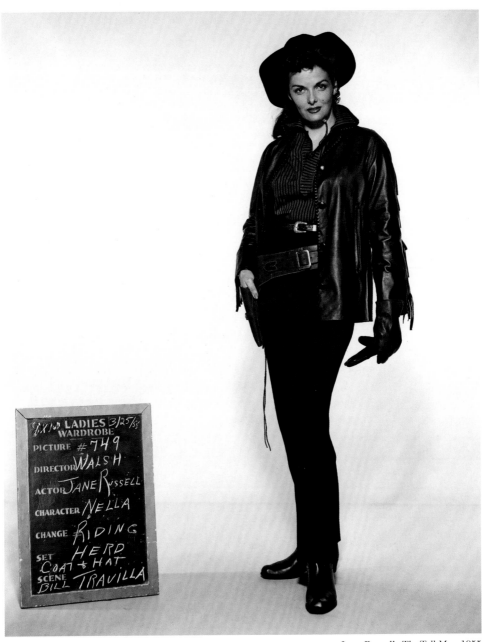

The following is written on the slate in the image:

8"×10" LADIES 3/25/55
WARDROBE
PICTURE #749
DIRECTOR WALSH
ACTOR JANE RUSSELL
CHARACTER NELLA
CHANGE RIDING
SET HERD
SCENE COAT & HAT
BILL TRAVILLA

Jane Russell, *The Tall Men*, 1955

Clark Gable, *The Tall Men*, 1955

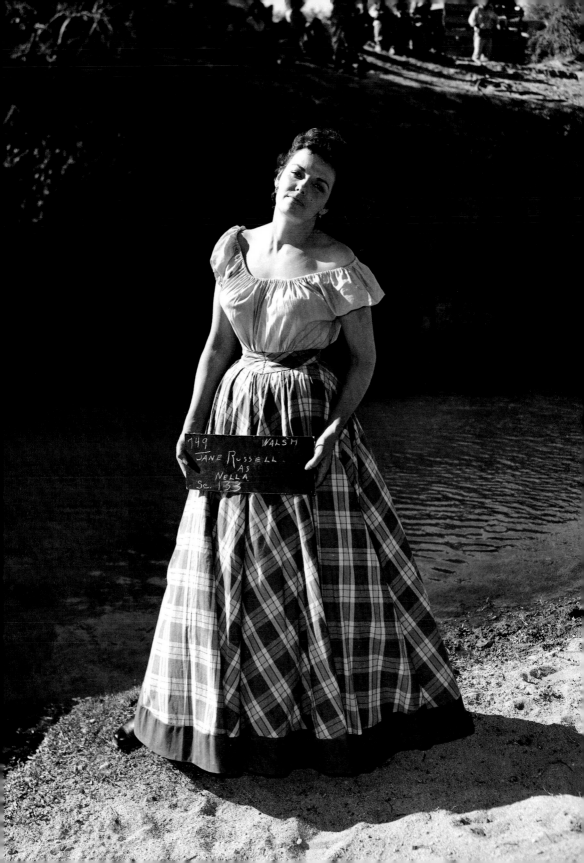

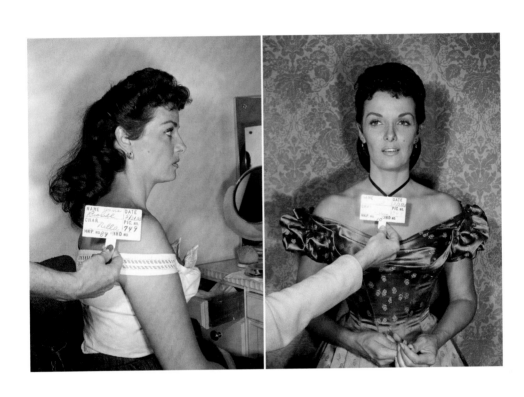

Jane Russell, *The Tall Men*, 1955

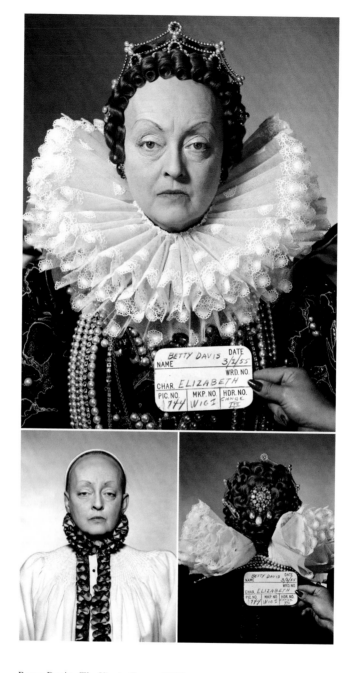

Bette Davis, *The Virgin Queen*, 1955

Sometimes the continuity placard would be prepared in such haste
that an actor's name would be misspelled—as seen above, where Bette
Davis's name was written as "Betty" in error.

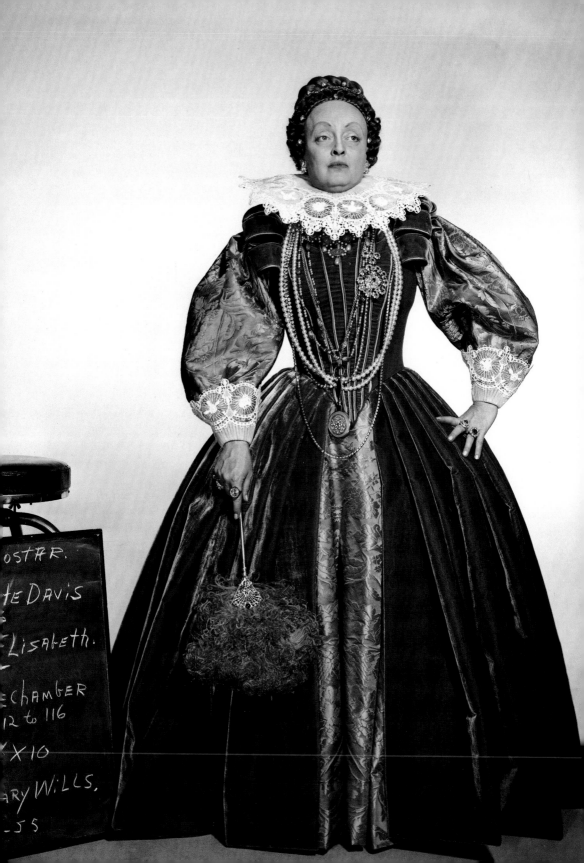

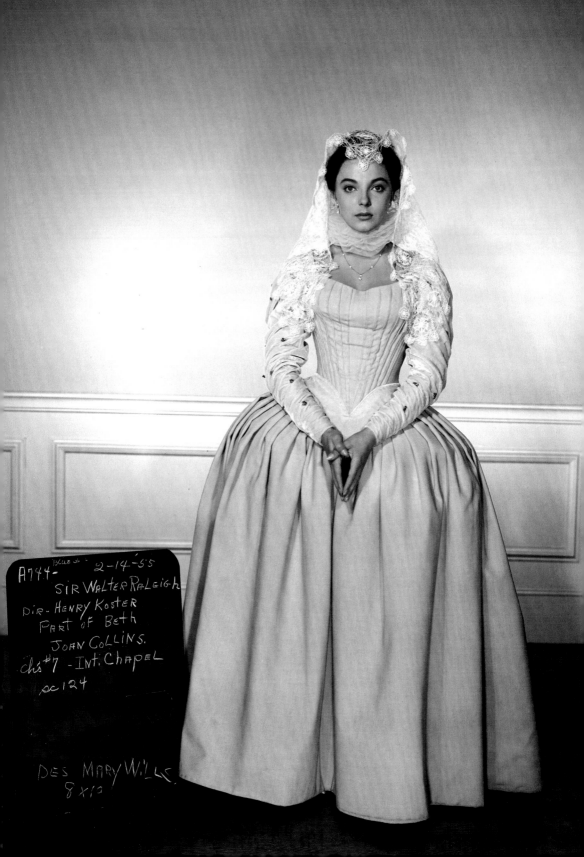

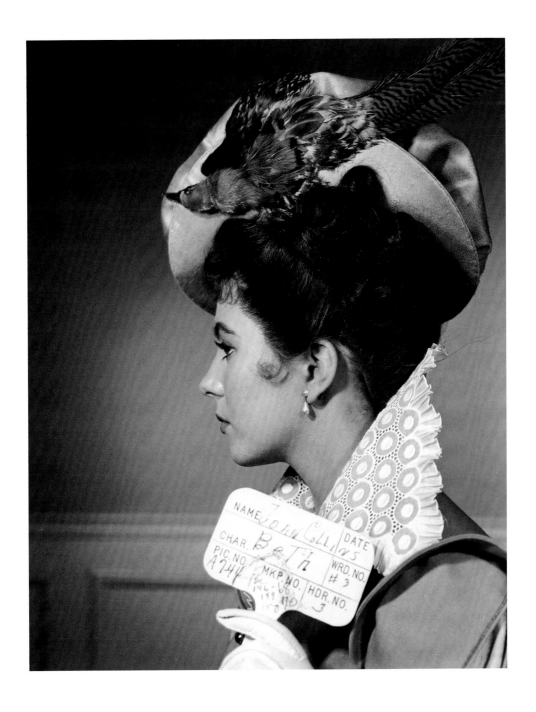

Joan Collins, *The Virgin Queen*, 1955

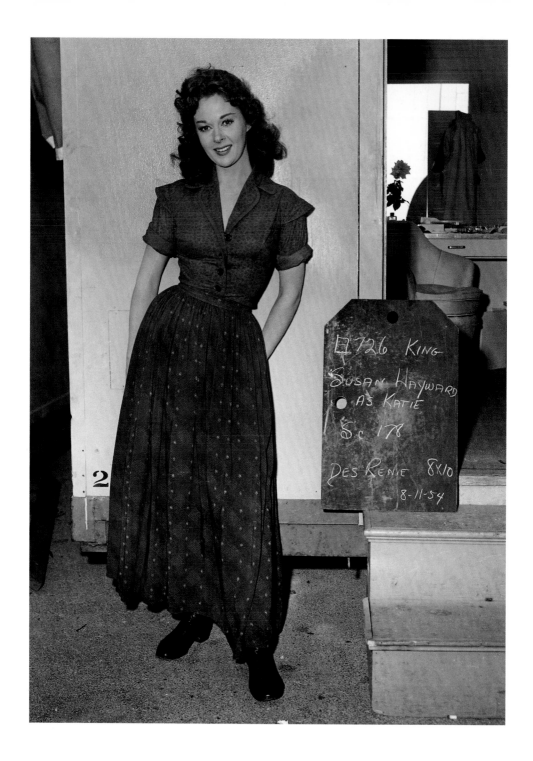

Susan Hayward, *Untamed*, 1955

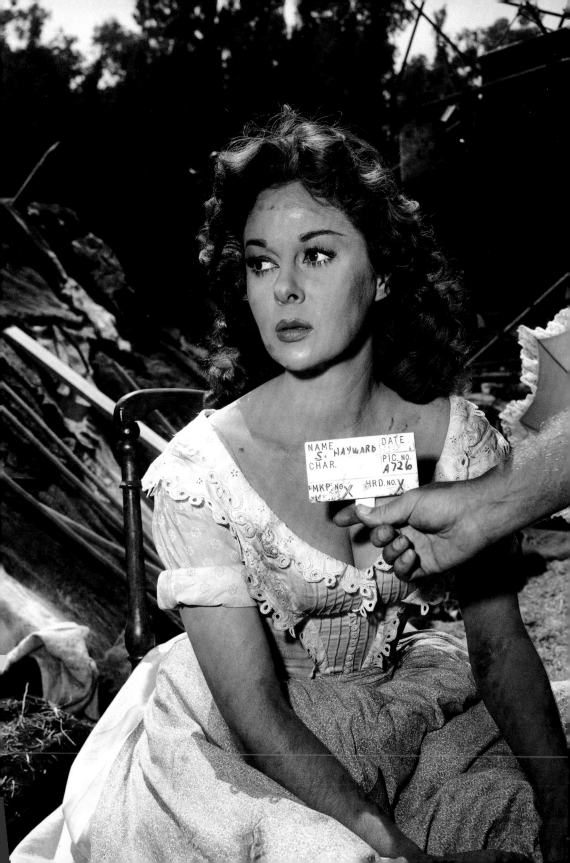

NAME S. HAYWARD DATE
CHAR.
PIC. NO. A726
MKP. NO. X HRD. NO. X

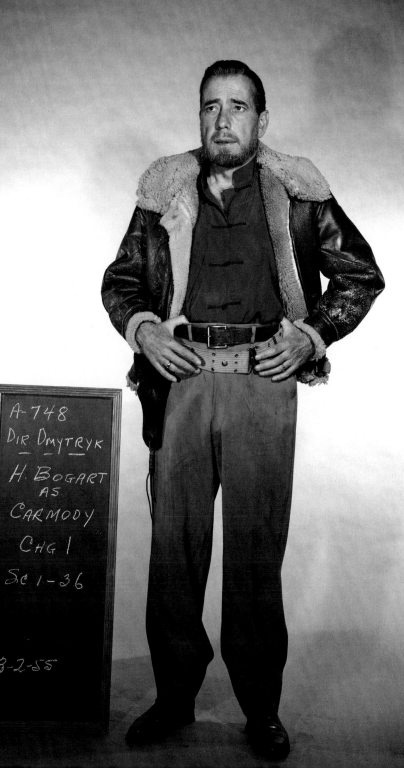

A-748
DIR DMYTRYK

H. BOGART
AS

CARMODY

CHG I

SC 1-36

3-2-55

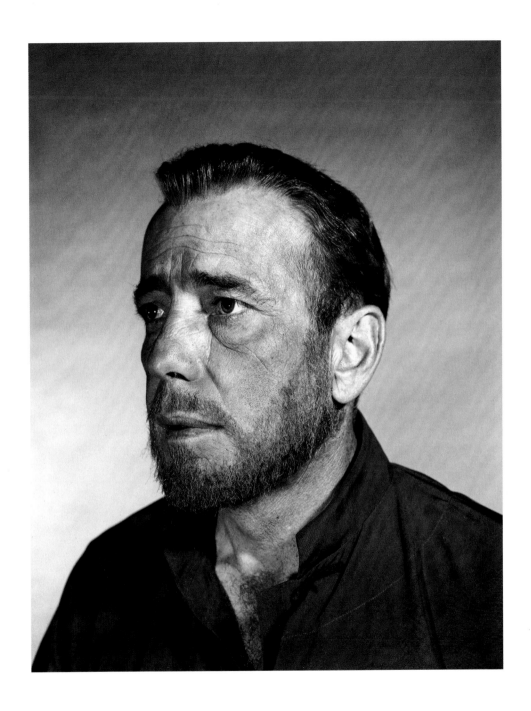

Humphrey Bogart, *The Left Hand of God*, 1955

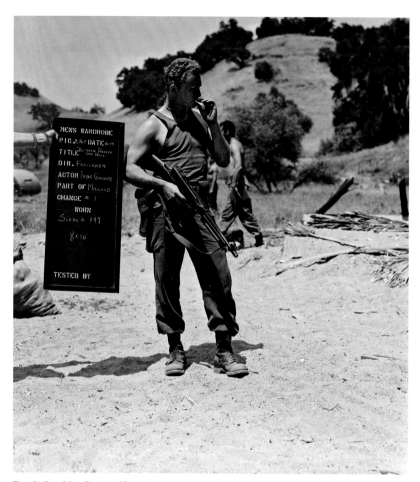

Frank Gorshin, *Between Heaven and Hell*, 1956

Richard Burton, *The Rains of Ranchipur*, 1955

Following his success in *The Robe*, Richard Burton was offered a
seven-year, $1 million contract with Twentieth Century Fox. He
initially declined the offer, but later agreed to it and completed
several Fox films, including *The Rains of Ranchipur*. Known as
a hell-raiser off camera, Burton could be a pussycat on the set.
According to one designer, when approached to approve a
costume, he was known to respond, "It's okay, love."

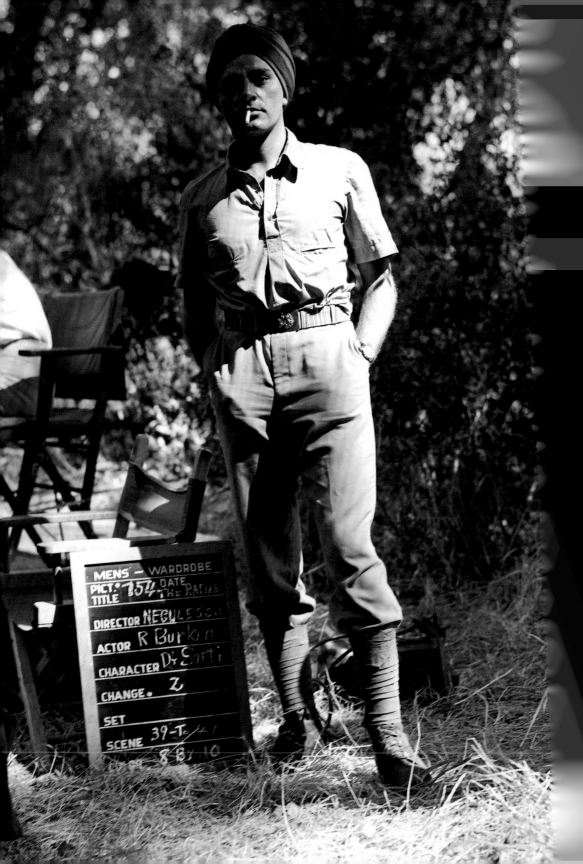

MENS - WARDROBE
PICT. 754 DATE
TITLE THE RAINS
DIRECTOR NEGULESCO
ACTOR R Burton
CHARACTER Dr Safti
CHANGE. 2
SET
SCENE 39-Ta 41
8 8/10

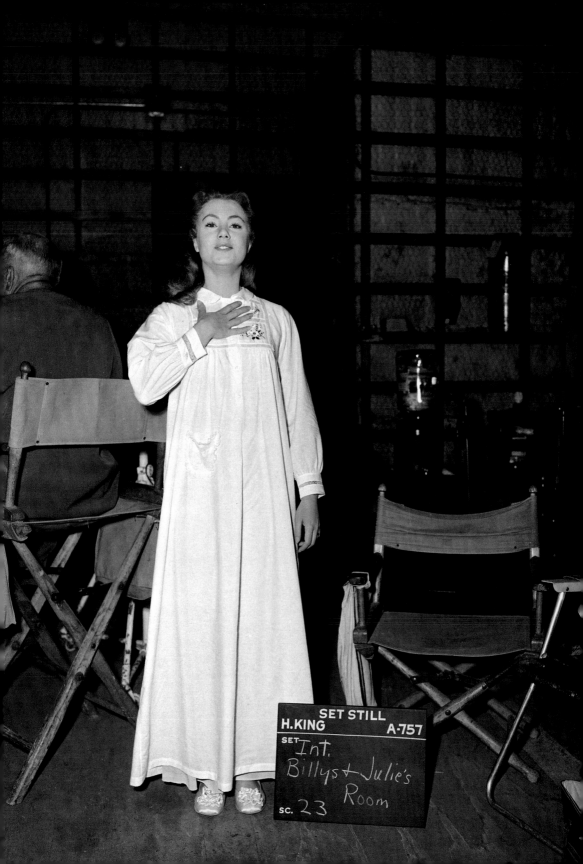

SET STILL
H. KING A-757
SET Int.
Billys + Julie's
Room
SC. 23

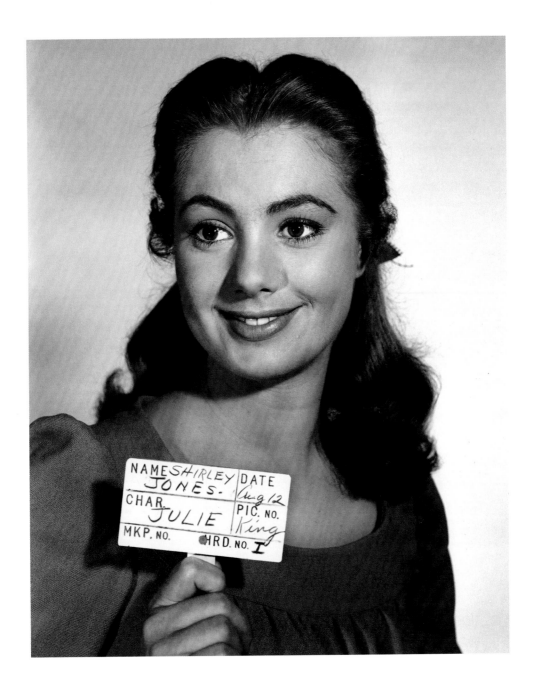

Shirley Jones, *Carousel*, 1956

The way a ribbon was tied in the hair, the tilt of a hat, or how many buttons
were left unbuttoned on a shirt were all details recorded in photographs in
case a scene was to be reshot or continued on another day.

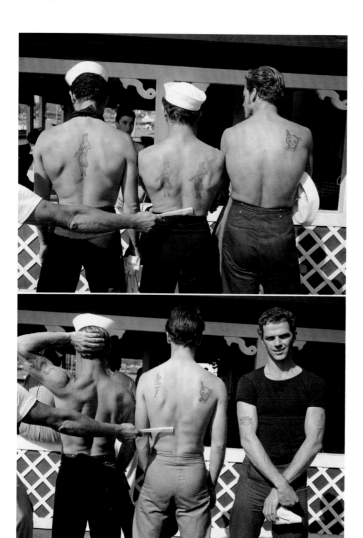

Extras, *Carousel*, 1956

Extras, background players, and *atmosphere* are terms for the people who appear in a scene without any lines but fill the background to convince a viewing audience of the authenticity of a scene. Depending on the production, there may be hundreds of people filling a bustling street in a town, fighting on the front line of battle, dancing at a carnival, being held captive in a prison, or cheering on gladiators in a coliseum. Extras color a scene with wardrobe, hair, and makeup, blending in with the atmosphere without distracting from the central action of the scene. It is the job of extras to create believable background action, and the job of the costume and hair departments to dress them appropriately. In these images from *Carousel*, the tattoos on the sailor extras' backs are photographed for continuity purposes.

Gordon MacRae, *Carousel*, 1956

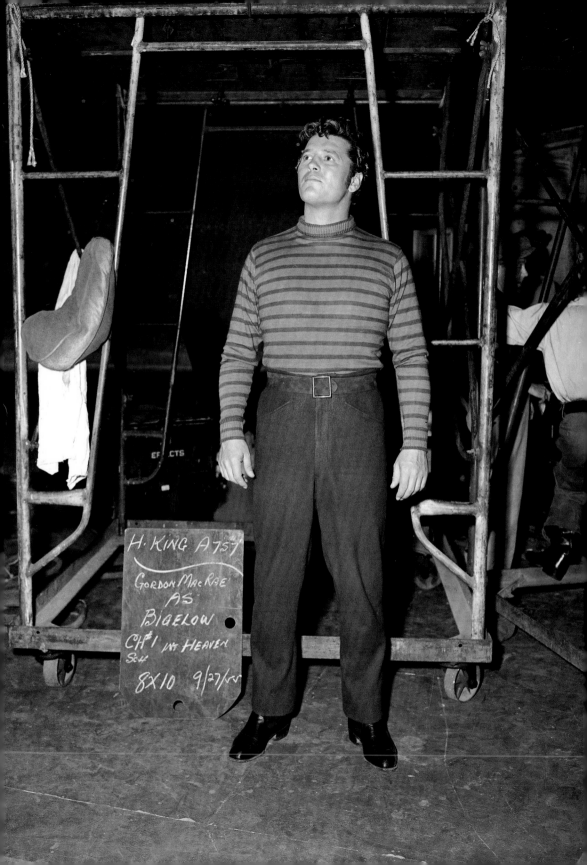

H. KING A757
GORDON MacRAE
AS
BIGELOW
CH#1 INT HEAVEN
SC-4
8X10 9/27/44

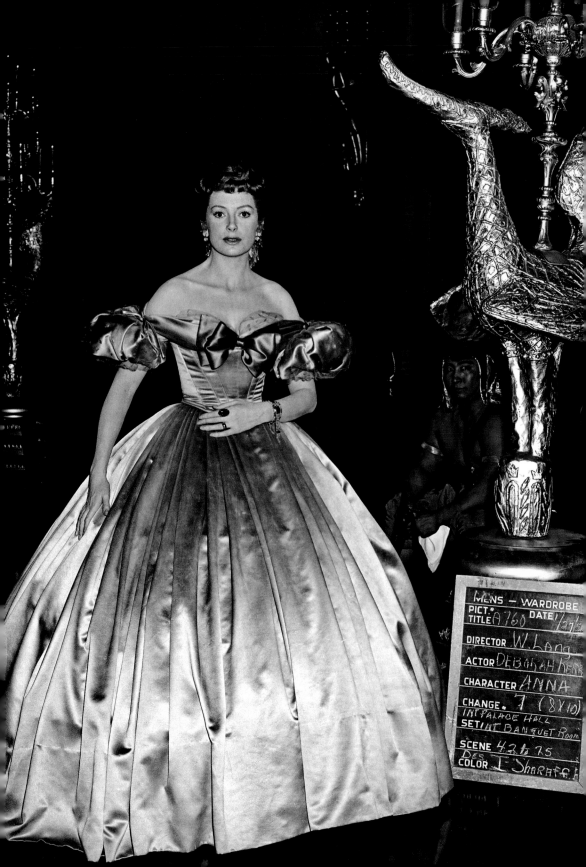

MENS — WARDROBE
PICT. TITLE A760 DATE 1/27/5
DIRECTOR W. Lang
ACTOR DEBORAH KERR
CHARACTER ANNA
CHANGE. 7 (8×10)
SET INT PALACE HALL
INT BANQUET ROOM
SCENE 43 to 75
DES
COLOR I Sharaff

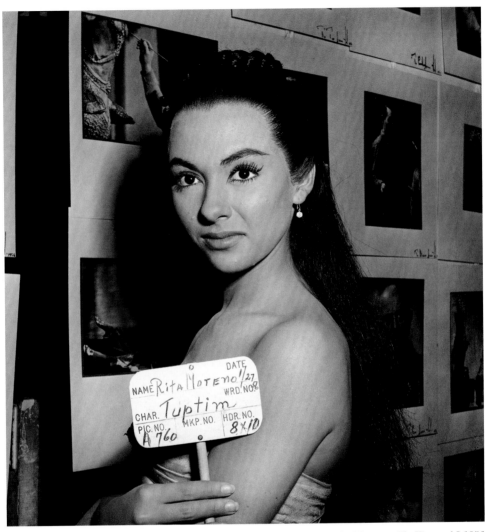

Rita Moreno, *The King and I*, 1956

Deborah Kerr, *The King and I*, 1956

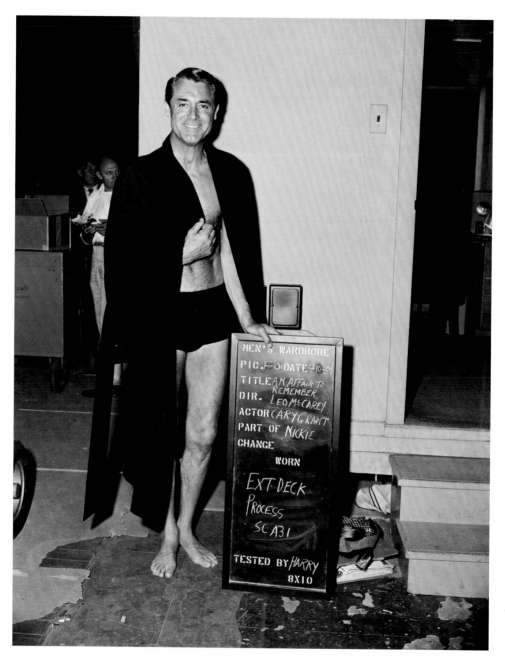

Cary Grant, *An Affair to Remember*, 1957

Aside from an early studio contract in the 1930s, Cary Grant was one of very few stars during the Golden Age who remained independent and freelance. He appeared in a handful of films for Twentieth Century Fox during his lengthy career, most notably *An Affair to Remember*.

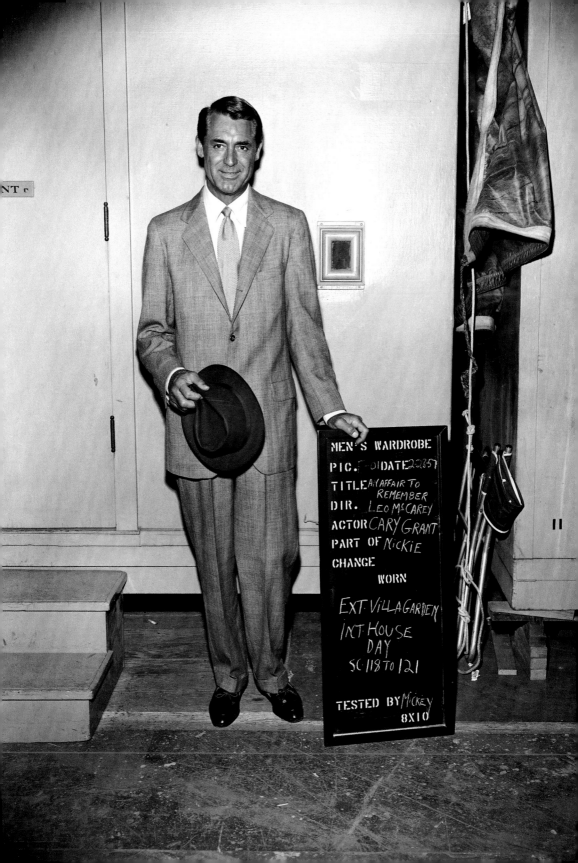

MEN'S WARDROBE

PIC. DATE 2-857

TITLE AN AFFAIR TO REMEMBER

DIR. LEO McCAREY

ACTOR CARY GRANT

PART OF NICKIE

CHANGE

WORN

EXT. VILLA GARDEN

INT. HOUSE

DAY

SC. 118 TO 121

TESTED BY MICKEY

8 X 10

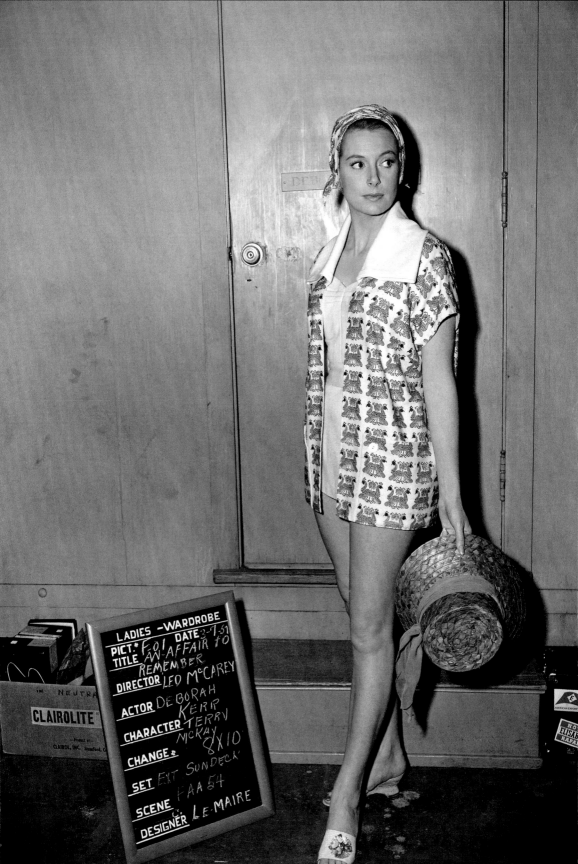

LADIES - WARDROBE
PICT # FOI DATE 3-7-51
TITLE AN AFFAIR TO
REMEMBER
DIRECTOR LEO McCAREY
ACTOR DEBORAH KERR
CHARACTER TERRY
McKAY 8X10
CHANGE #
SET EXT SUNDECK
SCENE FAA 54
DESIGNER LE-MAIRE

CLAIROLITE

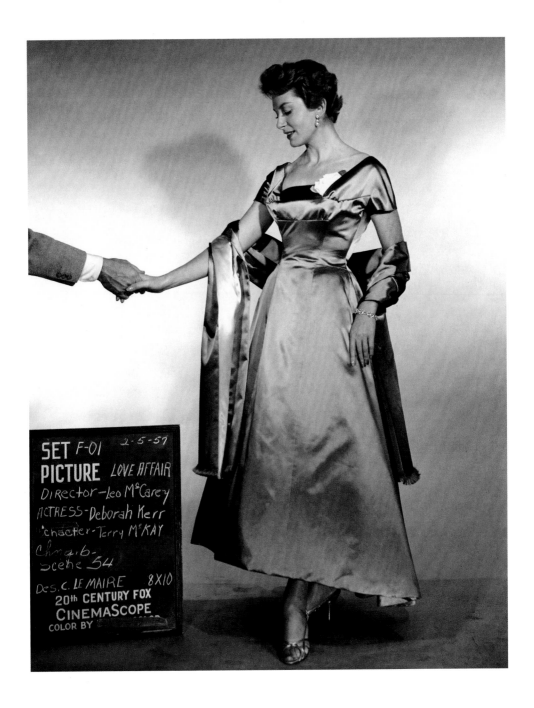

The text on the clapperboard in the image reads:

SET F-01 2-5-57
PICTURE LOVE AFFAIR
Director—Leo McCarey
ACTRESS—Deborah Kerr
'chacter—Terry McKAY
Chn 16 —
Scene 54
Des. C. LE MAIRE 8X10
20th CENTURY FOX
CINEMASCOPE
COLOR BY

Deborah Kerr, *An Affair to Remember*, 1957

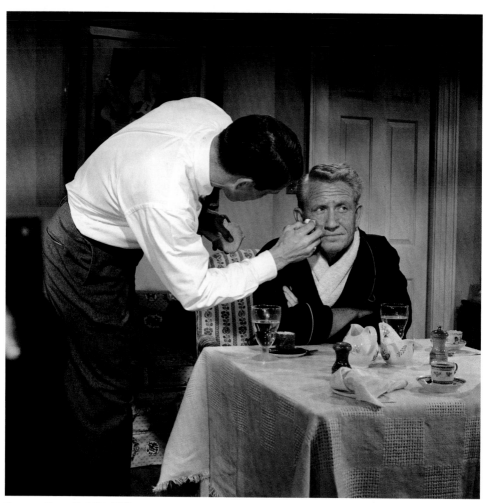

Spencer Tracy, *Desk Set*, 1957

Katharine Hepburn, *Desk Set*, 1957

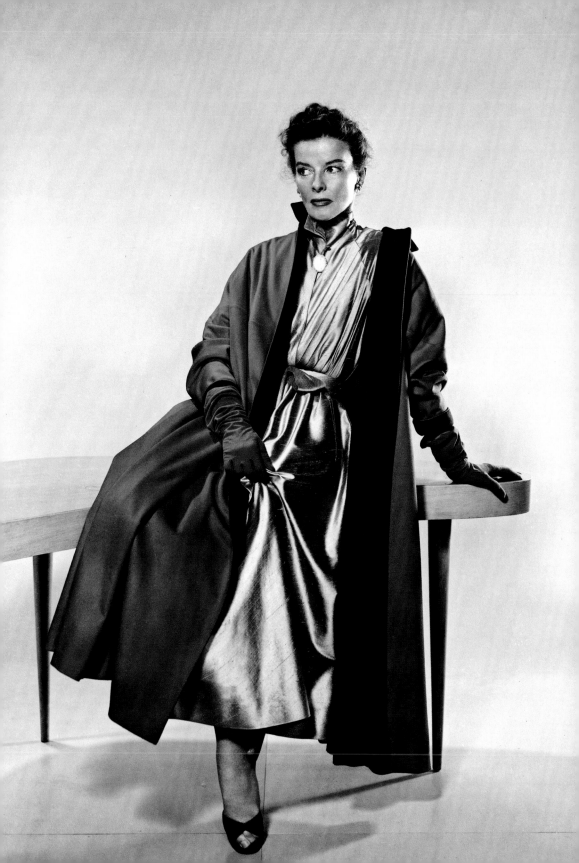

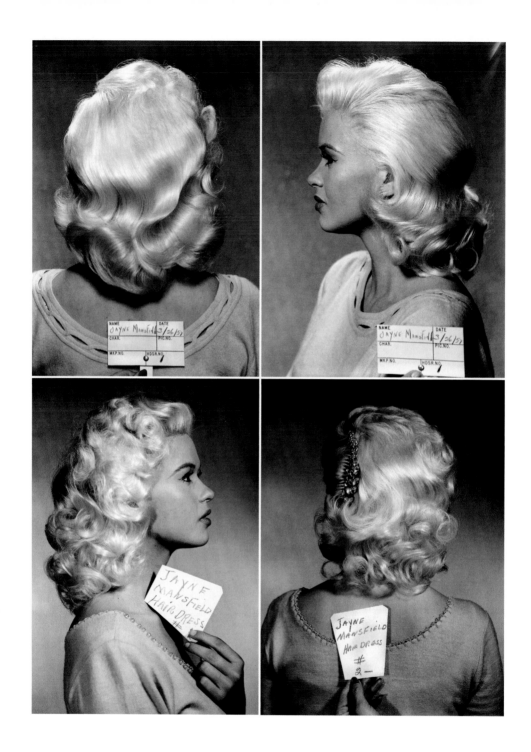

Jayne Mansfield, *Will Success Spoil Rock Hunter?*, 1957

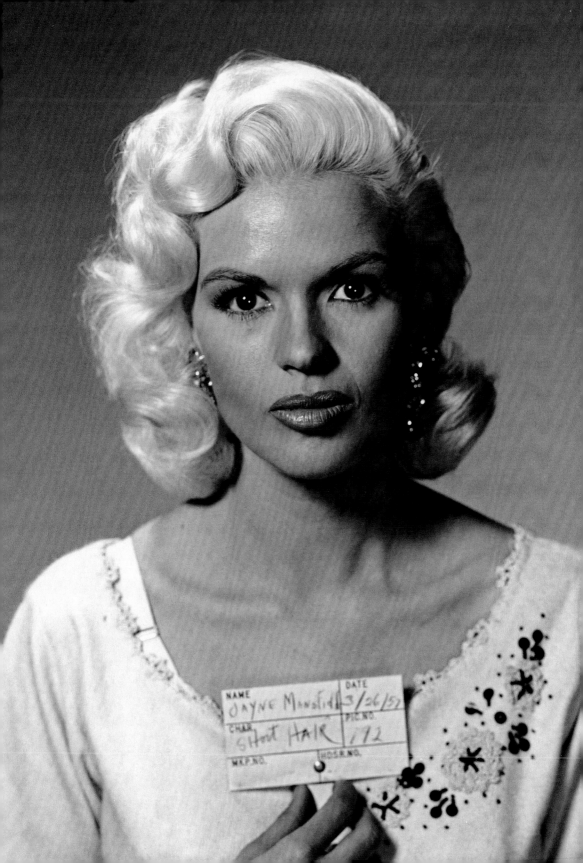

NAME Jayne Mansfield DATE 3/26/57
CHAR Short HAIR PIC. NO. 172
WKP. NO. HDSR. NO.

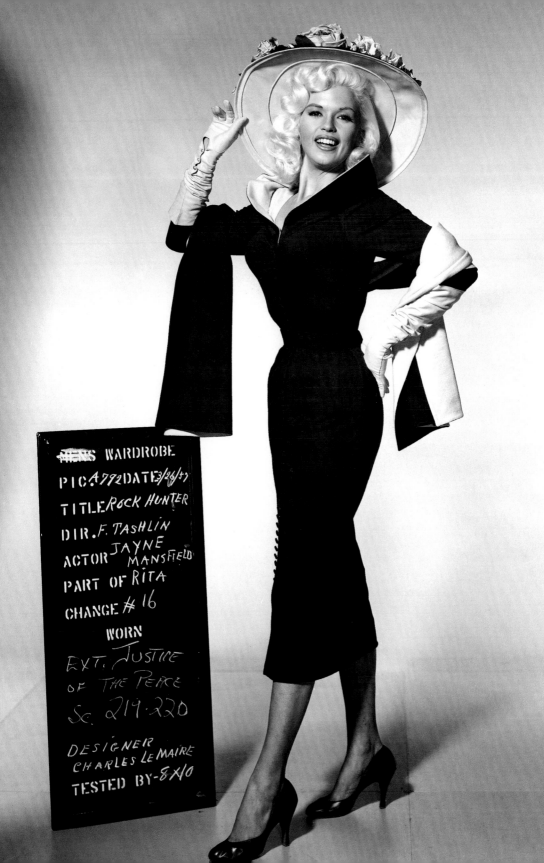

MENS WARDROBE
PIC 4792 DATE 3/28/57
TITLE ROCK HUNTER
DIR. F. TASHLIN
ACTOR JAYNE MANSFIELD
PART OF RITA
CHANGE # 16
WORN
EXT. JUSTICE
OF THE PEACE
SC. 219·220

DESIGNER
CHARLES LEMAIRE
TESTED BY 8X10

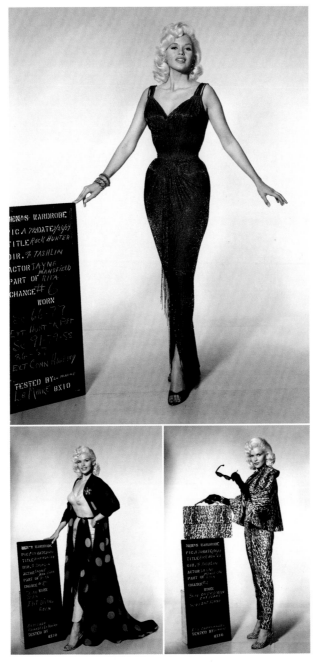

Jayne Mansfield, *Will Success Spoil Rock Hunter?*, 1957

Jayne Mansfield was marketed by Twentieth Century Fox as the
"Working Man's Monroe." She signed a six-year contract with the
studio in 1956 and appeared in numerous films, most memorably
Will Success Spoil Rock Hunter? Shortly after leaving Fox, she gave
birth to Mariska Hargitay, who became a successful television
actress. Costume designers found it challenging to create
wardrobe for her unique measurements.

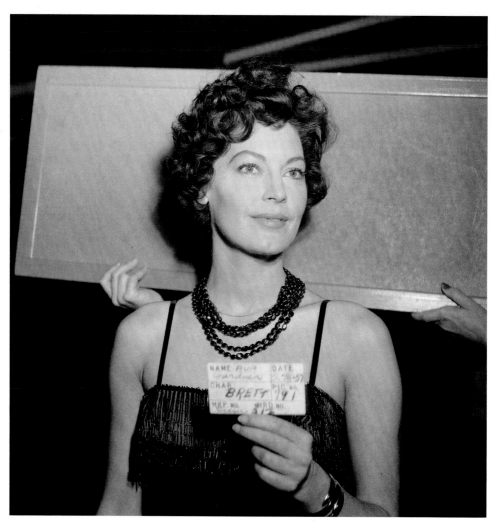

Ava Gardner, *The Sun Also Rises*, 1957

A wardrobe assistant holds a whiteboard behind Ava Gardner so that the
hair department can see the detail in the hairstyle when re-creating it for
future shoots.

Errol Flynn, Eddie Albert, and Ava Gardner, *The Sun Also Rises*, 1957

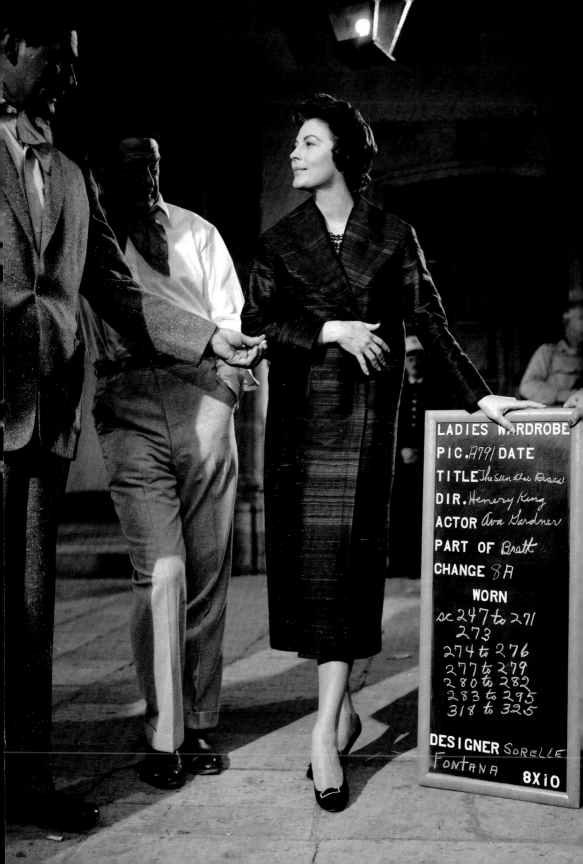

LADIES WARDROBE
PIC. A791 DATE
TITLE The Sun also Rises
DIR. Henery King
ACTOR Ava Gardner
PART OF Brett
CHANGE 8A
WORN
sc 247 to 271
273
274 to 276
277 to 279
280 to 282
283 to 295
318 to 325
DESIGNER SORELLE
Fontana 8x10

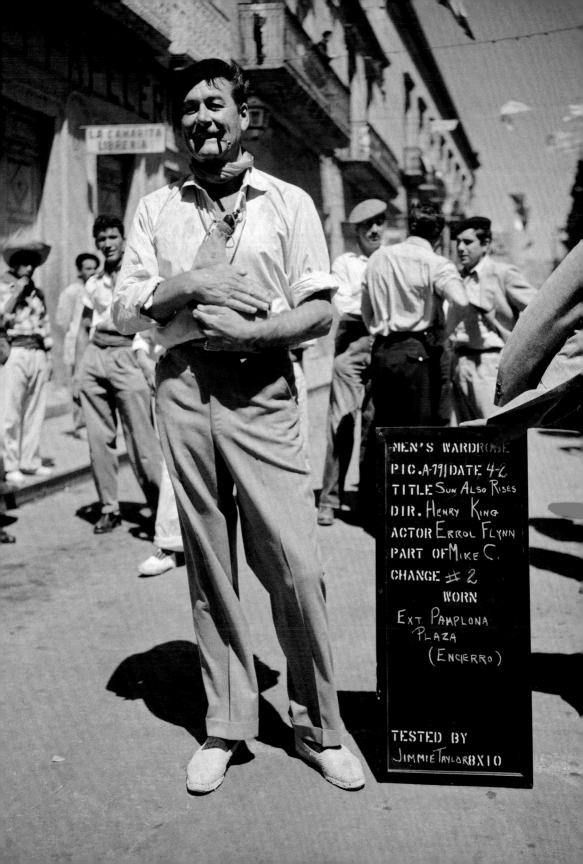

MEN'S WARDROBE
PIC. A-991 DATE 4-2
TITLE Sun Also Rises
DIR. Henry King
ACTOR Errol Flynn
PART OF Mike C.
CHANGE # 2
WORN
Ext. Pamplona
Plaza
(Encierro)

TESTED BY
Jimmie Taylor 8X10

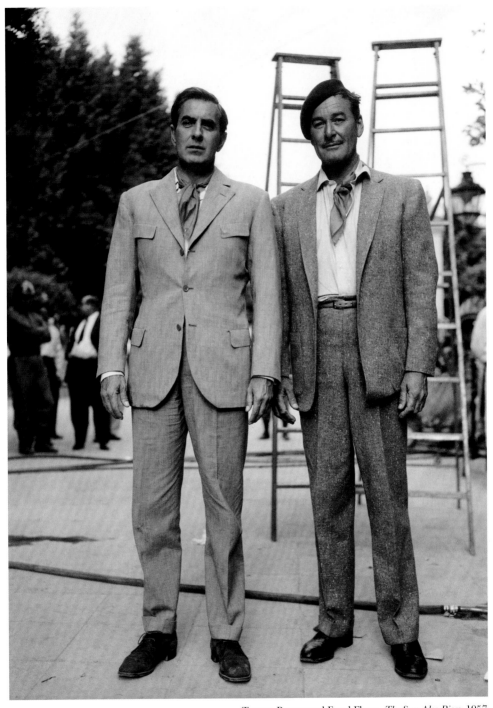

Tyrone Power and Errol Flynn, *The Sun Also Rises*, 1957

Errol Flynn, *The Sun Also Rises*, 1957

Rock Hudson, *A Farewell to Arms*, 1957

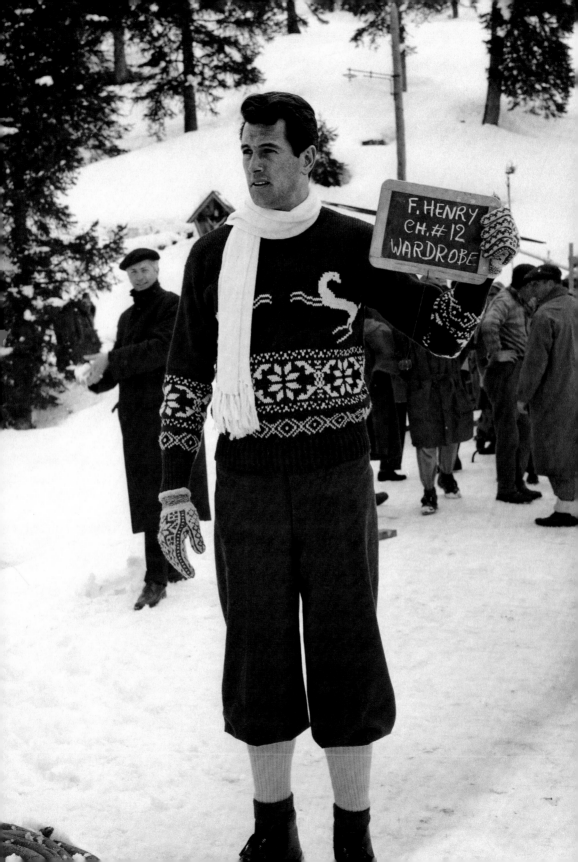

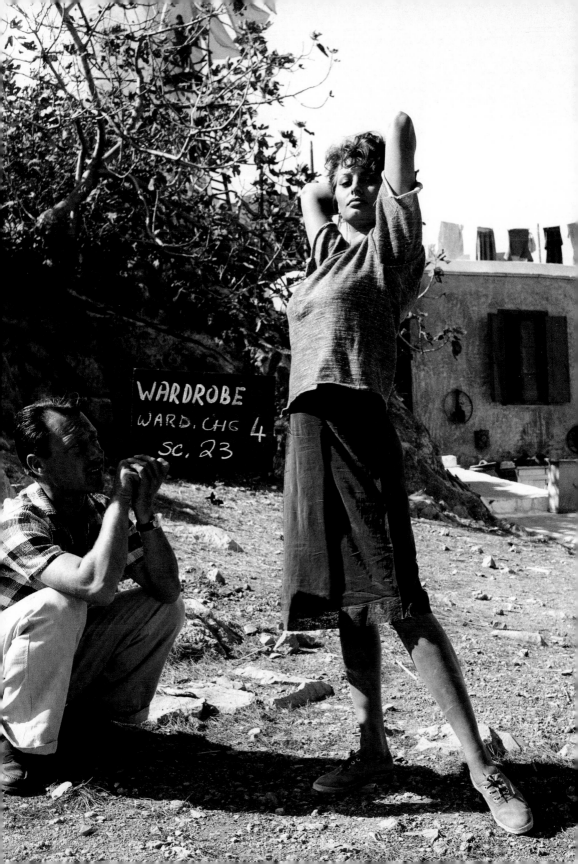

Lana Turner, *Peyton Place*, 1957

Sophia Loren, *Boy on a Dolphin*, 1957

In Love and War

1958

In Love and War stars Robert Wagner as one of three marines taking shore leave during World War II. Wagner had twenty film credits before making In Love and War, which had the working title "Hell Raisers" (as seen in many of the wardrobe placard photos). Just prior to the start of filming, Wagner had married Natalie Wood. Not wanting to be separated from her new husband, Wood turned down other film offers so she could be with him during production.

Wagner was just one of several Fox contract players in the film. All the major film companies, including Fox, had a stable of young actors who had signed seven-year contracts. These contract players were then literally groomed for stardom by the studio. They were subjected to innumerable hair, makeup, wardrobe, and screen tests; they were photographed; and then everything was reviewed by studio executives until they found the look they felt would appeal to the public. Contract players were also sent to a type of finishing school, where they were taught how to walk, talk, and sit before a camera. Classes in singing, dancing, and even acting were also available. Wagner was joined by fellow Fox contract players Hope Lange and Dana Wynter, among others, in In Love and War.

The drama also featured newcomer Veronica Cartwright. Child actors were in high demand in Hollywood during the '50s and '60s, and Fox had an excellent reputation for developing their talent, starting with Shirley Temple in the 1930s. This was Cartwright's first movie and the beginning of a long and illustrious career that includes her most famous Fox film, 1979's Alien.

Robert Wagner, In Love and War, 1958

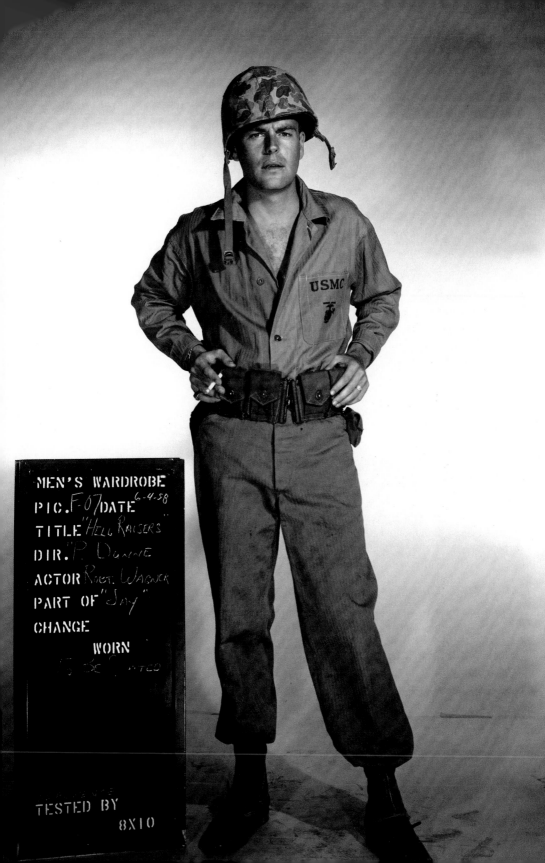

MEN'S WARDROBE
PIC. F-07 DATE 6-4-58
TITLE "HELL RAISERS"
DIR. "P. DUNNE"
ACTOR ROBT. WAGNER
PART OF "JAY"
CHANGE
 WORN

TESTED BY
 8X10

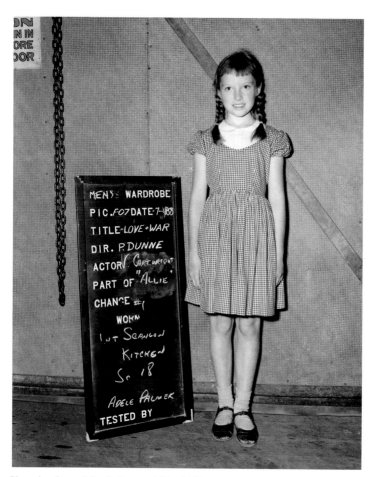

Veronica Cartwright, *In Love and War*, 1958

" What I remember most about the shoot was the gingham dress they had me wear as we sat at a table and ate chicken soup all day—gallons and gallons of chicken soup. Robert Wagner played my brother, and he was either going to war or coming back from war. His new wife, Natalie Wood, visited the set wearing capris and a white shirt, and she sat in a director's chair and watched everything.

"From the gingham dress and braids that I wore in *In Love and War* to my *Alien* space suit and crew cut, costume designers and hairstylists work to develop the visual look of a character. The costumes, makeup, and hair all complement and color the written words performed by the actor and are all important in making a character come to life. "

—VERONICA CARTWRIGHT

Hope Lange, *In Love and War*, 1958

MEN'S WARDROBE
~~LADIES~~
PIC. " DATE 1/3/59
TITLE *Hell Raisers*
DIR. P. Dunne
ACTOR H. Luke
PART OF 'An Ben'
CHANGE 1
WORN
EXT INN

SC B-25

TESTED BY
A. PALME 8X10

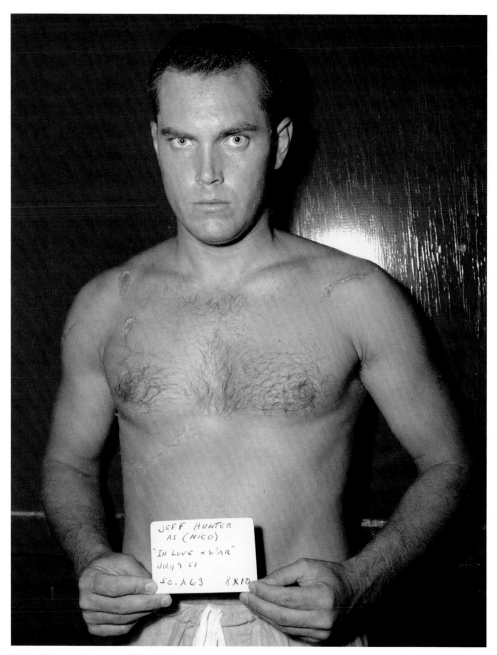

Jeffrey Hunter, *In Love and War*, 1958

France Nuyen, *In Love and War*, 1958

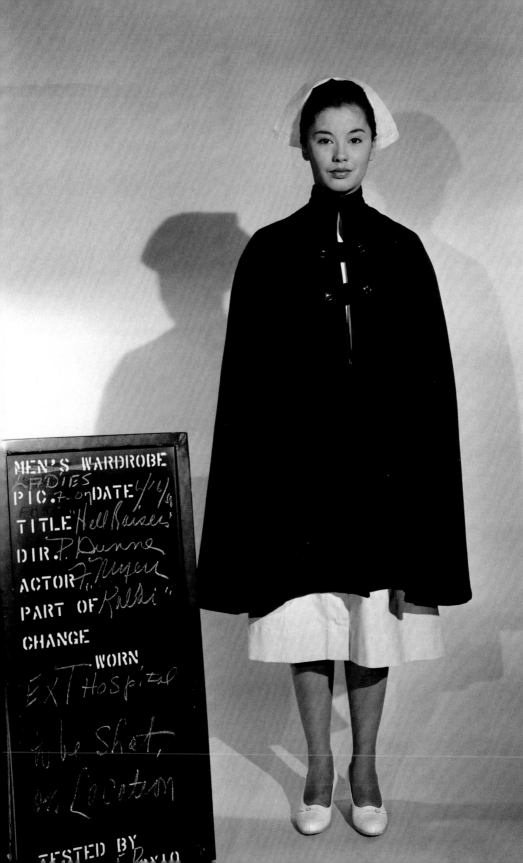

MEN'S WARDROBE
LADIES
PIC. 7-07 DATE 4/4/58
FOR
TITLE 'Hell Raisers'
DIR. P. Dunne
ACTOR F. Nuyen
PART OF "Kelei"
CHANGE
WORN
EXT Hospital
to be shot,
on Location

TESTED BY

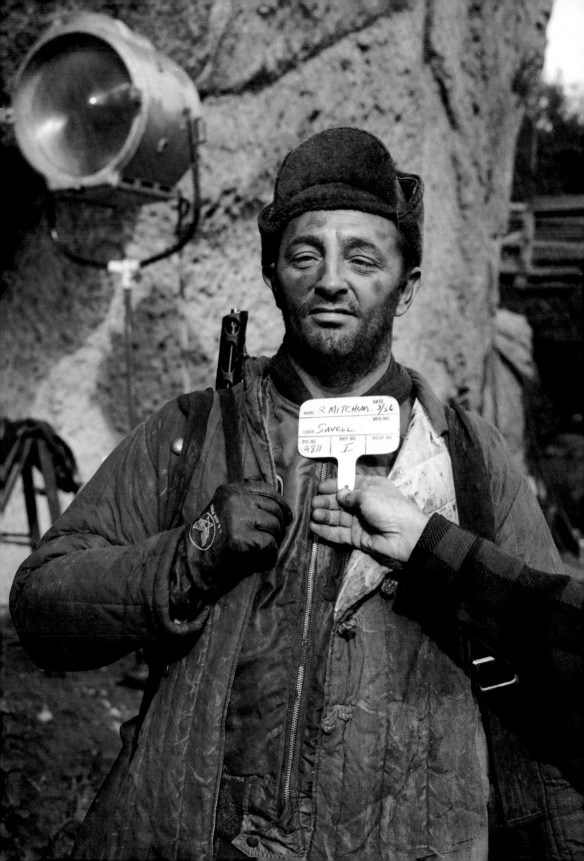

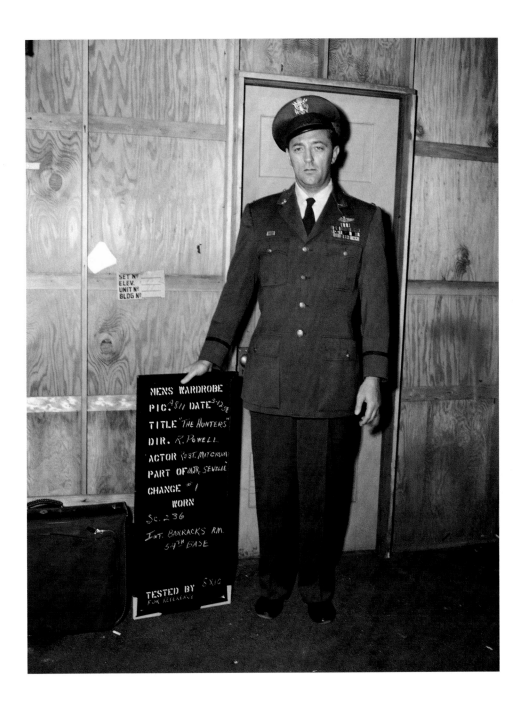

Robert Mitchum, *The Hunters*, 1958

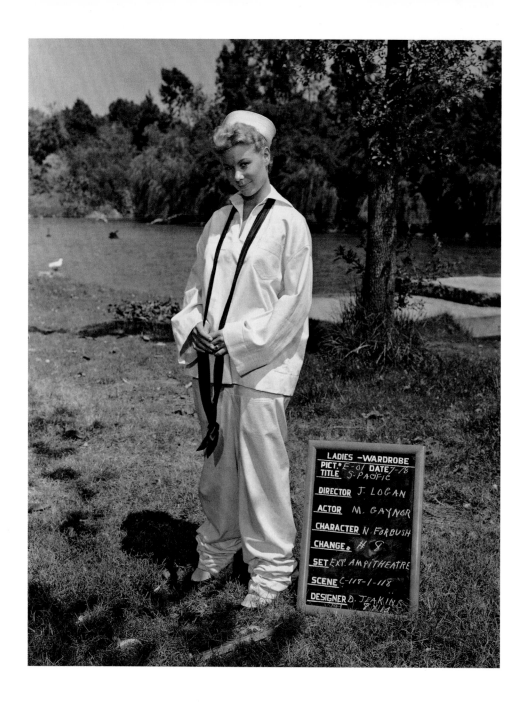

Mitzi Gaynor, *South Pacific*, 1958

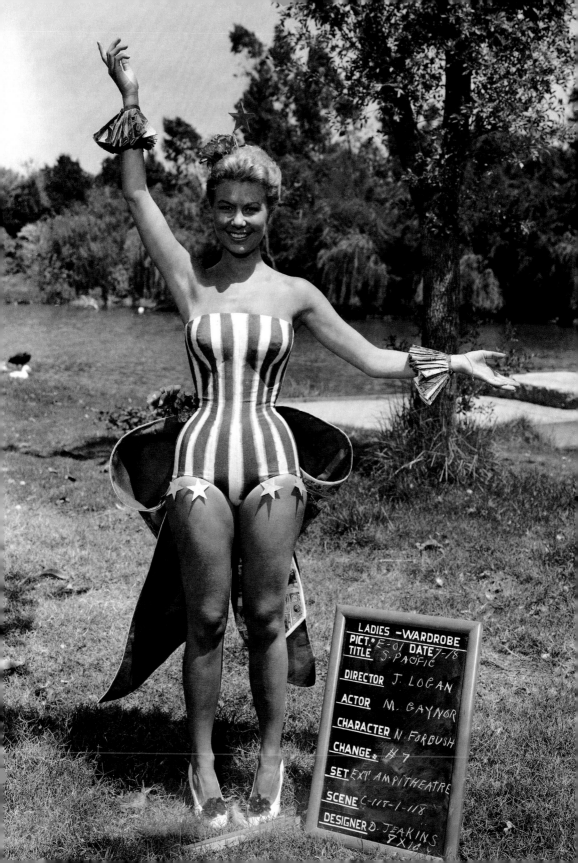

LADIES -WARDROBE
PICT* E-01 DATE 7-18
TITLE S-PACIFIC

DIRECTOR J. LOGAN

ACTOR M. GAYNOR

CHARACTER N. FORBUSH

CHANGE # 7

SET EXT. AMPITHEATRE

SCENE C-118-1-118

DESIGNER D. JEAKINS
8 X 10 V

The Young Lions

1958

The *Young Lions* is a critically acclaimed military drama focusing on the very different experiences of three soldiers during World War II. The three soldiers were portrayed by Method actors Marlon Brando and Montgomery Clift along with singer-comic Dean Martin in his first dramatic role. It's been written that Brando and Clift were intense rivals off camera, possibly because they were too similar in many respects. Both actors tended to inhabit a character, to become that person during filming to give a realistic performance. Interestingly, both Brando and Clift decided to define their characters more through makeup instead of costume, perhaps due to the limitations of wearing uniforms throughout most of the movie.

Brando was cast as a Nazi lieutenant who was conflicted by his loyalty to his country and the increasingly unsavory missions he was asked to execute on its behalf. For his role in *The Young Lions*, Brando asked the makeup man to re-create the look of an actor he had seen in an old German movie. The actor was blond with a very sharp nose, so a hairpiece and a putty nose were created for Brando to wear. This was still not realistic enough for the notorious perfectionist; so, while still in preproduction, rather than continuing to fuss with wigs, Brando simply bleached his hair. Throughout the rest of the shoot he had it rinsed every few days to maintain the look. Sometimes the rinse had the side effect of turning his hair green, but fortunately for producers, Brando's ever-changing hair color did not register on the black-and-white film.

Montgomery Clift played a Jewish man enlisted in the US Army who was forced to face anti-Semitism within his barracks. To look and—more important to Clift—*feel* the part, he put wax behind his ears so they would stick out, and then he altered the shape of his nose with putty. As a final touch, Clift, who was already a slim man, took off another eleven pounds, giving him an emaciated frame.

Marlon Brando, *The Young Lions*, 1958

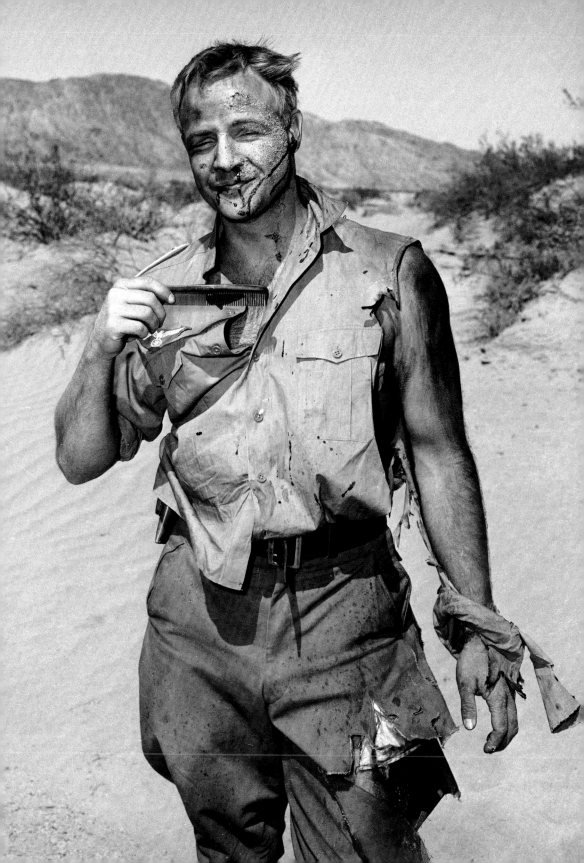

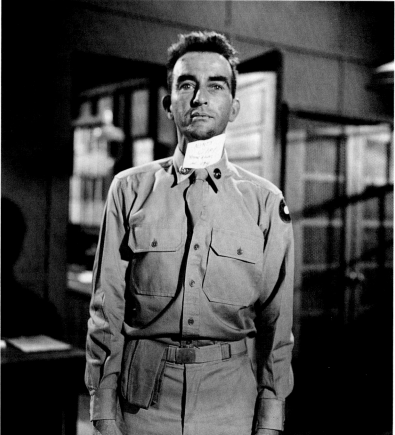

Montgomery Clift, *The Young Lions*, 1958

Marlon Brando, *The Young Lions*, 1958

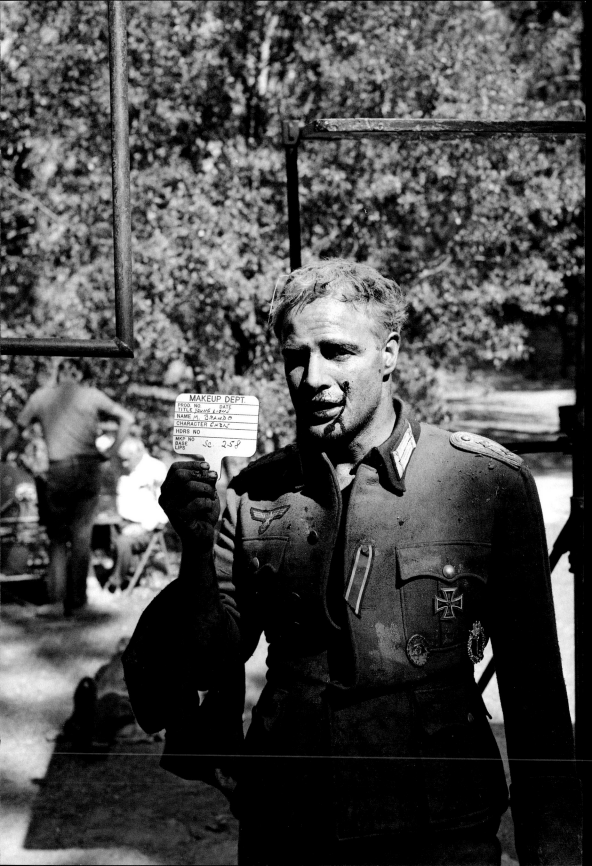

MAKEUP DEPT.
PROD. NO. DATE
TITLE YOUNG LIONS
NAME M. BRANDO
CHARACTER CHRN
HDRS NO
MKP NO
BASE SC. 258
LIPS

MENS WARDROBE
PICA798 DATE 9-23
TITLE YOUNG-LIONS
DIR. E. DMYTRYK
ACTOR D. MARTIN
PART OF MICHAEL
CHANGE ...
WORN
INT. COMMANDANTS
OFFICE
Sc. 257-A

TESTED BY 8x10

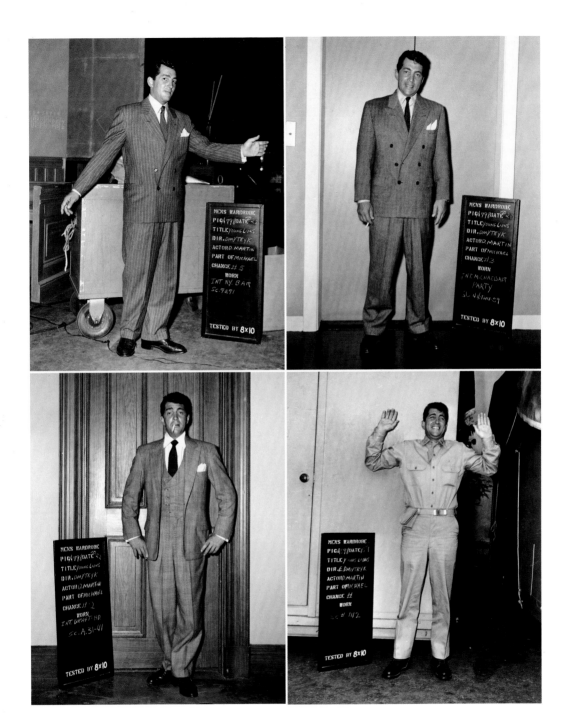

Dean Martin, *The Young Lions*, 1958

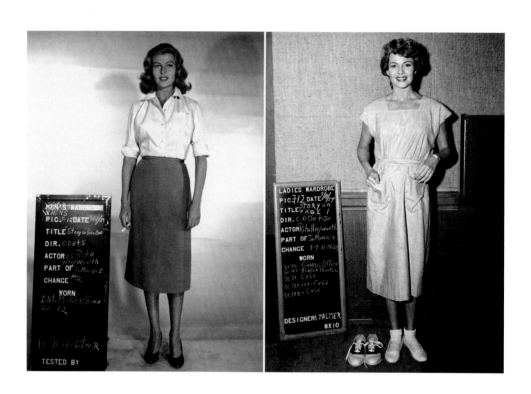

Rita Hayworth, *The Story on Page One*, 1959

On the clapperboard:

NAME Rita Hayworth DATE 8-27-57
CHAR. Jo PIC. NO. F 13
MKP. NO. HDSR. NO.
SCENE # 25-31

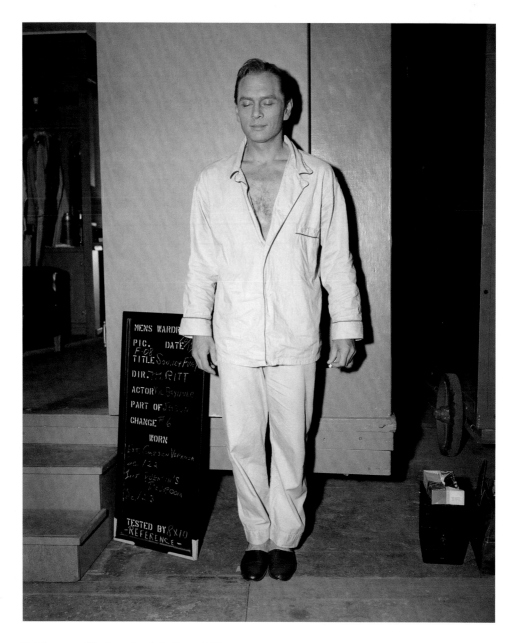

Yul Brynner, *The Sound and the Fury*, 1959

Yul Brynner's continuity shot from *The Sound and the Fury* serves dual purposes for both the wardrobe and makeup departments. The makeup artist would often ask the actor to look downward so the eye and other facial makeup would be recorded for subsequent scenes. Sometimes, however, the actor would close his or her eyes to guarantee the photo would not be used for anything other than continuity purposes.

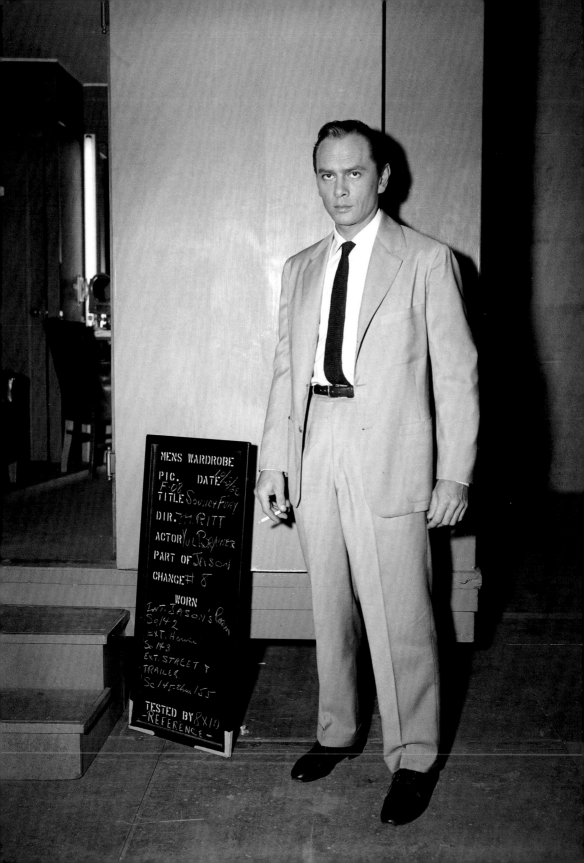

MENS WARDROBE

PIC. DATE 18/6/58

F-08

TITLE Sound & Fury

DIR. M. RITT

ACTOR Yul Brynner

PART OF JASON

CHANGE # 8

WORN

INT. JASON'S ROOM

Sc. 142

EXT. HOUSE

Sc. 143

EXT. STREET &

TRAILER

Sc. 145 thru 155

TESTED BY 8 X 10

- REFERENCE -

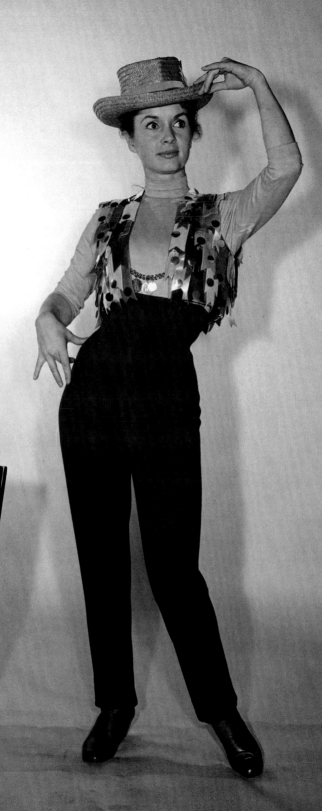

LADIES
WARDROBE

PICTURE E-02 2/3/59
TITLE "SAY ONE FOR ME"
DIRECTOR FRANK TASHLIN
ACTRESS DEBBIE REYNOLDS
PART OF HOLLY LAMAISE
CHANGE NO. 10
SCENE NO. CHG 072 CHA 064
DIRECTOR ADELE PALMER
DRESS # 8 X 10

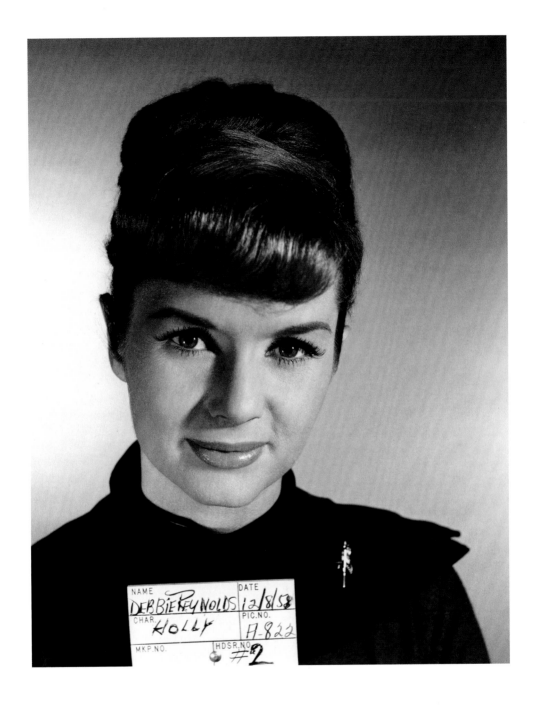

NAME DEBBIE REYNOLDS DATE 12/8/58
CHAR. HOLLY PIC.NO. A-822
MKP.NO. HDSR.NO. #2

Debbie Reynolds, *Say One for Me*, 1959

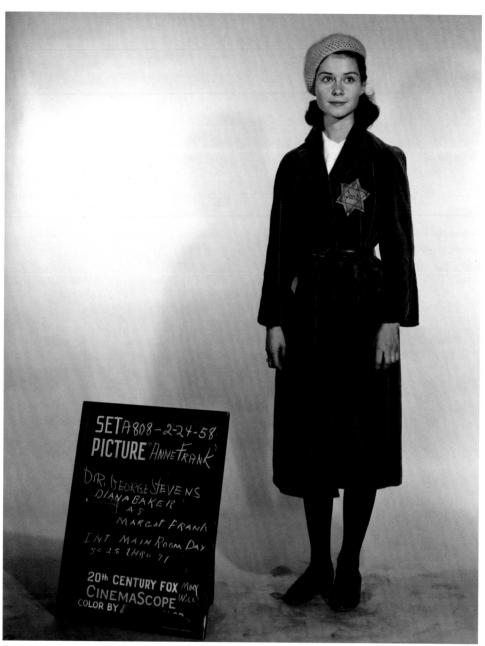

Diane Baker, *The Diary of Anne Frank*, 1959

Millie Perkins, *The Diary of Anne Frank*, 1959

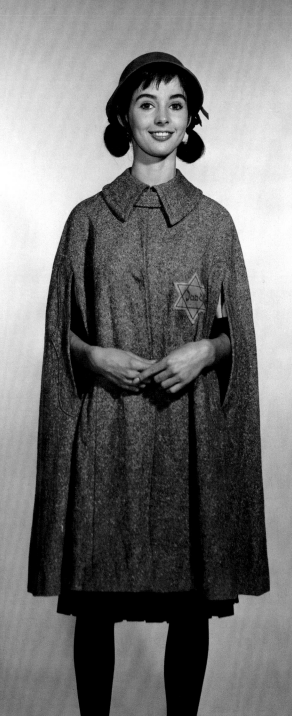

MENS Wardrobe
"DIARY OF ANNE FRAN
DIR. GEO STEVENS - 2/26/
MILLIE PERKIN AS ANNE FRA
INT- HIDE OUT BLDG
DAY
SC- 23 to 29

DES.
MARY WILL

WOMENS Wardrobe
A-808 "DIARY OF ANNE FRANK
DIR. GEO STEVENS - 2/26/58
SHELLEY-WINTER'S AS
MRS. VAN DAAN
HANUKKA
DRESS
DES.
MARY WILLS
8x10

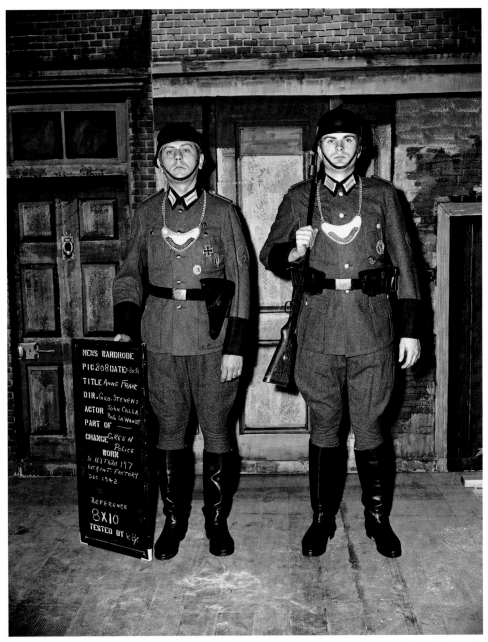

Supporting actors, *The Diary of Anne Frank*, 1959

Shelley Winters, *The Diary of Anne Frank*, 1959

LADIES WARDROBE
PIC.F-09 DATE 4-9
TITLE BEST OF
EVERYTHING
DIR. NEGULESCO
ACTOR JOAN CRAWFORD
PART OF AMANDA FARROW
CHANGE

WORN

To be SPOTTED

DESIGNER

8X10

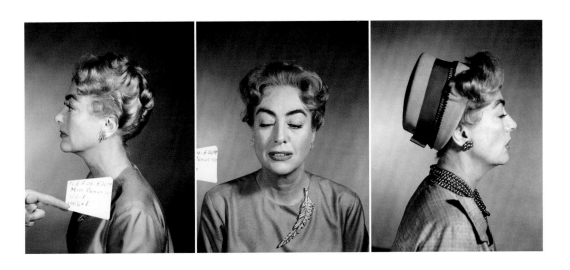

Joan Crawford, *The Best of Everything*, 1959

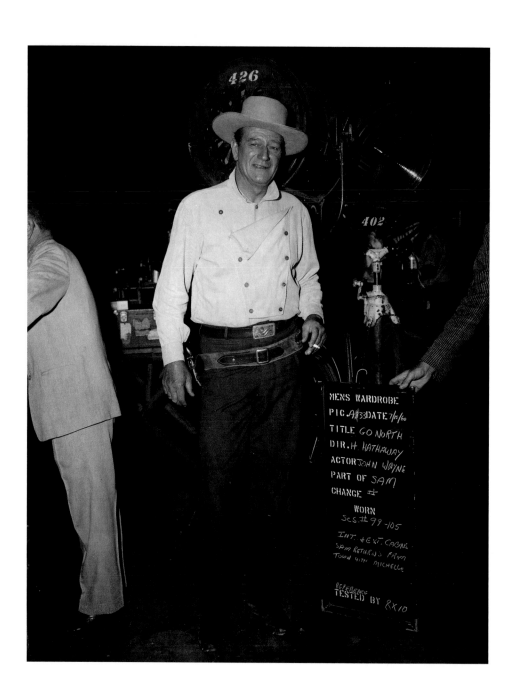

John Wayne, *North to Alaska*, 1960

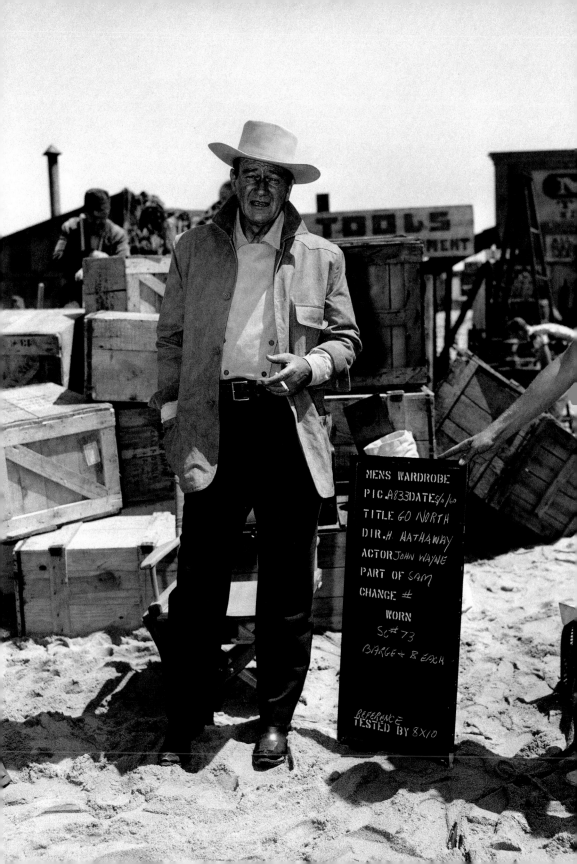

MENS WARDROBE
PIC. A833 DATE 5/11/60
TITLE GO NORTH
DIR. H. HATHAWAY
ACTOR JOHN WAYNE
PART OF SAM
CHANGE #
WORN
Sc# 73
BARGE & BEACH

REFERENCE
TESTED BY 8×10

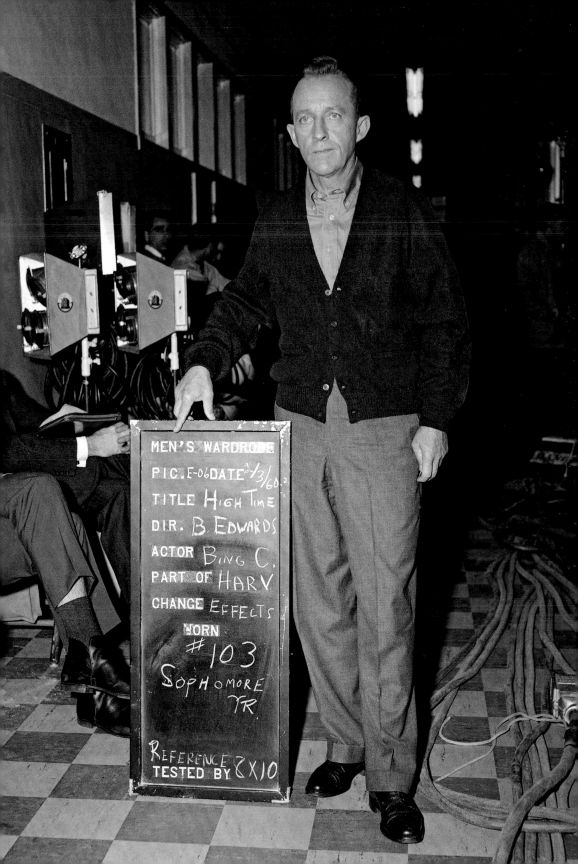

MEN'S WARDROBE
PIC. F-06 DATE 1/3/60
TITLE High Time
DIR. B. Edwards
ACTOR Bing C.
PART OF Harv
CHANGE Effects
WORN
103
Sophomore
YR.

REFERENCE
TESTED BY 8 X 10

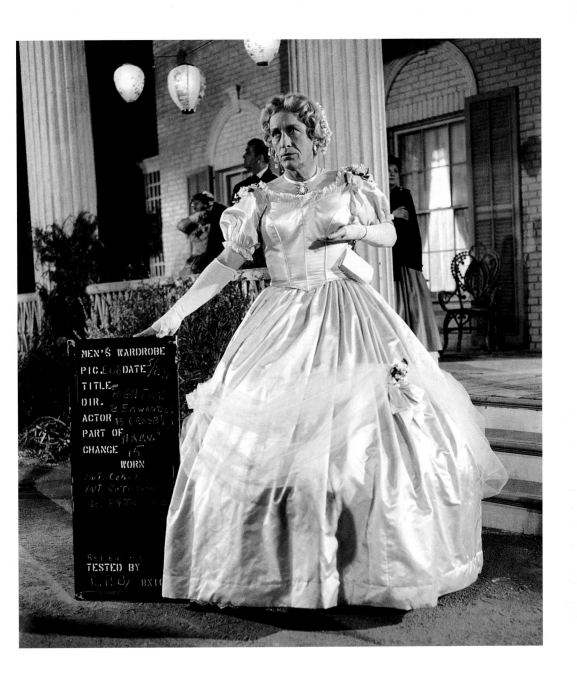

Bing Crosby, *High Time*, 1960

PORTER
WANTED

MEN'S WARDROBE
PIC. E06 DATE 3/3/60
TITLE HIGH TIME
DIR. B. Edwards
ACTOR DICK BEYMER
PART OF BANNERMAN
CHANGE 19
WORN
INT. HARV'S ROOM
SC. 182

REFERENCE
TESTED BY
R.P.B. 8X10

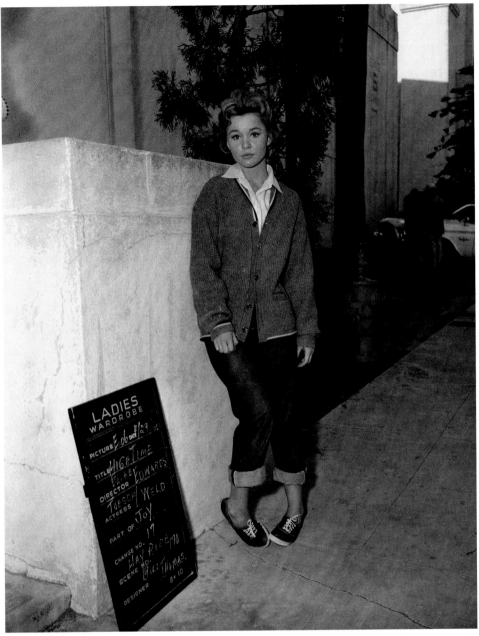

Tuesday Weld, *High Time*, 1960

Richard Beymer, *High Time*, 1960

From the Terrace

1960

Paul Newman and Joanne Woodward starred in the 1960 drama *From the Terrace*, the third of seven movies that they made with each other. Ironically, the film was about a couple in a loveless marriage. In real life, they had one of the most successful Hollywood marriages ever, staying married for fifty years until Newman's death in 2008. Newman and Woodward were one of Hollywood's first power couples, with a string of critically acclaimed and popular movies.

From the Terrace was filmed shortly after Woodward won the Academy Award for Best Actress in The Three Faces of Eve and Newman was nominated as Best Actor in *Cat on a Hot Tin Roof*. The film also stars Myrna Loy as Newman's alcoholic mother and features Barbara Eden in one of her first film appearances. Costumes were designed by William Travilla, who had won an Academy Award earlier in his career. He costumed many of Marilyn Monroe's Fox films in the 1950s. Woodward's sophisticated yet at times sexy wardrobe reflected a shift toward more provocative costumes in the 1950s. The ballroom scene dress with the miniature crown emphasizes a more ladylike side of her character.

Joanne Woodward, *From the Terrace*, 1960

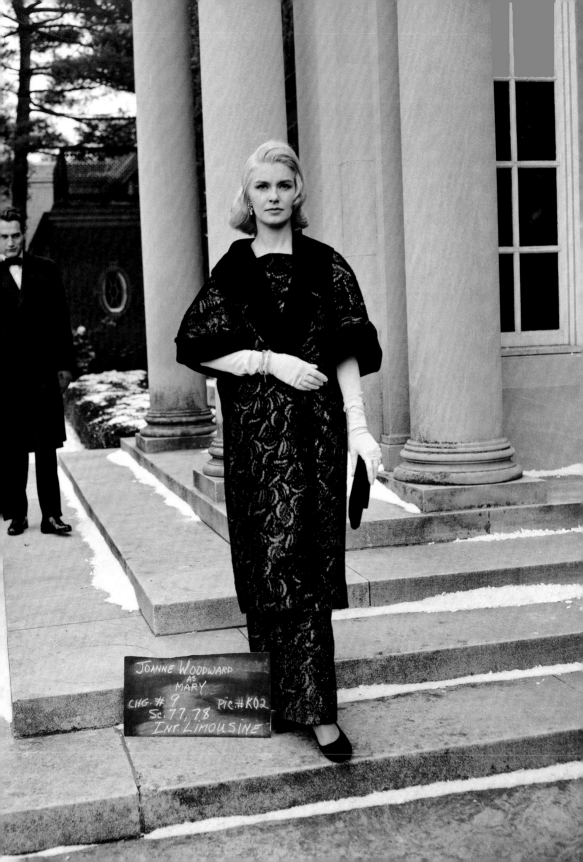

JOANNE WOODWARD
AS
MARY
CHG. #9 PIC. #K02
Sc. 77, 78
INT. LIMOUSINE

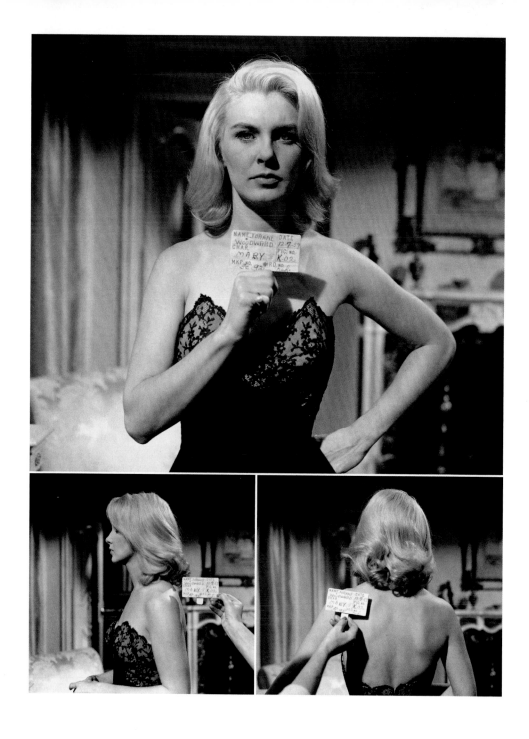

Joanne Woodward, *From the Terrace*, 1960

PAUL N

PICTURE # K02
TITLE — "FROM THE TERRACE
DIRECTOR — M. ROBSON
ACTRESS J. WOODWARD
PART OF MARY
CHG# 16
SC: 116 - 118
INT. HOTEL BALLROOM

DES-TRAVILLA.
4/10 2/8/60

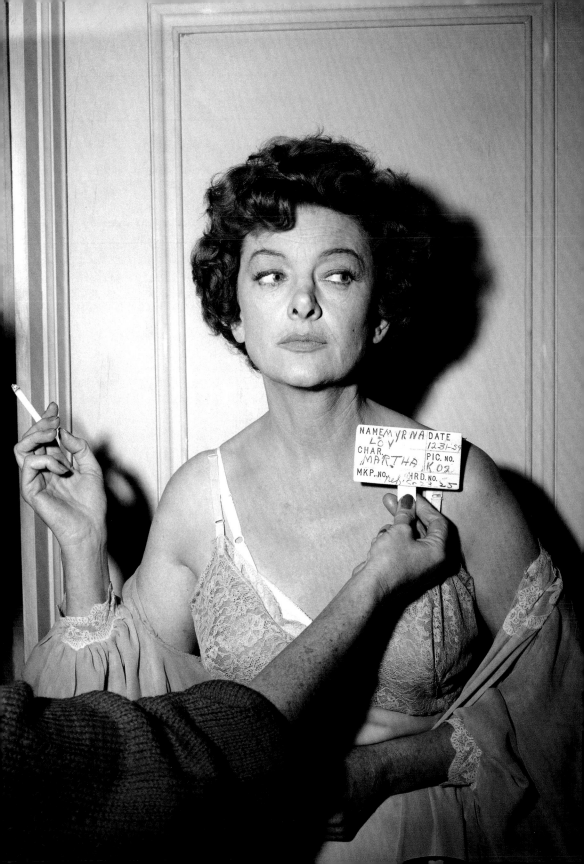

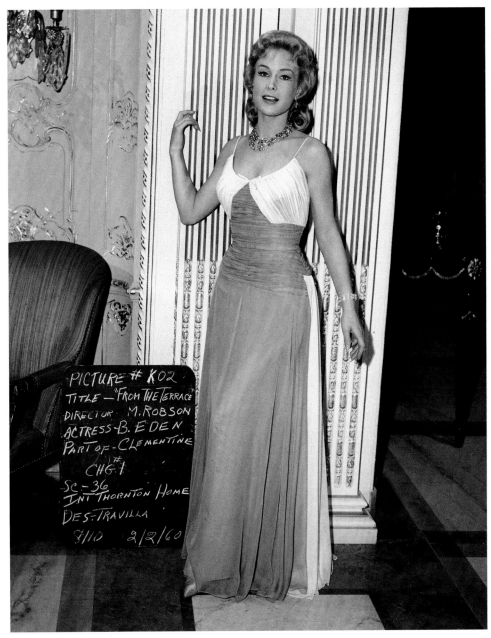

Barbara Eden, *From the Terrace*, 1960

The clapperboard reads:

PICTURE # K02
TITLE - "FROM THE TERRACE"
DIRECTOR - M. ROBSON
ACTRESS - B. EDEN
PART OF - CLEMENTINE
CHG # 1
SC. - 36
INT THORNTON HOME
DES - TRAVILLA
8/10 2/2/60

Myrna Loy, *From The Terrace*, 1960

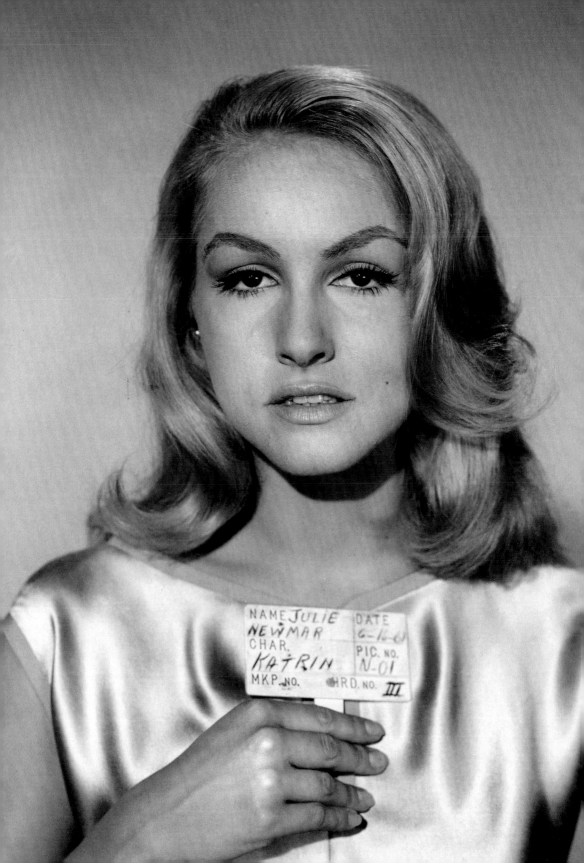

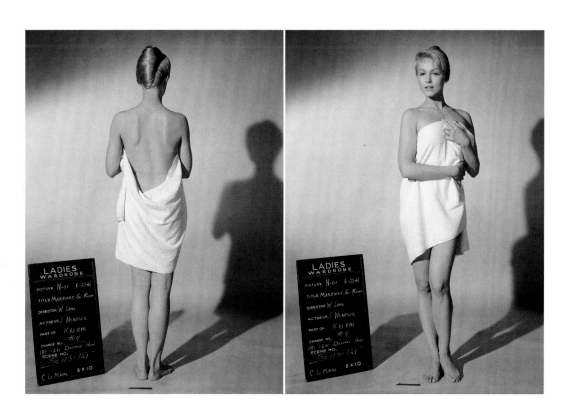

Julie Newmar, *The Marriage-Go-Round*, 1961

Appearing on-screen in a bath towel was risqué for the time. A single fold out of place would have captured the censor's attention, as well as the audience's.

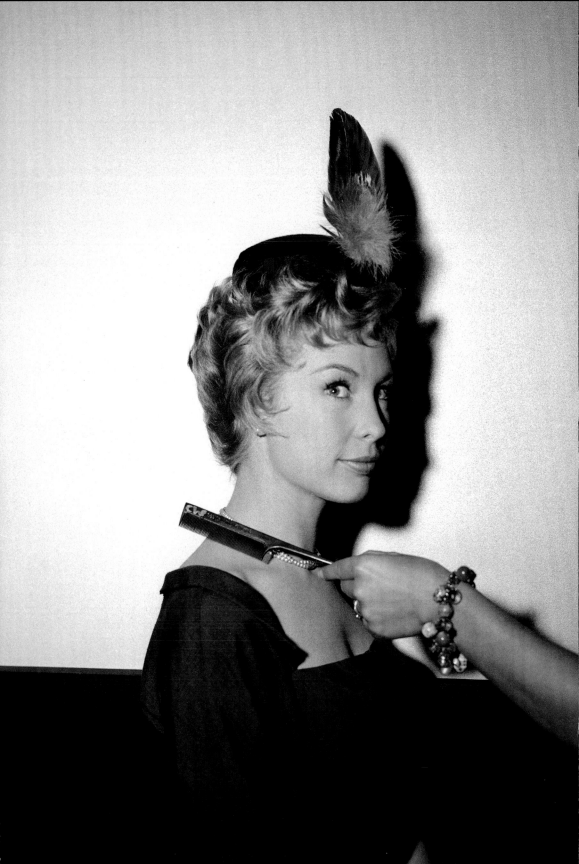

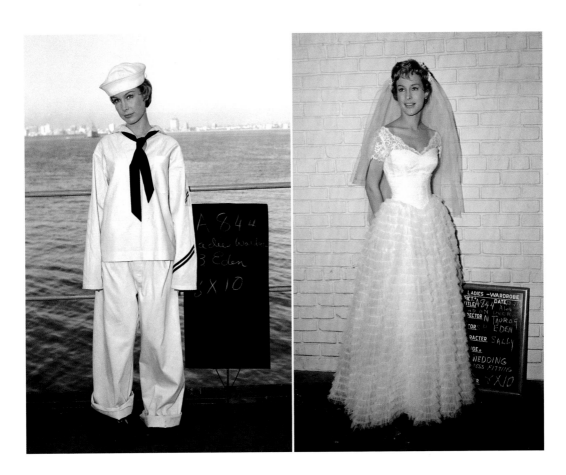

Barbara Eden, *All Hands on Deck*, 1961

Barbara Eden was a successful Fox contract player during the late 1950s and early 1960s. She played the Marilyn Monroe role in the television version of *How to Marry a Millionaire*. Eden went on to star in several Fox films, including 1961's comedy *All Hands on Deck*. She gained TV fame a few years later in the series *I Dream of Jeannie*.

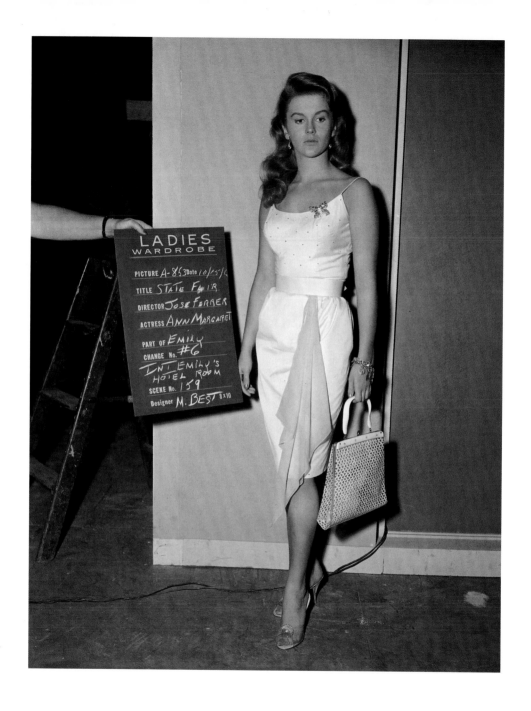

Ann-Margret, *State Fair*, 1962

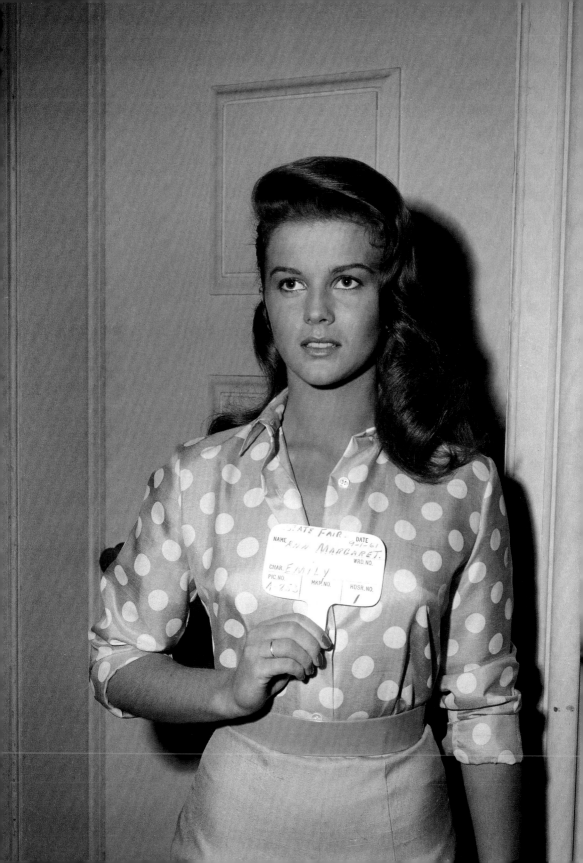

STATE FAIR. DATE 9-1-61
NAME ANN MARGRET. WRD. NO.
CHAR. EMILY.
PIC. NO. MKP. NO.
A-253 HDSR. NO. 1

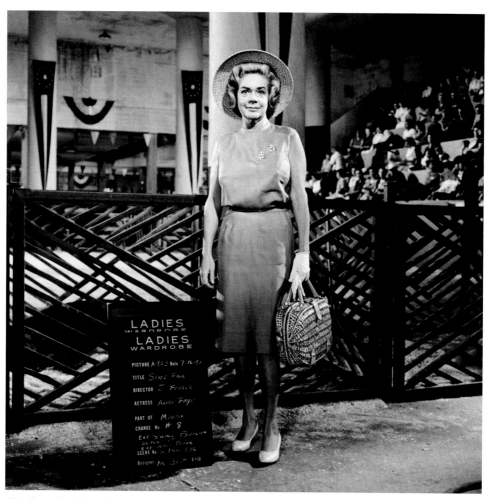

Alice Faye, *State Fair*, 1962

Pat Boone, *State Fair*, 1962

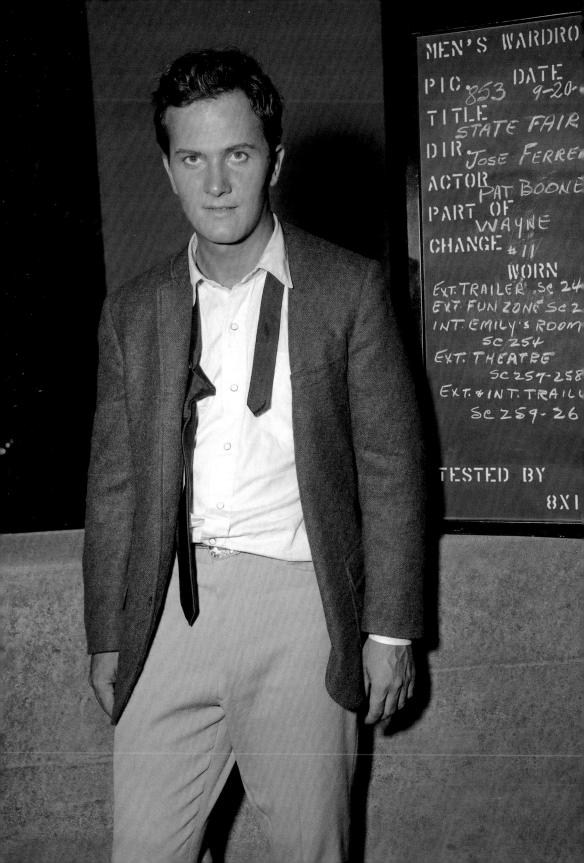

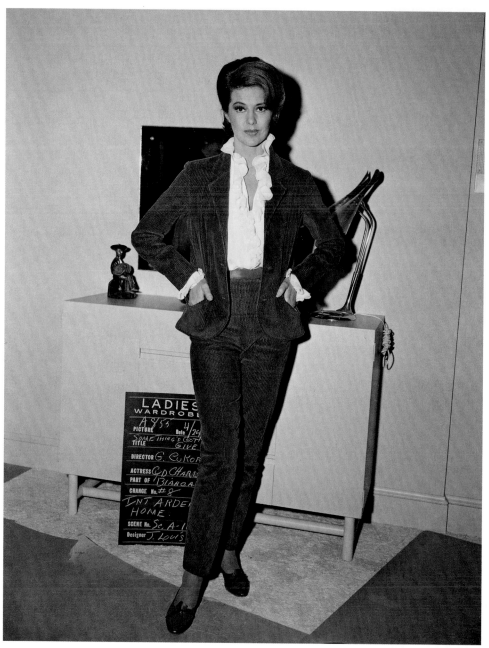

Cyd Charisse, *Something's Got to Give*, 1962

Dean Martin and Cyd Charisse, *Something's Got to Give*, 1962

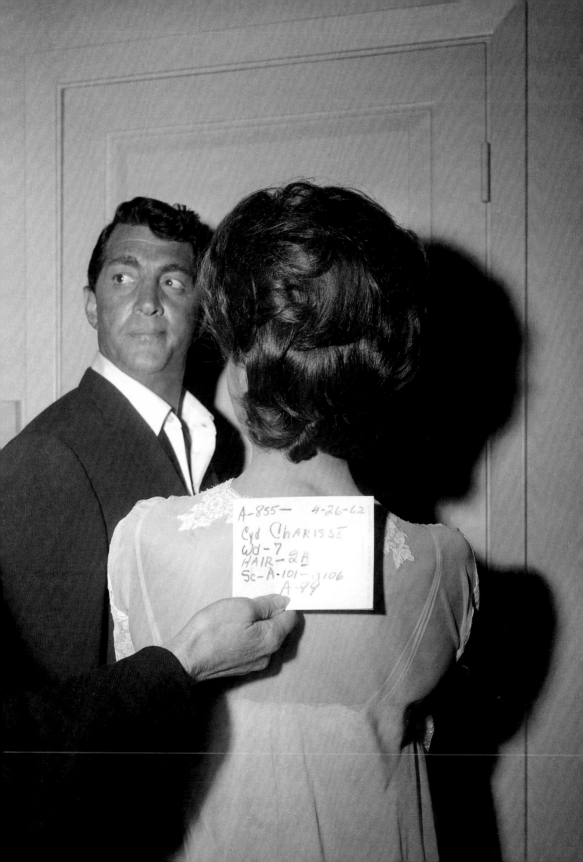

A-855— 4-26-62
Cyd Charisse
WD-7
HAIR-2A
Sc-A-101-·1106
A-99

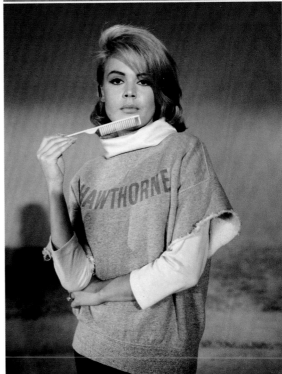

Sandra Dee, *Take Her, She's Mine*, 1963

Cleopatra

1963

Famous—and occasionally infamous—for its lengthy and tumultuous production schedule, *Cleopatra* cost a then-staggering $44 million and used an astonishing seventy-nine sets during filming. The movie took a loss during the initial year of release (1963), but ultimately it became one of the highest-grossing movies of the 1960s.

Cleopatra was originally conceived in 1958 as a "sin and sand" film along the lines of other similar Fox productions such as *The Egyptian* and *Princess of the Nile*. Joan Collins was briefly cast as Cleopatra and was screen-tested three times, each with different costumes, hair, and makeup, but after several delays she became unavailable. It has been said that Taylor had jokingly agreed to do the film for a million dollars, and in 1959 she became the first Hollywood star to receive such a fee for a single picture.

Even after Elizabeth Taylor was hired and the production moved from the Fox back lot to England to take advantage of tax incentives, Cleopatra was plagued with problems. It was so cold that the actors' breath could be seen on film, ruining the illusion that they were in Rome or Egypt. Furthermore, cast members became so chilled in the abbreviated costumes that they fell ill. Taylor herself was the most critical, nearly dying of pneumonia. Production moved from London to Rome following Taylor's illness, and the film's elaborate sets and props all had to be broken down, moved, and reconstructed.

When filming resumed yet again in 1962, in Italy, Irene Sharaff had designed costumes for Taylor inspired by the clothing of ancient Egyptian statues. Taylor's most famous costume was the twenty-four-carat cloth-of-gold cape designed to look like the wings of a phoenix. It was intricately assembled from gold leather and embellished with thousands of beads and sequins. The budget for Taylor's costumes alone was nearly $200,000, by far the highest for an actor at that time.

Besides Taylor's wardrobe, another twenty-thousand costumes were needed for other actors and extras in *Cleopatra*. Vittorio Nino Novarese handled the men's costumes, with the exception of Rex Harrison's, which Sharaff tailored to fit the actor's physique. Renié Conley produced the costumes for other women and extras, renting many of them from Italian costume agencies. In spite of the production delays and the challenges of filming abroad without normal studio resources, the trio won the Academy Award for Best Costume Design in Color.

Elizabeth Taylor, *Cleopatra*, 1963

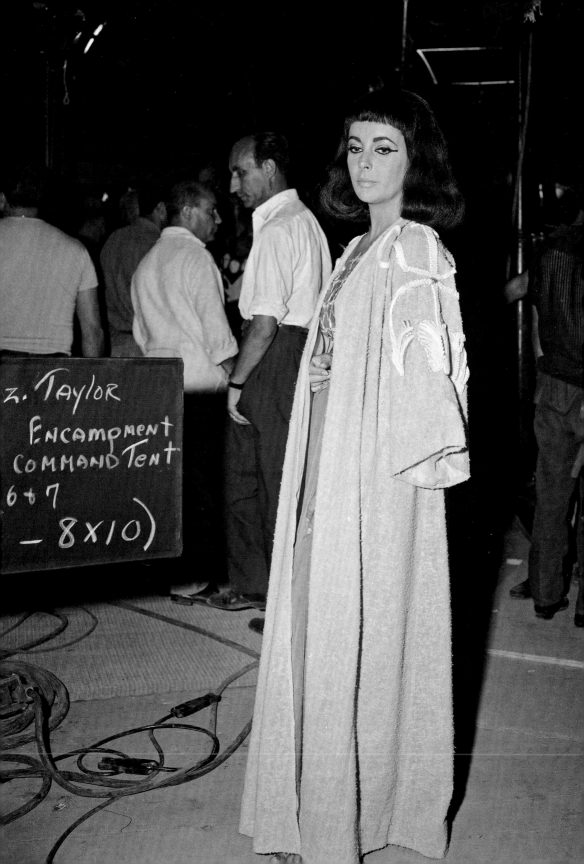

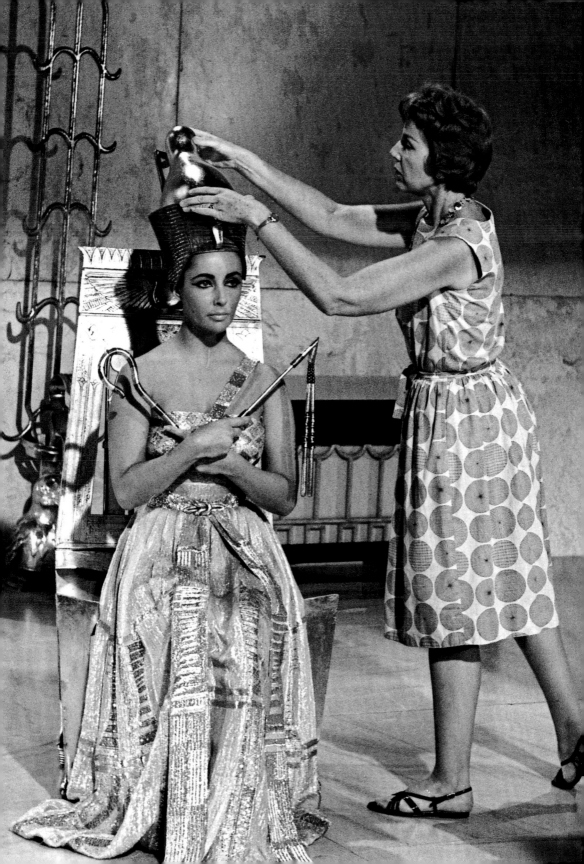

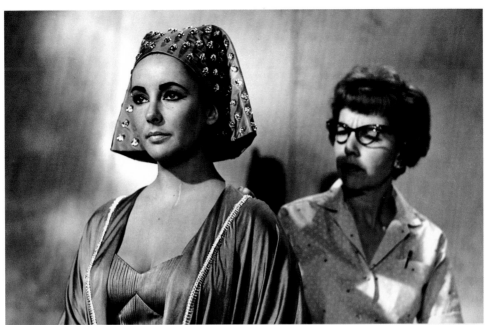

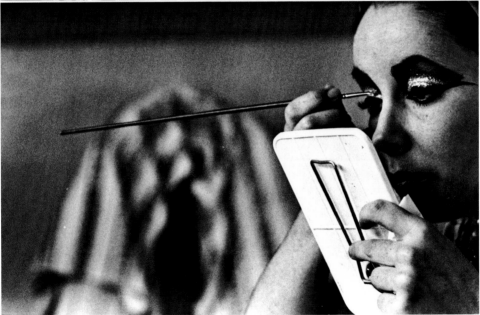

Elizabeth Taylor, *Cleopatra*, 1963

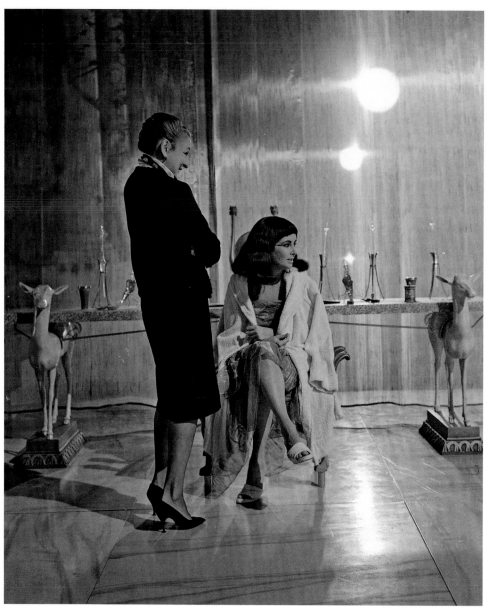

Elizabeth Taylor and Costume Designer Irene Sharaff, *Cleopatra*, 1963

Joan Collins, screen test for *Cleopatra*

Before the casting of Elizabeth Taylor, Joan Collins screen-tested for the title role in 1963's *Cleopatra*. Collins had signed a seven-year contract with Twentieth Century Fox in 1955 and starred in several Fox films prior to this test, including *The Virgin Queen*. The British actress became best known for her role of Alexis Carrington in the television series *Dynasty*.

194

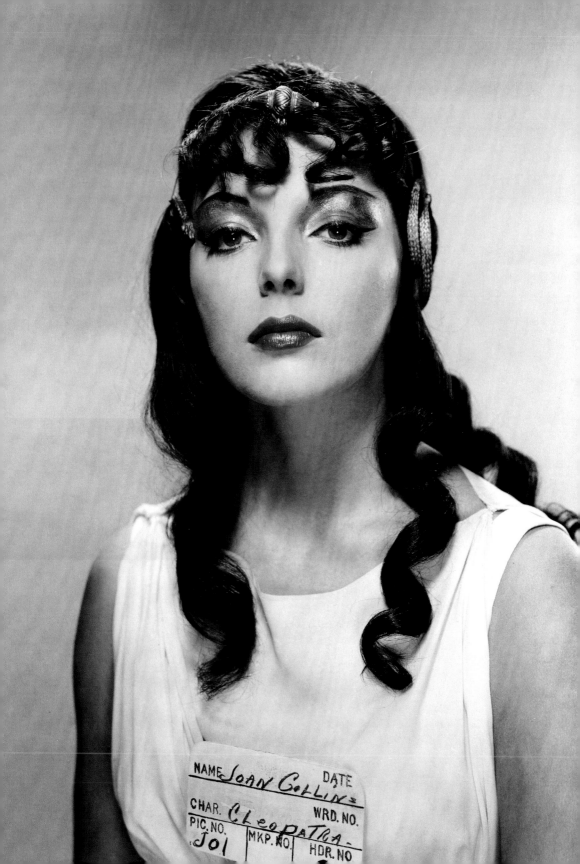

NAME *Joan Collins* DATE
CHAR. *Cleopatra* WRD. NO.
PIC. NO. *101* MKP. NO. HDR. NO.

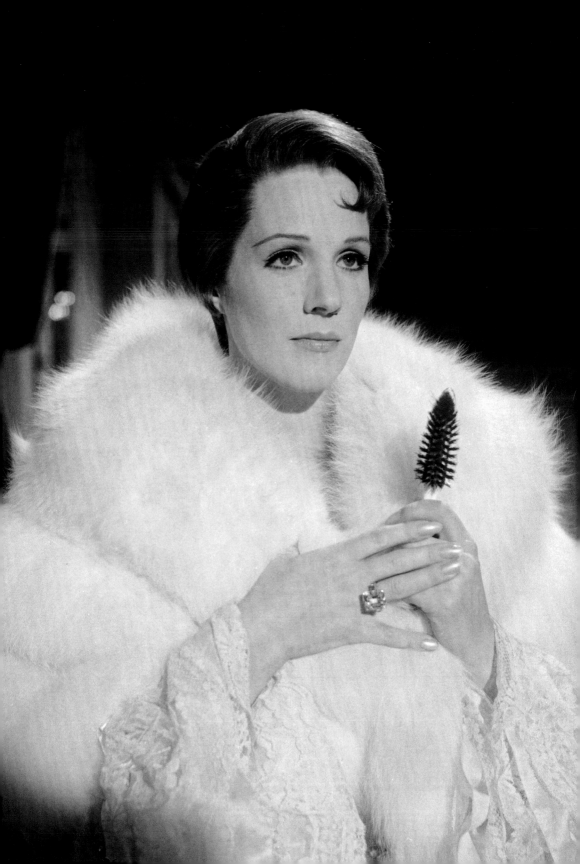

Part Two

THE NEW HOLLYWOOD

T**HE NEW HOLLYWOOD** emerged in the 1960s from the disintegrating studio system that had created the Golden Age. This new period in filmmaking was marked by the independence of actors and other creative personnel from lengthy and binding studio contracts, but it simultaneously left a vacuum in those studios. Several changes that began in the latter years of the Golden Age continued into the new era. When the Supreme Court ruled in 1948 that studios must begin divesting themselves of their theater chains, it disrupted the smooth chain of supply (movies) and distribution (theaters) that guaranteed studios a venue to show their product. Theater owners were liberated: They were no longer restricted to showing a single studio's films on their screens.

Theaters, however, were also facing a steadily growing economic crisis—one that began in the 1950s with the increasing ubiquity of television. Instead of going to the movies in the evenings, viewers elected to stay in and watch television at home. It was free and more convenient.

Studios responded by providing what television could not: CinemaScope, 3-D, and more color. Big-screen epics like *The Robe* and *Cleopatra* were produced to entice audiences back into the theaters. More films were shot at least in part on location—like *The Pleasure Seekers*, which provided not only realism but a glimpse of Europe to voyeuristic tourists in the age before global tourism.

The studio was churning out big-budget films like *Cleopatra* as well as more family-oriented ones like *The Sound of Music*. However, in step with the times, the green light was also given to riskier and more risqué films such as *Valley of the Dolls* and *Myra Breckinridge*. Although Fox hedged its bet by continuing to produce traditional big-budget musicals like *Hello, Dolly!* and *Star!*, younger producers and directors developed grittier and more violent films reflecting the social revolution of the 1960s. The result was a schizophrenic output. Even within a single film there was an uneasy blending of the old with the new, as seen in *Myra Breckinridge*. Edith Head, representing the Golden Age of Hollywood, was hired to design Mae West's costumes in the film, while Theadora van Runkle, fresh from her success on *Bonnie and Clyde*, was responsible for Raquel Welch's revealing wardrobe in *Myra*.

In the 1970s, Fox discovered a big-budget format that worked for them at the box office: the disaster film. Unlike 1953's *Titanic*, in which the sinking of the ocean liner served as the backdrop to a family soap opera, in *The Poseidon Adventure* and *The Towering Inferno* the special effects were dazzling, and the all-star casts drew ticket buyers to the box office.

Costume designers used disaster films as opportunities for exposure with strategically ripped and torn costumes—almost always worn by the female cast members. And the looser morality of the 1960s pushed the lines of censorship with skintight costumes, such as the catsuit hugging Raquel Welch's remarkable curves in *Fantastic Voyage* and the brief miniskirts in *Valley of the Dolls*.

Julie Andrews, *Star!*, 1968

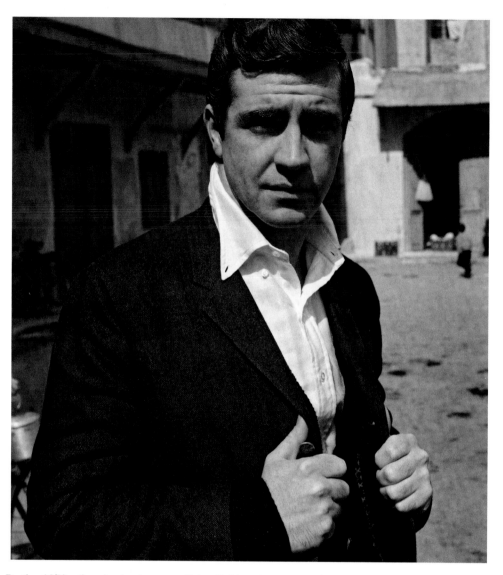

By the 1970s, the classic glamour of the Golden Age was no longer applicable. Audiences wanted more-realistic fare with stronger language, more violence, and adult storylines—the type of material they could not view on television at that time. Studios produced fewer films with tighter budgets while trying to determine what the public wanted. Costume designers were sketching and creating fewer costumes from scratch. Instead, they were carefully choosing and buying more pieces off the rack, or reworking existing clothing that hung in the wardrobe department by adding trims or by dyeing.

Some stars fell by the wayside or turned to television when their cinematic image could not make the transition. Others, such as Ann-Margret, adapted and thrived, while Paul Newman's nonconformist screen persona perfectly suited the emerging trends in filmmaking. There was also room for new talent, like Robert Redford. These stars were journeyman actors, though, traveling from studio to studio to make films, no longer under contract to a single studio. This is the New Hollywood, seen here in all its risqué, eclectic, and sometimes dark diversity.

Anthony Quinn, *Zorba the Greek*, 1964

Alan Bates, *Zorba the Greek*, 1964

The Pleasure Seekers

1964

Ann-Margret was considered the last of the "Fox girls" following in the tradition of Betty Grable and Marilyn Monroe by signing one of the studio's final long-term (seven-year) contracts in 1961. *The Pleasure Seekers* was the second of three films that she would make for the studio during the 1960s.

Although set in Madrid, Spain, *The Pleasure Seekers* supplemented location shooting with extensive filming on the Fox lot in Century City, California. Released in 1964, the film starred Carol Lynley and Pamela Tiffin, but it is best remembered as a vehicle for Ann-Margret. Her flamenco dance as a nightclub performer was the film's most memorable moment. Capitalizing on this scene, the movie poster and soundtrack album cover prominently featured Ann-Margret in the famous pink flamenco dress.

The film is a remake of the 1954 Fox film called *Three Coins in the Fountain*, with the three leading ladies—played by Dorothy McGuire, Jean Peters, and Maggie McNamara—searching for romance in Rome, Italy.

The glamour of Hollywood is juxtaposed with the labor-intensive process of filmmaking, never more evident than in the image of Ann-Margret posing in character in her flamenco song-and-dance costume in front of a barrage of technical film equipment and tools (right). This is a perfect example of a wardrobe image taken strictly for continuity purposes and obviously never meant for public release. When one compares these continuity photos to the stills taken just two years earlier for *State Fair*, one sees that Ann-Margret's screen image had clearly matured from ingenue into leading lady.

Ann-Margret, *The Pleasure Seekers*, 1964

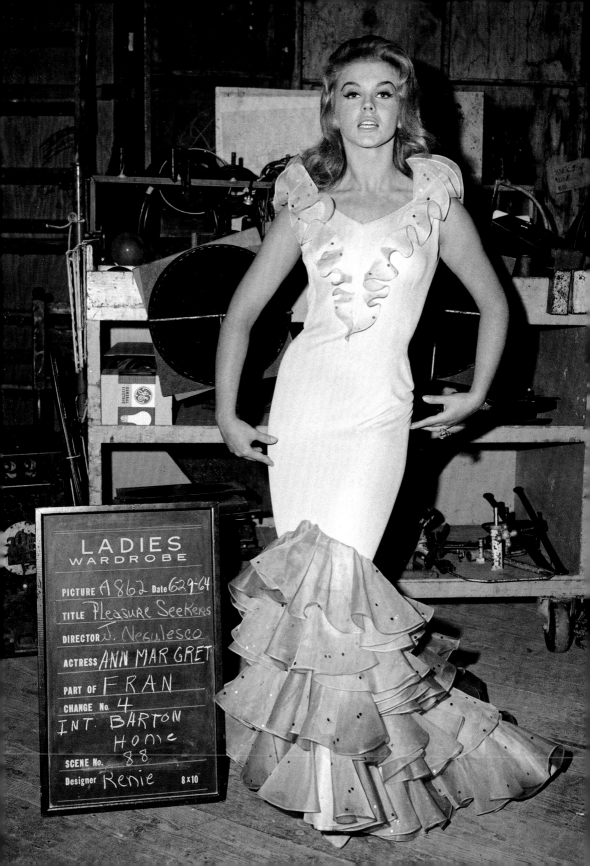

LADIES
WARDROBE

PICTURE A 862 Date 6-29-64
TITLE Pleasure Seekers
DIRECTOR J. Negulesco
ACTRESS ANN MARGRET
PART OF FRAN
CHANGE No. 4
INT. BARTON
Home
SCENE No. 88
Designer Renie 8 x 10

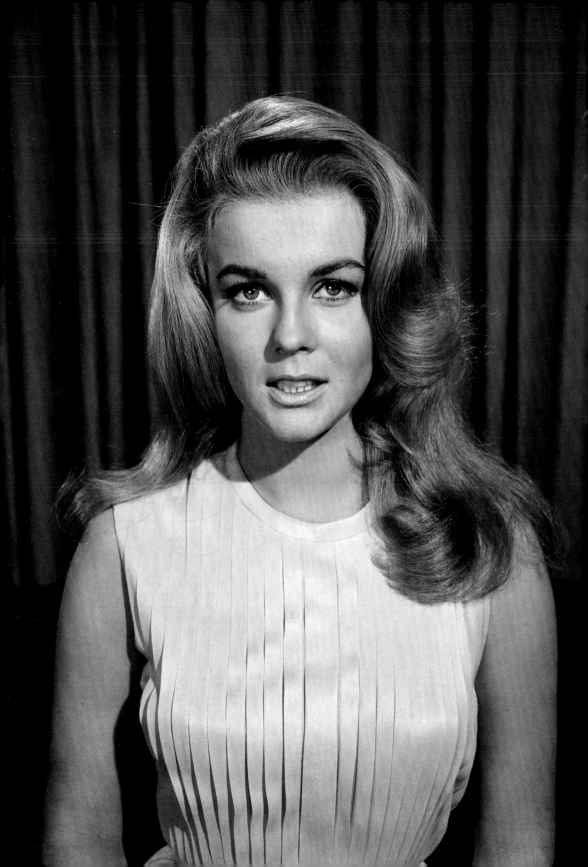

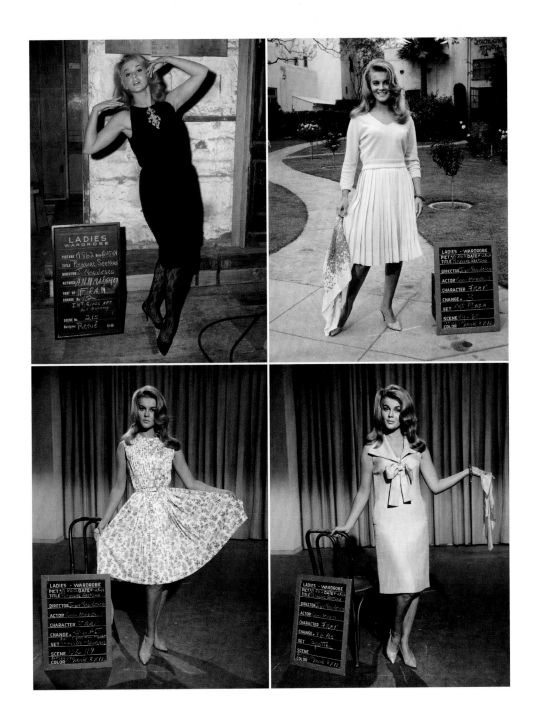

Ann-Margret, *The Pleasure Seekers*, 1964

20th CENTURY
FOX FILM
COR...

GLASS

LADIES
WARDROBE

PICTURE A 862 Date 6-22-64
TITLE Pleasure Seekers
DIRECTOR J. Negulesco
ACTRESS Carol Lynley
PART OF Maggie
CHANGE No. 2
INT. Barton
Home
SCENE No. 78-91
Designer Renie 8x10

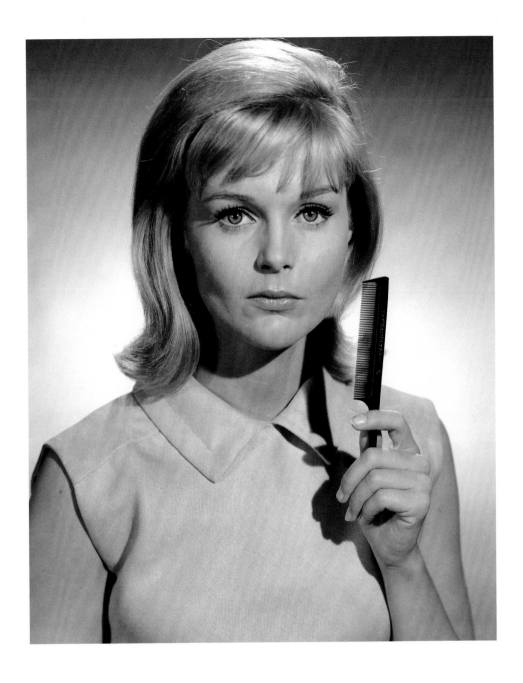

Carol Lynley, *The Pleasure Seekers*, 1964

Ingrid Bergman, *The Visit*, 1964

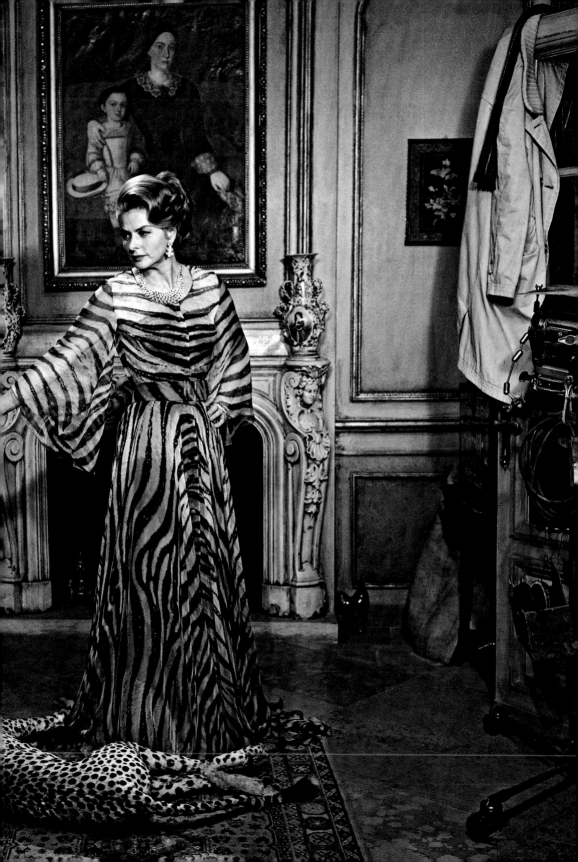

SPOTLIGHT

Hush . . . Hush, Sweet Charlotte

1964

Originally planned as a reteaming of Bette Davis and Joan Crawford after the box office success of *What Ever Happened to Baby Jane?*, *Hush . . . Hush, Sweet Charlotte* began production with both actresses on location in Louisiana. Their disruptive real-life feud is legendary; both actresses worked on the movie together for a mere two weeks before Crawford left. She was replaced by Olivia de Havilland, one of Bette Davis's favorite professional colleagues as well as a personal friend.

Director Robert Aldrich did not want to further postpone filming to wait for Crawford's wardrobe to be either altered or remade for de Havilland, so instead de Havilland wore her own personal clothing for the film. Her wardrobe mirrored her different approach to the role. She brought a sense of refined elegance that differed dramatically from Crawford's intense performance.

Bette Davis interpreted her character as a Southern belle in a state of arrested development. Her long, free-flowing hair and frilly dresses were reminiscent of those worn by a debutante rather than a middle-aged woman. It is only in the final scene of the film, after she has been freed from her past, that Davis dresses as a mature woman in a stylish suit with impeccable hair and makeup.

The film boasted two strong supporting actors as well. Mary Astor, best known from *The Maltese Falcon*, appeared in her final movie role, and Agnes Moorehead, a veteran film, radio, and stage performer who gained TV fame as the memorable witch Endora in *Bewitched*, was also cast.

Bette Davis, *Hush . . . Hush, Sweet Charlotte*, 1964

BETTE DAVIS

LADIES
WARDROBE
PICTURE H-06 Date 7-21-64
TITLE HUSH, SWEET CHARLOTTE
DIRECTOR B. ALDRICH
ACTRESS BETTE DAVIS
PART OF CHARLOTTE
CHANGE No. 4A
INT. CHARLOTTE'S
BEDROOM — 1ST
SCENE No.
Designer NORMA KOCH
8 x 10

Bette Davis, *Hush . . . Hush, Sweet Charlotte*, 1964

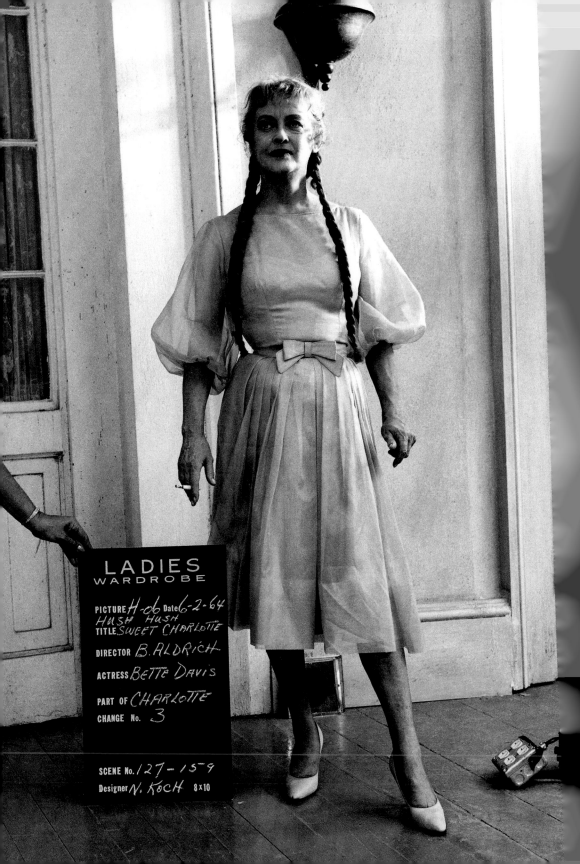

LADIES
WARDROBE

PICTURE *H-06* Date *6-2-64*
TITLE *HUSH HUSH SWEET CHARLOTTE*
DIRECTOR *B. ALDRICH*
ACTRESS *BETTE DAVIS*
PART OF *CHARLOTTE*
CHANGE No. *3*

SCENE No. *127-15-9*
Designer *N. KOCH* *8x10*

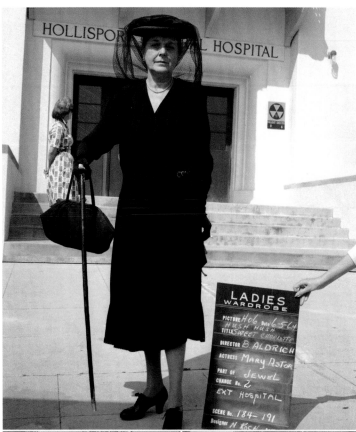

TOP: Mary Astor, *Hush . . . Hush, Sweet Charlotte*, 1964
ABOVE: Agnes Moorehead, *Hush . . . Hush, Sweet Charlotte*, 1964

Olivia de Havilland, *Hush . . . Hush, Sweet Charlotte*, 1964

AVILLAND

LADIES
WARDROBE
PICTURE H-07 Date 9-10-64
TITLE Hush Charlotte
DIRECTOR R'Aldrich
ACTRESS Olivia DeHavilland
PART OF MIRIAM
CHANGE No. 10
373-400
SCENE No.
Designer Koch 8 x 10

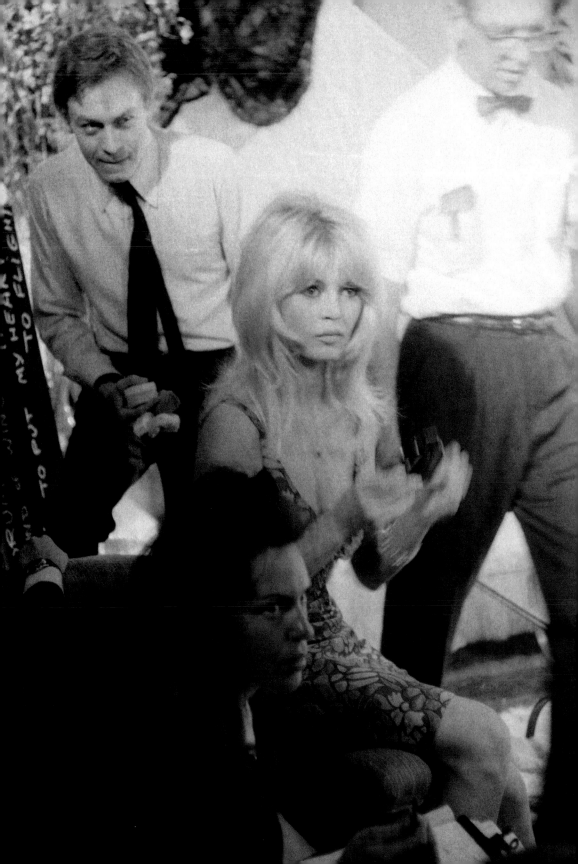

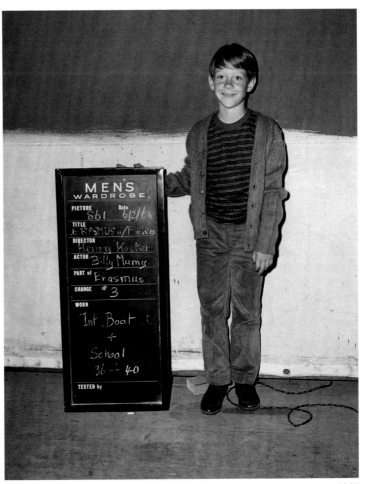

Bill Mumy, *Dear Brigitte*, 1965

"Most ten-year-old boys don't get excited about trying on clothes. I was lucky to have worked in many different styles and productions as a young actor, from old-timey westerns to fantastic futuristic sci-fi space epics.

"Six months before starting the long-running *Lost in Space* TV series at Twentieth Century Fox, I costarred with the great Jimmy Stewart in a Twentieth film titled *Dear Brigitte*. The original shooting title was "Erasmus with Freckles." I remember many of my wardrobe changes from that film. Most of them were simply jeans, a T-shirt, and a windbreaker, but they also included a sports coat and tie for the scenes we filmed outside of Paris, France, with the lovely Brigitte Bardot. The wardrobe perfectly captured the everyday all-American California boy from the mid-'60s. And reflecting back on it, that was me."

—BILL MUMY

Brigitte Bardot, *Dear Brigitte*, 1965

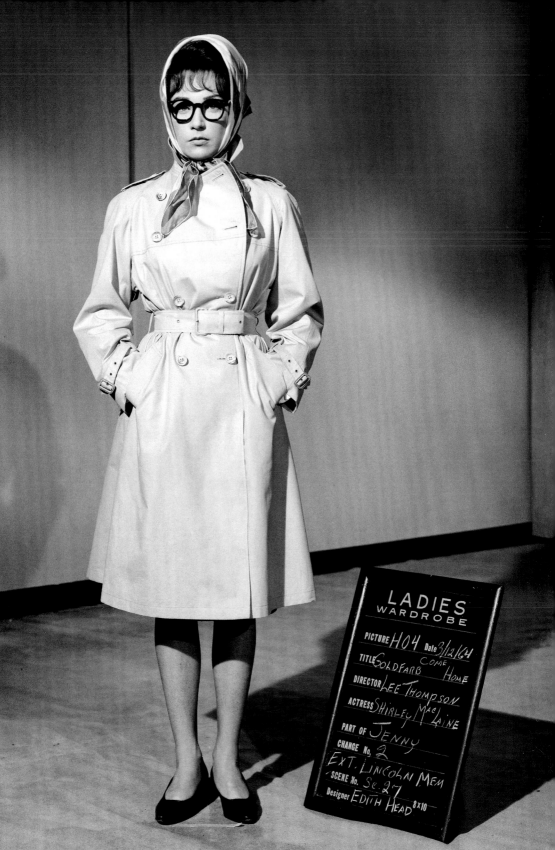

LADIES
WARDROBE

PICTURE H O 4 Date 3/12/64

TITLE GOLDFARB
 COME HOME

DIRECTOR Lee Thompson

ACTRESS Shirley MacLaine

PART OF JENNY

CHANGE No. 2

EXT. LINCOLN MEM

SCENE No. Sc. 27

Designer EDITH HEAD 8 x 10

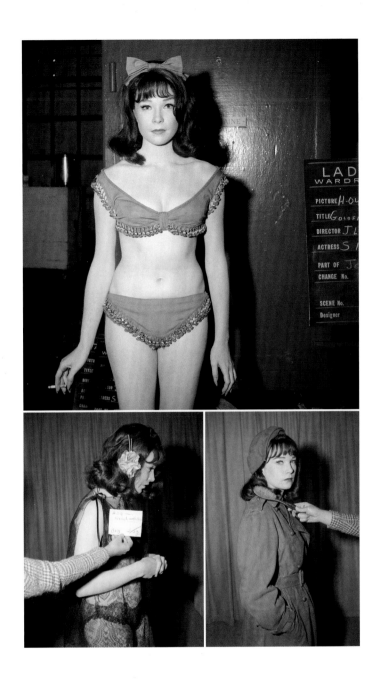

Shirley MacLaine, *John Goldfarb, Please Come Home!*, 1965

The Sound of Music

1965

One of the most famous and successful movie musicals of all time, The Sound of Music continues to captivate audiences with its grand scenic cinematography and timeless themes about the importance of family, the joys of youth, and overcoming hardship. The Fox film was nominated for ten Academy Awards, including Best Costume Design (for Dorothy Jeakins). The movie won five awards, including Best Picture and Best Director (Robert Wise).

Much of the film was shot in and around Salzburg, Austria. Filming on location is always precarious, but *The Sound of Music* had the additional challenge of maintaining continuity with a posse of growing actors portraying the von Trapp children. There were lost baby teeth, which had to be fit with false ones, as well as growth spurts, necessitating shoe lifts and lowered hemlines to provide consistency in the children's heights in relation to their siblings.

The Austrian Alps also impacted the costume design. Amid such spectacular natural scenery, Director Robert Wise instructed Production Designer Boris Leven and Costume Designer Jeakins to simplify the look of the film version compared to the heavily adorned gingerbread look of the original Broadway stage production. Practicality as opposed to sentimentality was what Wise sought from Jeakins's costumes.

Jeakins did have the opportunity to produce one of cinema's most gorgeous wedding dresses for Julie Andrews in *The Sound of Music*. It's captivating how perfectly Dorothy Jeakins interpreted the character of the former nun Maria by creating the exquisite wedding gown and diaphanous veil. What is only briefly seen on-screen is the ornate and finely detailed clothing the von Trapp children wear during the wedding scene. Each piece had been made specifically for the individual who wore it and was adorned with embroidery and fine lace.

The scenery, songs, story, sets, and costumes all blended seamlessly in the final film; guided by Wise's vision and stewardship, and enchanced by the talents of the team he assembled, *The Sound of Music* was arguably Twentieth Century Fox's greatest film.

Julie Andrews, *The Sound of Music*, 1965

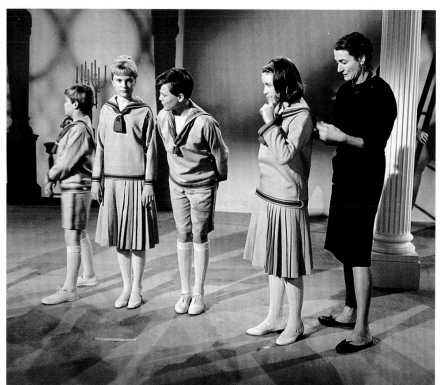

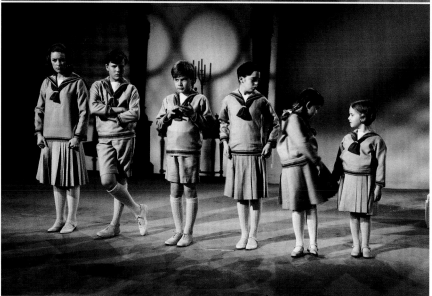

TOP (from left to right): Duane Chase, Heather Menzies, Nicholas Hammond, Charmian Carr, and Costume Designer Dorothy Jeakins, *The Sound of Music*, 1965
ABOVE (from left to right): Charmian Carr, Nicholas Hammond, Duane Chase, Angela Cartwright, Debbie Turner, and Kym Karath, *The Sound of Music*, 1965

“I remember multiple wardrobe shots taken of the seven von Trapp children who were cast before the actual shooting began on *The Sound of Music*. We were called to the portrait studio on the lot and dressed in our costumes. Each time we changed, we were asked to take our position in the von Trapp lineup, and we stood for what seemed like hours while important decisions were made. Costume Designer Dorothy Jeakins and her assistants discussed the length of the hems, the colors, and the fabric choices for each piece of wardrobe. The seamstresses took intricate measurements of us so our costumes would fit perfectly.

"Multiple wardrobe changes and working with seven children created challenges. Week after week, one of us would grow an inch or gain a pound—especially when we were in Austria, where the Wiener schnitzel and fresh apple strudel were impossible for some to resist! Our clothes would have to be adjusted on location to compensate for this constant state of change. Exceptional seamstresses are vital on any production."

—ANGELA CARTWRIGHT

ABOVE (from left to right, seated): Director Robert Wise, Angela Cartwright, Duane Chase, and Charmian Carr, *The Sound of Music*, 1965

221

TOP: Peggy Wood, *The Sound of Music*, 1965, ABOVE LEFT: Marni Nixon (left) and Doreen Tryden (right), *The Sound of Music*, 1965, ABOVE CENTER: Portia Nelson, *The Sound of Music*, 1965, ABOVE RIGHT: Anna Lee, *The Sound of Music*, 1965

Duane Chase (left) and Nicholas Hammond (right), *The Sound of Music*, 1965

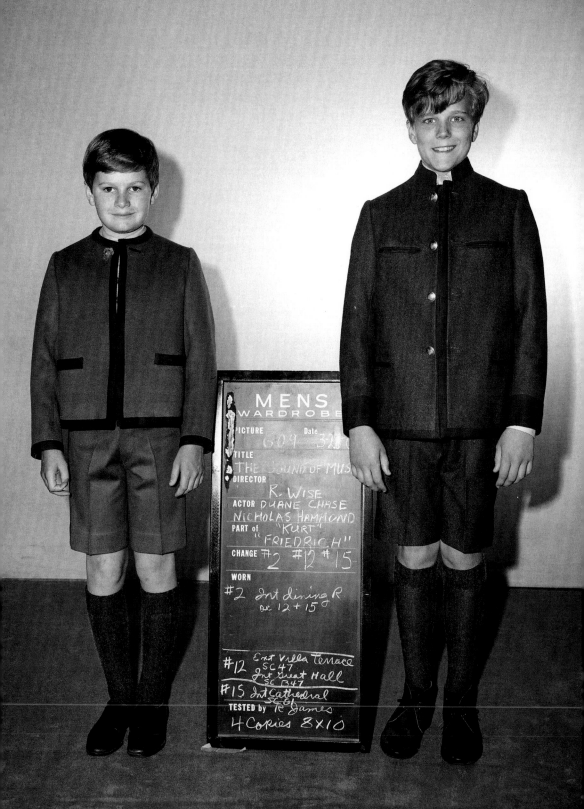

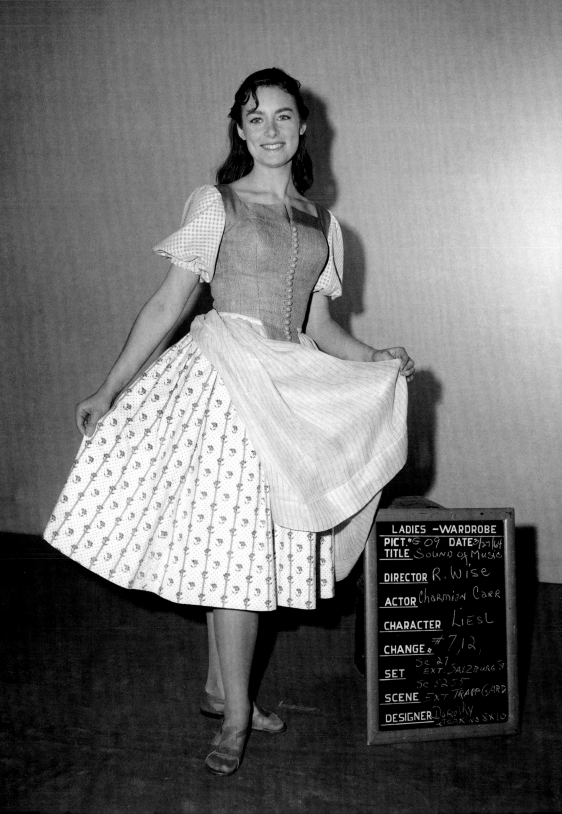

LADIES – WARDROBE
PICT.# G 09 DATE 3/27/64
TITLE Sound of Music
DIRECTOR R. Wise
ACTOR Charmian Carr
CHARACTER Liesl
CHANGE # 7,12,
SET Sc 27 EXT. SALZBURG St
Sc 52.55
SCENE EXT TRAPP GARD
DESIGNER Dorothy
Jeakins 8x10

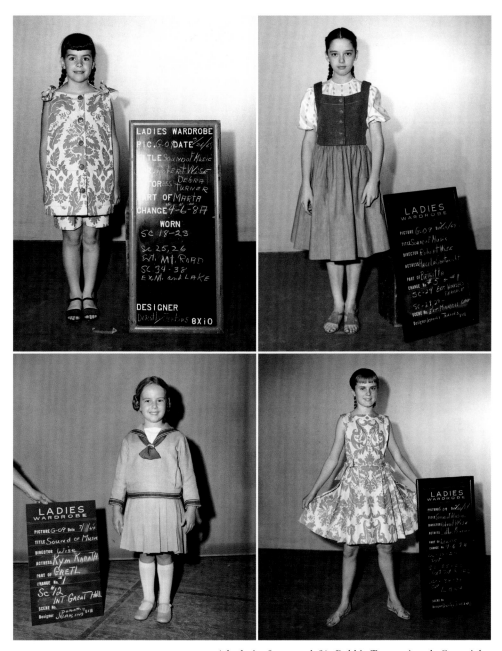

ABOVE (clockwise from top left): Debbie Turner, Angela Cartwright, Heather Menzies, Kym Karath, *The Sound of Music*, 1965

Charmian Carr, *The Sound of Music*, 1965

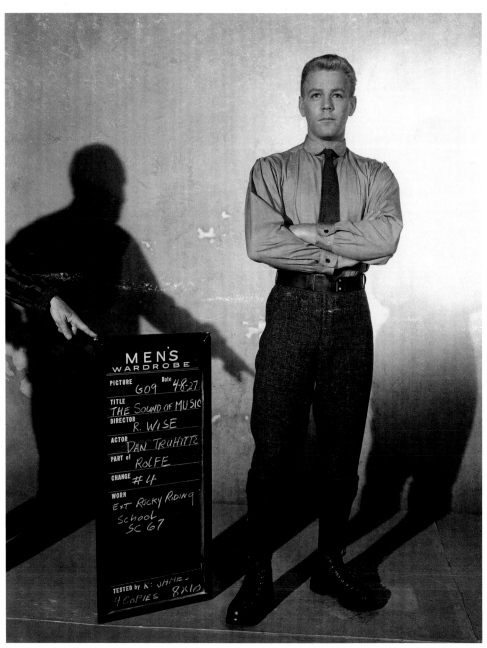

Daniel Truhitte, *The Sound of Music*, 1965

Christopher Plummer, *The Sound of Music*, 1965

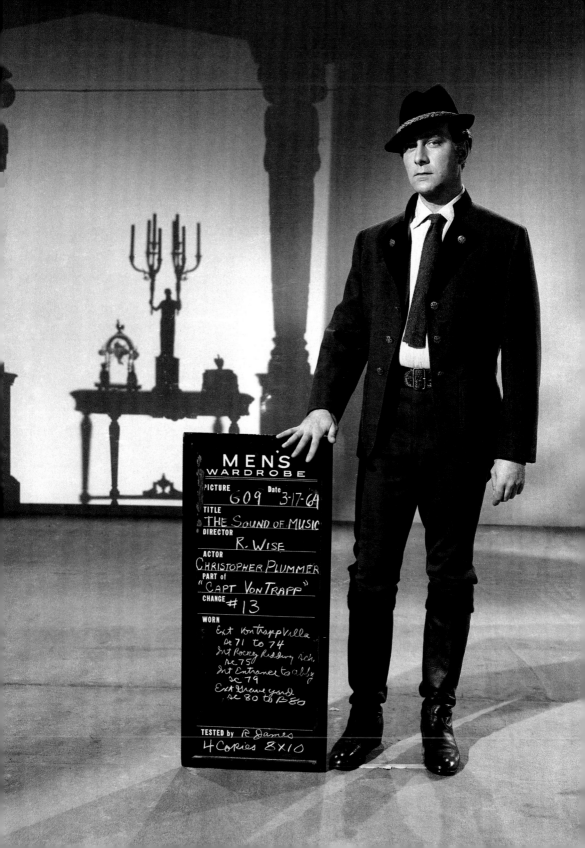

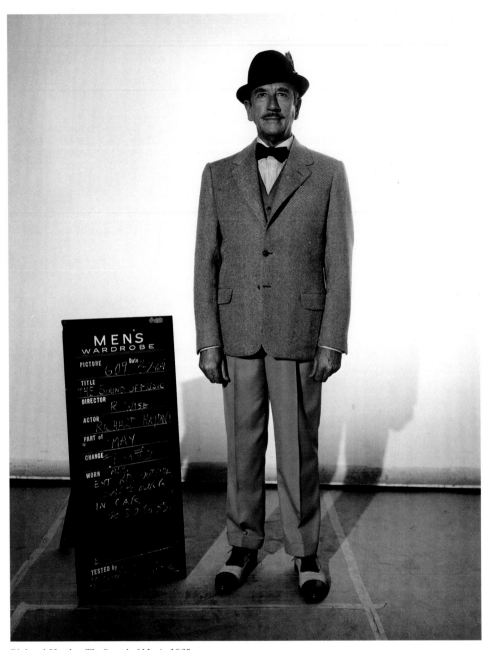

Richard Haydn, *The Sound of Music*, 1965

Eleanor Parker, *The Sound of Music*, 1965

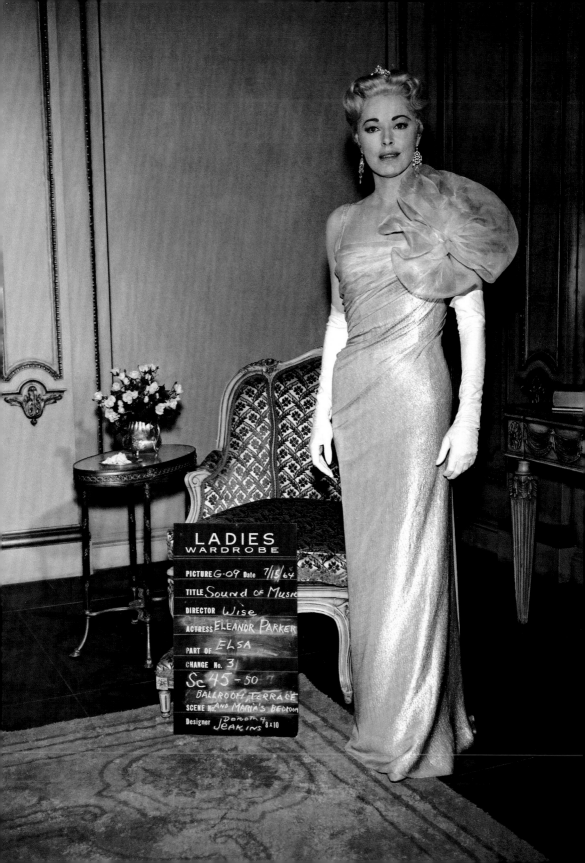

LADIES
WARDROBE

PICTURE G-09 Date 7/15/64
TITLE Sound of Music
DIRECTOR Wise
ACTRESS ELEANOR PARKER
ELSA
PART OF
CHANGE No. 3
Sc 45 - 50
BALLROOM TERRACE
SCENE No. AND MARIA'S BEDROOM
Designer Dorothy 8x10
JEAKINS

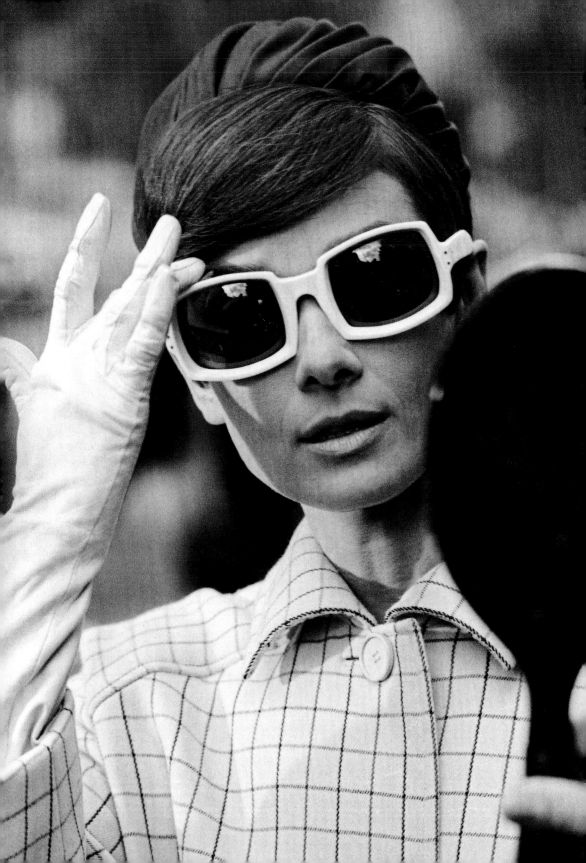

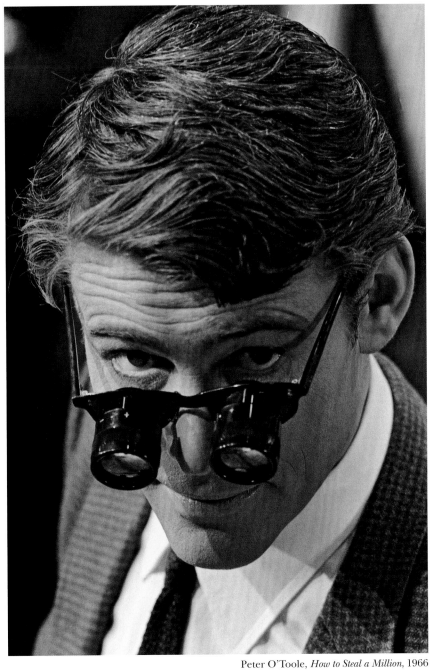

Peter O'Toole, *How to Steal a Million*, 1966

Audrey Hepburn, *How to Steal a Million*, 1966

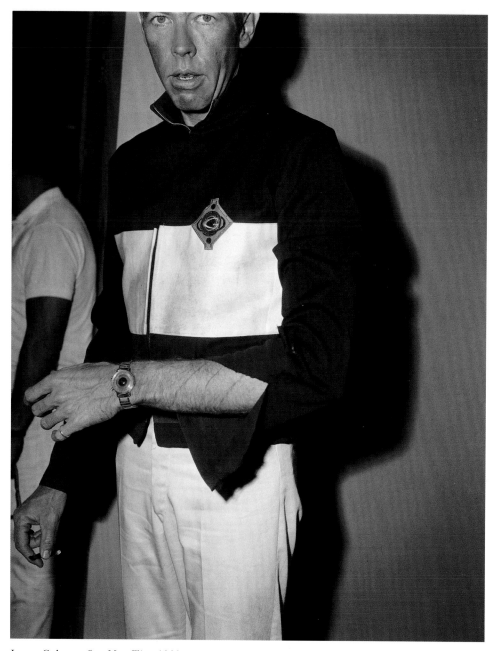

James Coburn, *Our Man Flint*, 1966

James Coburn's torn sleeve is photographed so that it will match
perfectly in a scene to be shot at a later date.

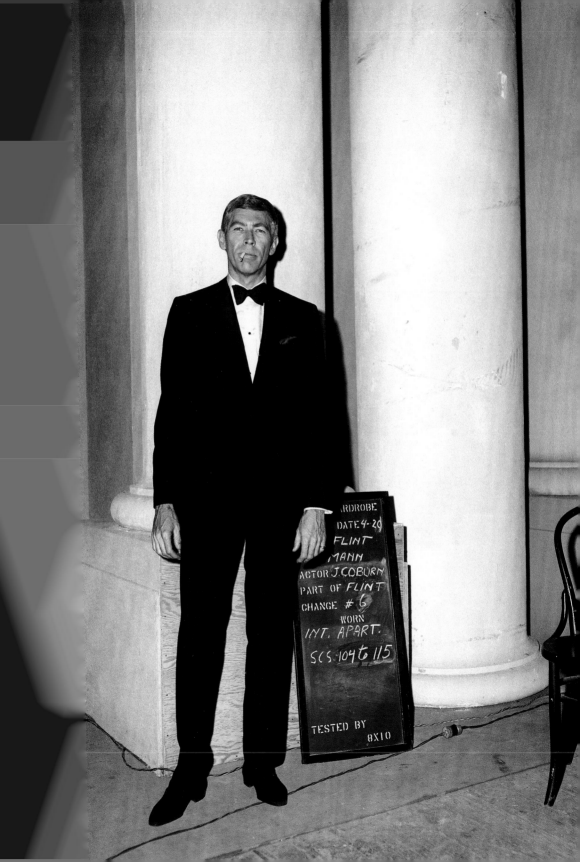

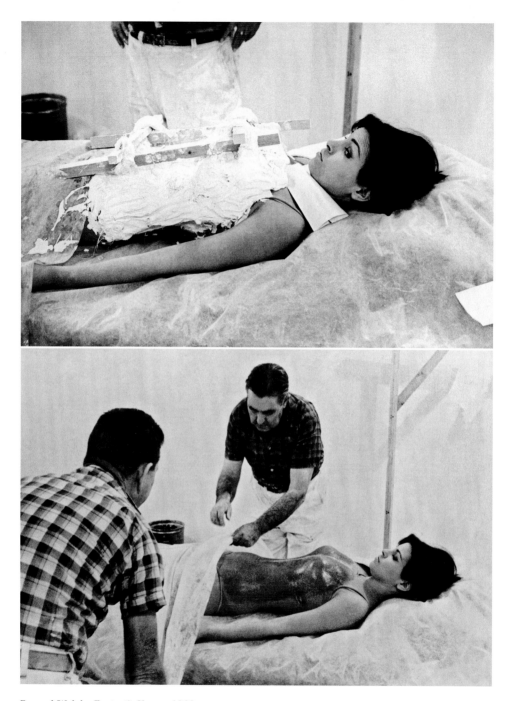

Raquel Welch, *Fantastic Voyage*, 1966

Raquel Welch was virtually poured into her bodysuit for *Fantastic Voyage*. A mold of her body was made for the perfect fit. Welch was one of the last Fox contract players and starred in several films for the studio, including *Myra Breckinridge*.

RAQUEL WELCH

LADIES
WARDROBE

PICTURE A864 Date 7-14-65
TITLE FANTASTIC VOGAGE
DIRECTOR R FLEISCHER
ACTRESS R WELCH
PART OF CORA
CHANGE No. 3
WET-SUIT
SCENE No. 87
Designer 8 x 10

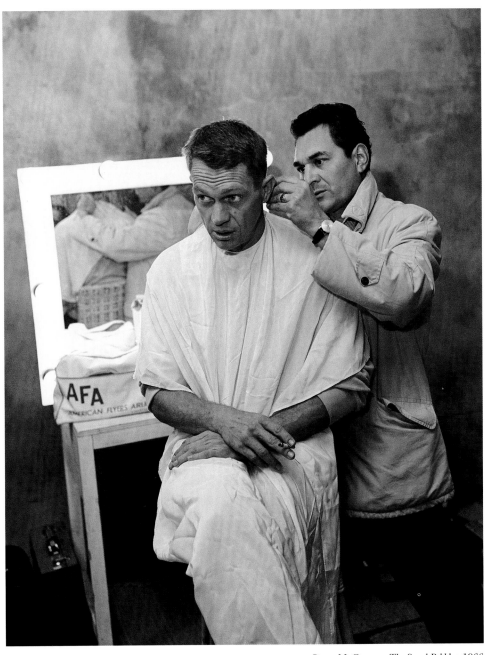

Steve McQueen, *The Sand Pebbles,* 1966

Candice Bergen, *The Sand Pebbles,* 1966

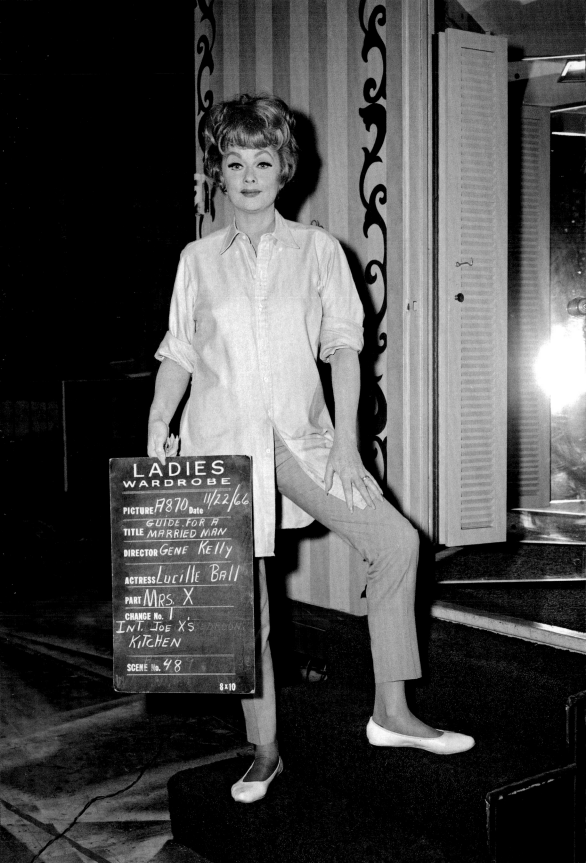

LADIES
WARDROBE
PICTURE A870 Date 11/22/66
TITLE GUIDE FOR A
MARRIED MAN
DIRECTOR GENE KELLY
ACTRESS LUCILLE BALL
PART MRS. X
CHANGE No. 1
INT. JOE X'S BEDROOM
KITCHEN
SCENE No. 48
8×10

Walter Matthau, *A Guide for the Married Man*, 1967

Lucille Ball, *A Guide for the Married Man*, 1967

Doris Day, *Caprice*, 1967

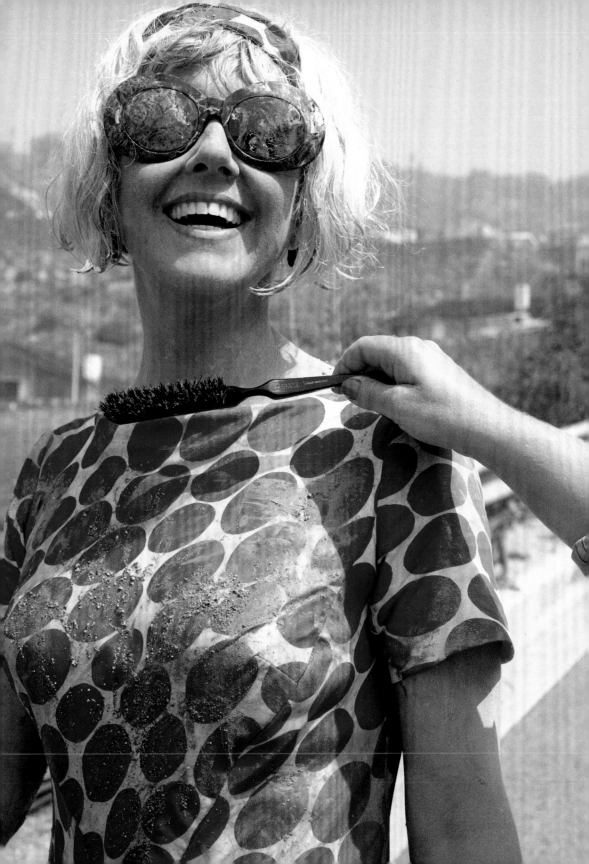

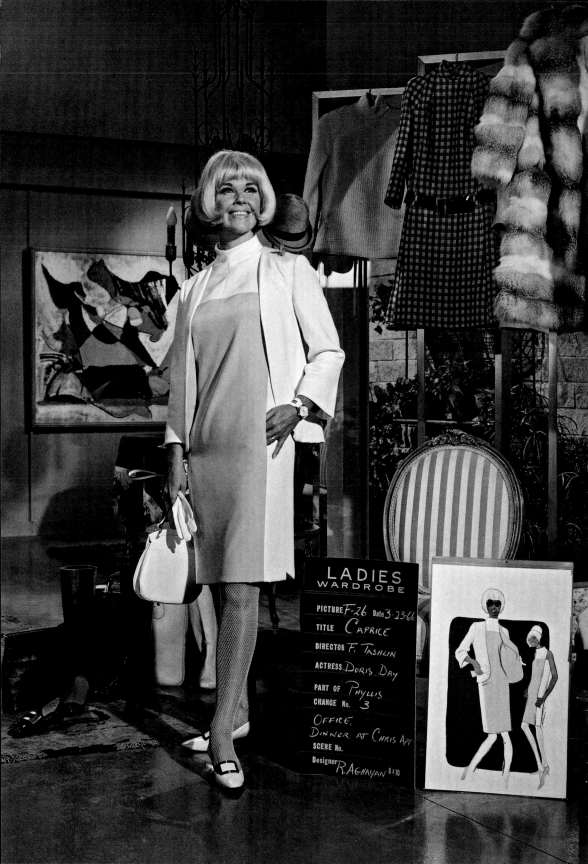

LADIES
WARDROBE

PICTURE F-26 Date 3-23-66
TITLE Caprice
DIRECTOR F. Tashlin
ACTRESS Doris Day
PART OF Phyllis
CHANGE No. 3

OFFICE,
DINNER AT CHRIS APT
SCENE No.
Designer R. Aghayan 8x10

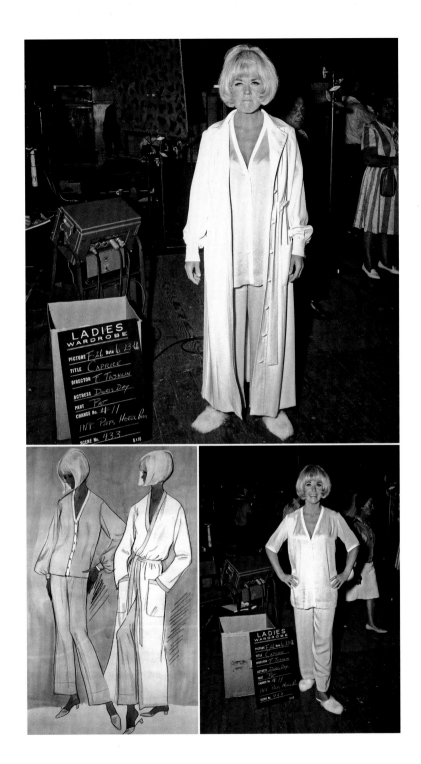

Doris Day, *Caprice*, 1967

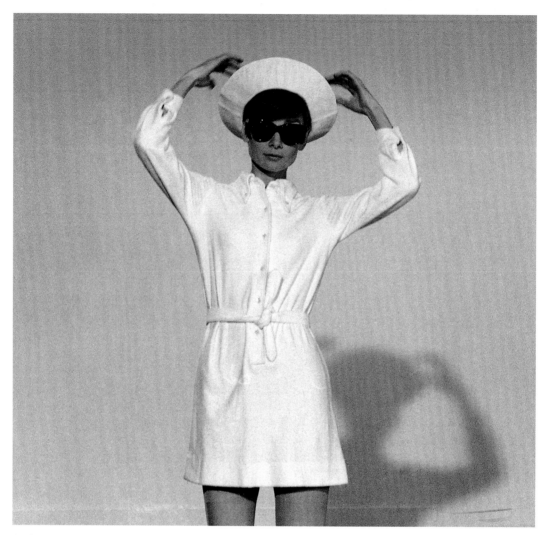

Audrey Hepburn, *Two for the Road*, 1967

Audrey Hepburn was given a team of costumers for *Two for the Road*, including
Wardrobe Supervisor Clare Rendlesham and four top designers of the day:
Mary Quant, Paco Rabanne, Michèle Rosier, and Ken Scott.

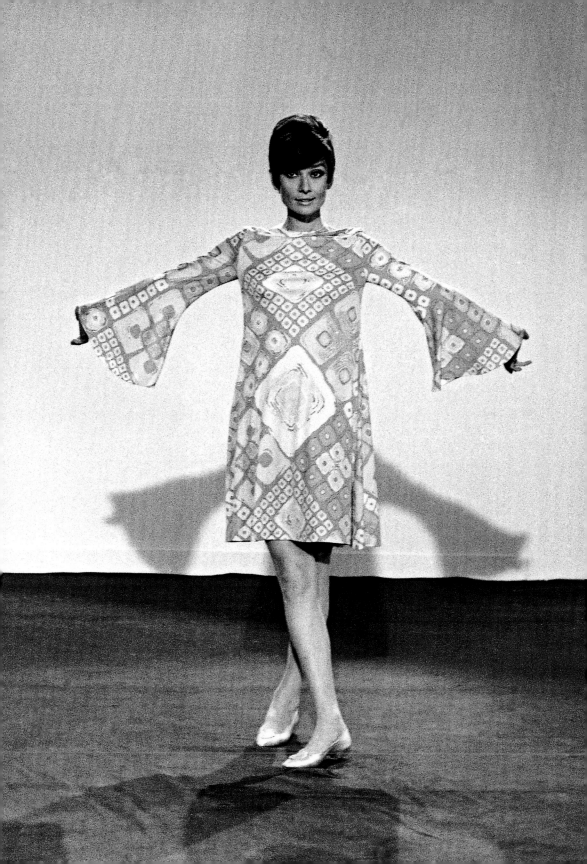

Valley of the Dolls

1967

Twentieth Century Fox acquired the rights to Jacqueline Susann's salacious best-selling novel *Valley of the Dolls* shortly after it was published in 1966. Barbara Parkins, Patty Duke, and Sharon Tate were cast as the young women coming of age while grappling with sex, drugs, alcohol, and lovers. Judy Garland was hired to portray an aging Broadway star (as seen in the rare wardrobe test photo), but she left the production and was replaced by Susan Hayward.

William Travilla was hired once again for costume design and was also offered a role in the film as Patty Duke's costume-designing husband. Although Travilla turned down the role, he did create the trendy late-1960s costumes seen on-screen, demonstrating his ability to evolve with the times, not just updating his look from the 1950s but creating an entirely new one.

Garland loved her costumes so much that she asked to take them with her when she was dismissed from the film. Travilla declined, explaining that they were studio property, but to appease Garland he apparently re-created several of the pieces for her. It's been reported that costar Patty Duke remembers seeing Garland a year later wearing one of the replicated costumes while performing onstage at the Hollywood Palace.

Although a huge box office hit for Twentieth Century Fox, *Valley of the Dolls* was critically and universally panned. The psychedelic colors, miniskirts, and plastic jewelry accented by overteased hair and heavy eye makeup evoke the best and worst excesses of the era. The film's look and plot are inextricably linked together. Today, the film is considered a cult classic and an over-the-top excursion into the swinging lifestyle of the 1960s.

Sharon Tate, *Valley of the Dolls*, 1967

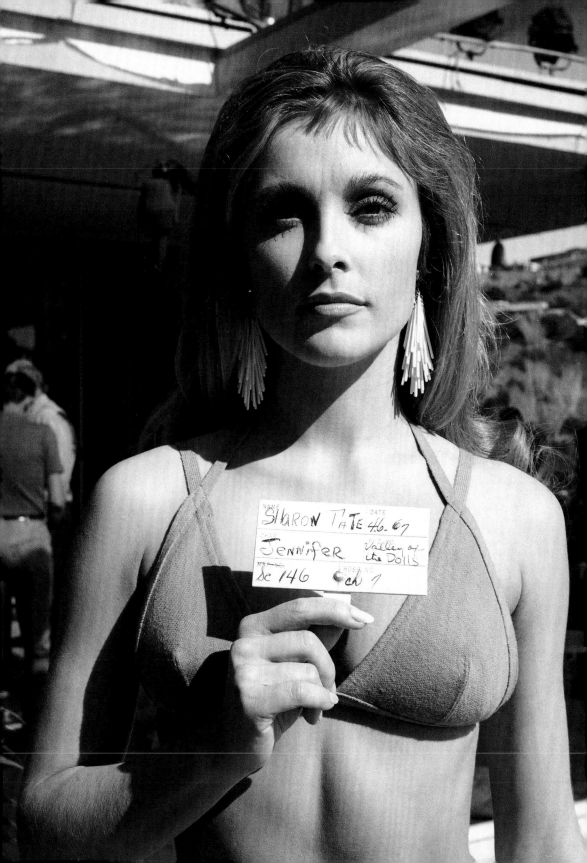

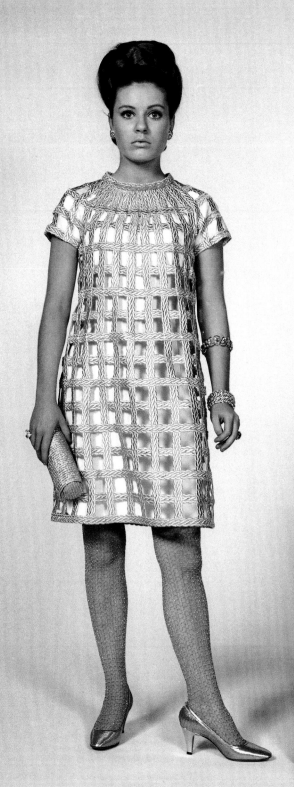

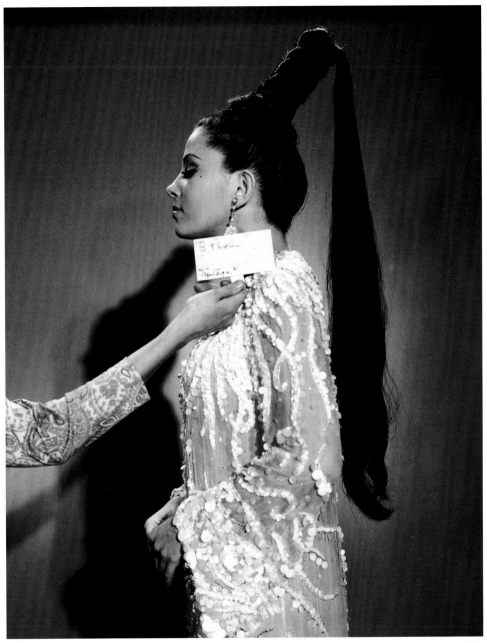

Barbara Parkins, *Valley of the Dolls*, 1967

Patty Duke, *Valley of the Dolls*, 1967

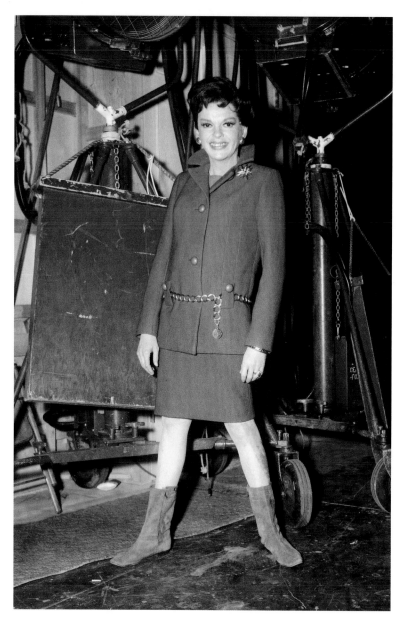

Judy Garland, *Valley of the Dolls*, 1967

Lee Grant, *Valley of the Dolls*, 1967

In hair department photographs, the actor would usually hold a comb or brush to indicate the photo was intended for continuity purposes. When a comb or brush was not close at hand, the hair department would substitute a broom or something similar to indicate that these images were meant for internal use by the hair department only. Lee Grant holds a broom as an example of this with her *Valley of the Dolls* hair test photo.

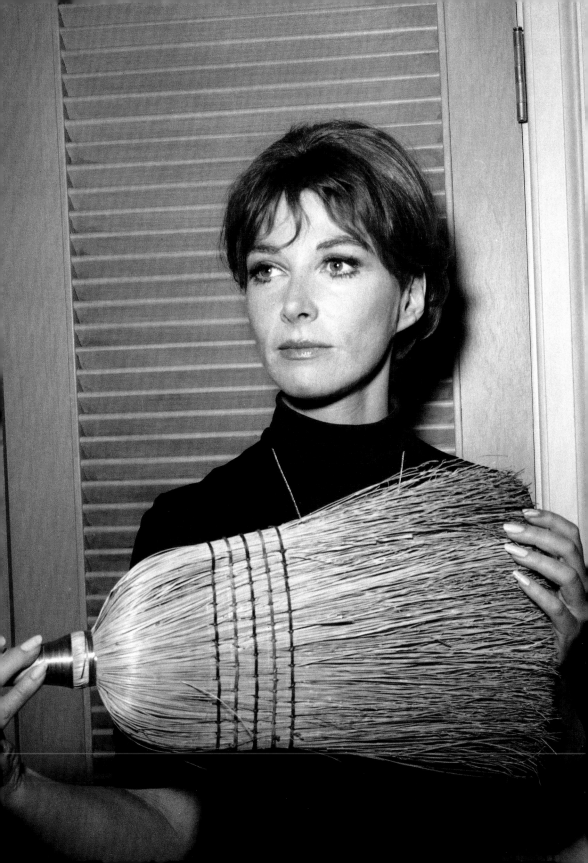

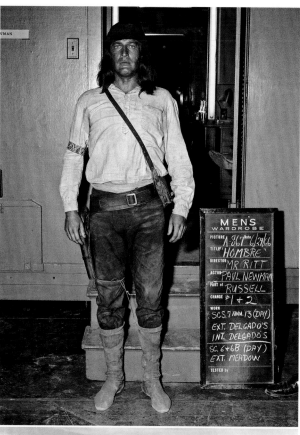

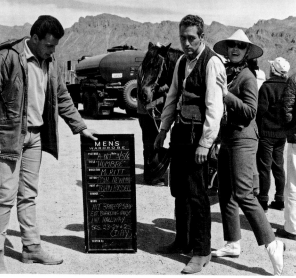

TOP AND OPPOSITE: Paul Newman, *Hombre*, 1967
ABOVE: Joanne Woodward visits Newman on the set of *Hombre*, 1967

MENS
WARDROBE

PICTURE A867 Date 2-28-66
TITLE "HOMBRE"
DIRECTOR M. RITT
ACTRESS PAUL NEWMAN
PART OF JOHN RUSSELL
CHANGE No. 4+5 NIGHT
INT. WAITING ROOM
EXT. HATCH + HODGES
INT. MUD WAGON
SCENE No. 35 THRU 39
Designer FELD 8 x 10

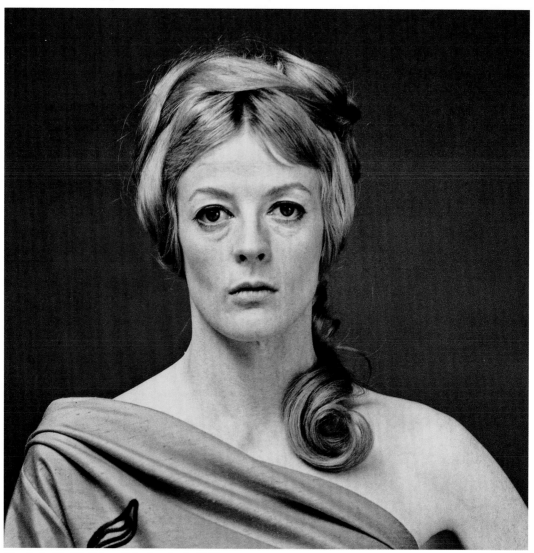

Maggie Smith, *The Prime of Miss Jean Brodie*, 1969

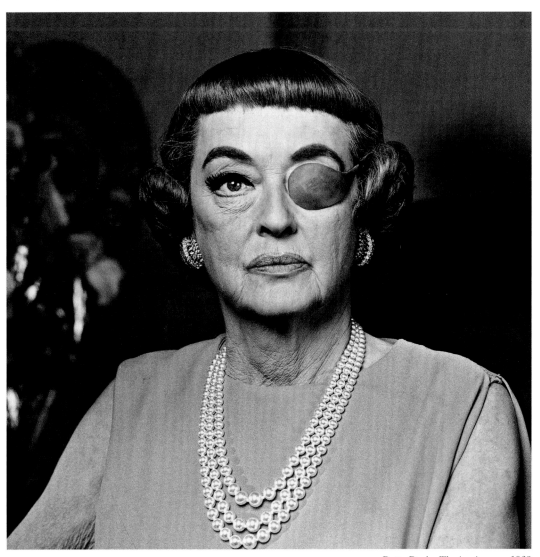

Bette Davis, *The Anniversary*, 1968

Planet of the Apes

1968

One of the most successful Fox film franchises, *Planet of the Apes* began with the landmark 1968 film starring Charlton Heston. It was followed by four sequels between 1970 and 1973, as well as a TV series, an animated TV series, various merchandising tie-ins, a film remake in 2001, and a film reboot in 2011 and 2014. Morton Haack, who also costumed the sequel *Beneath the Planet of the Apes*, was nominated for Best Costume Design for his work on the original, although the most memorable parts of the costumes—the ape masks—were created by Makeup Artist John Chambers.

Chambers, who occasionally moonlighted for the CIA (John Goodman portrayed him in *Argo*) won an honorary Academy Award for his outstanding makeup achievement. Chambers reportedly spent many hours at the Los Angeles Zoo, studying the apes' facial expressions, before designing the actors' masks. It is rumored that a "death mask" was made of Debbie, the most employed chimpanzee in the business (including a role as the Bloop in TV's *Lost in Space*), for the mold of the ape masks.

The process of applying the prosthetics to the actors' faces was performed by a team of more than eighty makeup artists. Makeup application was extremely lengthy, and actors were required to leave the masks on during breaks, so meals were liquefied and consumed through straws. Leftover ape makeup materials were used for another Fox production on the lot: the episode of "Fugitives in Space" of the TV series *Lost in Space*. During the '60s and '70s, costumes, wigs, and sets were often recycled and repurposed for other film and television productions, a practice that is not as common today.

Charlton Heston, *Planet of the Apes*, 1968

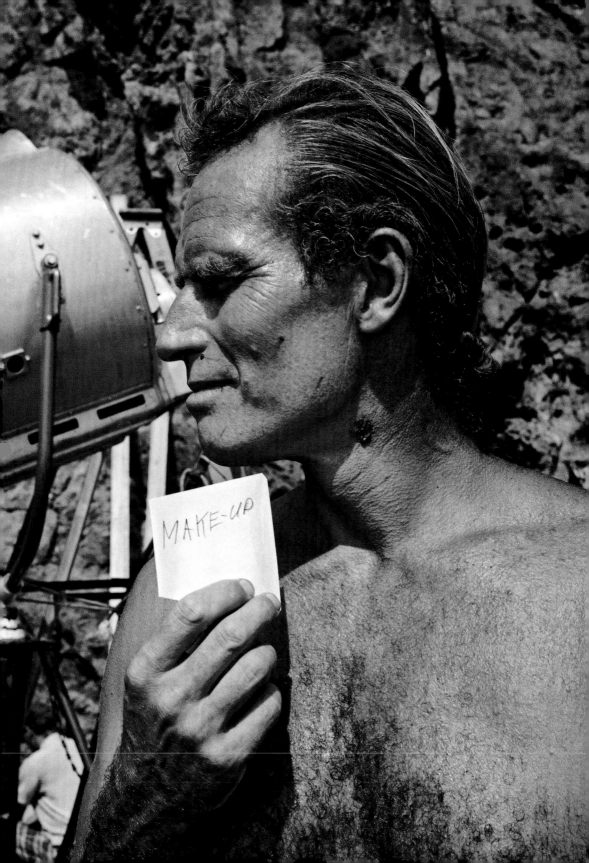

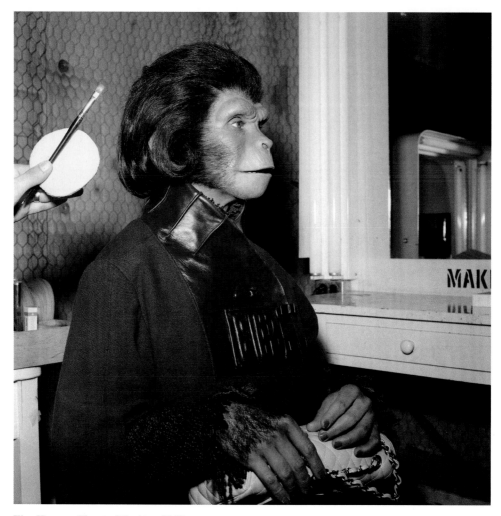

Kim Hunter, *Planet of the Apes*, 1968

A makeup artist holds a powder puff and makeup brush in the frame of Kim Hunter's photograph to show the photo was for makeup department use only. More than one hundred makeup and design technicians created everything from dentures to sculpted molds and hairpieces for *Planet of the Apes*.

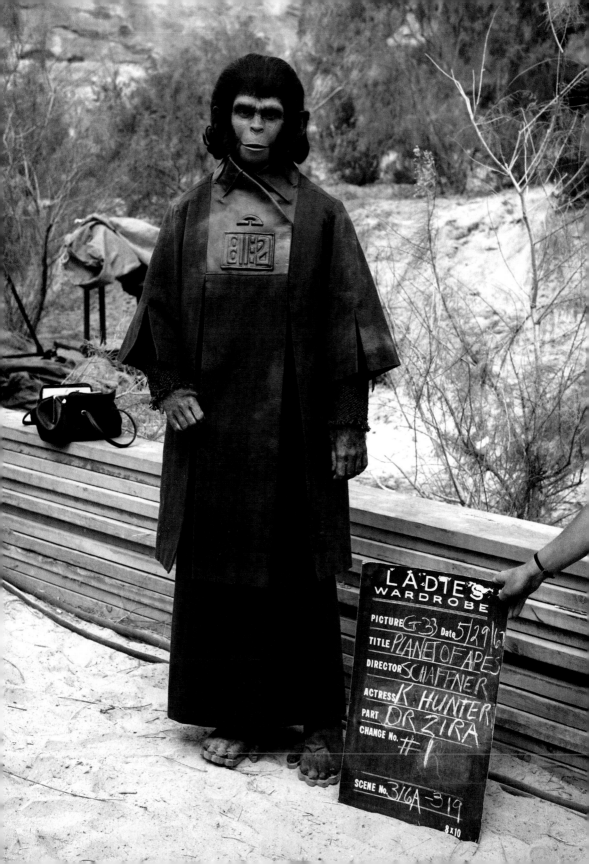

LADIES WARDROBE

PICTURE G-33 Date 5/29/67
TITLE PLANET OF APES
DIRECTOR SCHAFFNER
ACTRESS K HUNTER
PART DR ZIRA
CHANGE No. #1

SCENE No. 316A-319

8x10

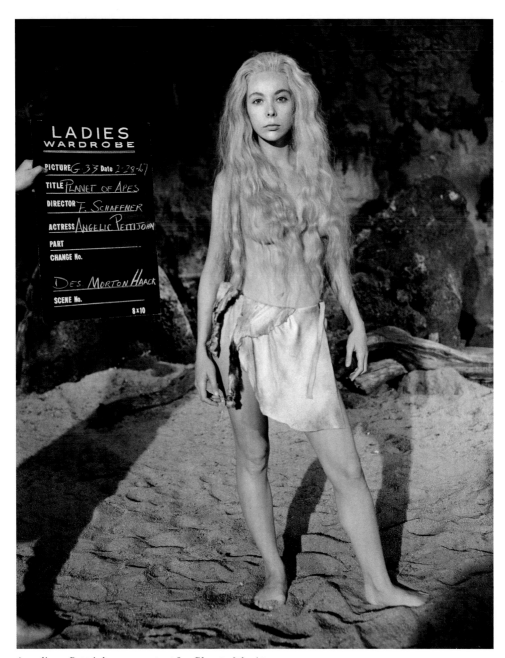

Angelique Pettyjohn, screen test for *Planet of the Apes*

A blond Angelique Pettyjohn (best known to sci-fi fans for an episode of television's *Star Trek*) tested for the role of Nova in 1968's *Planet of the Apes*. The role went to Linda Harrison (opposite), Richard Zanuck's girlfriend at the time and later his spouse.

Linda Harrison, *Planet of the Apes*, 1968

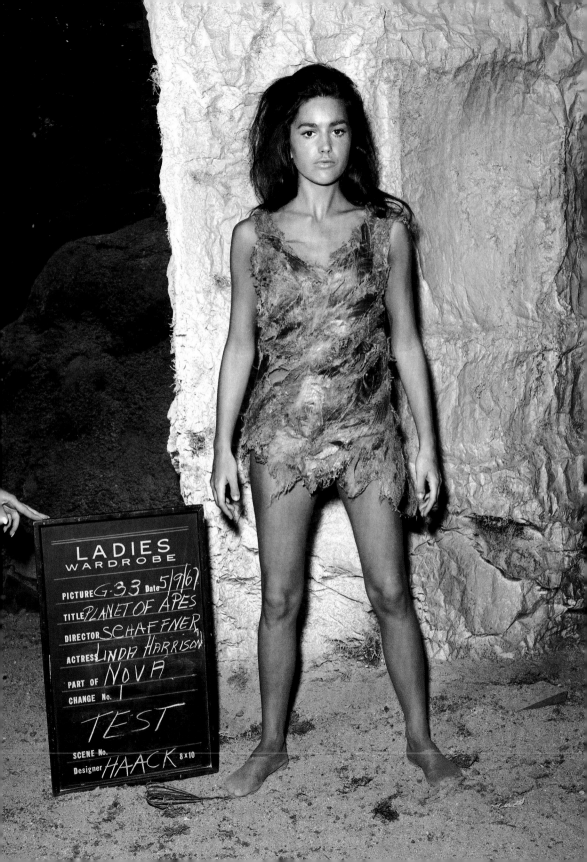

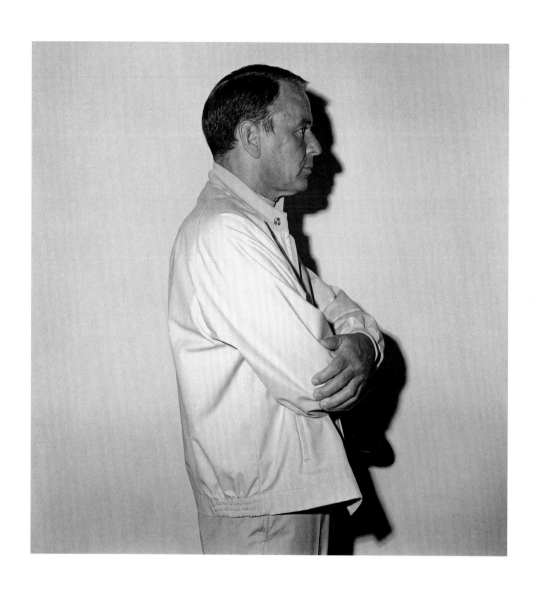

Frank Sinatra, *Lady in Cement*, 1968

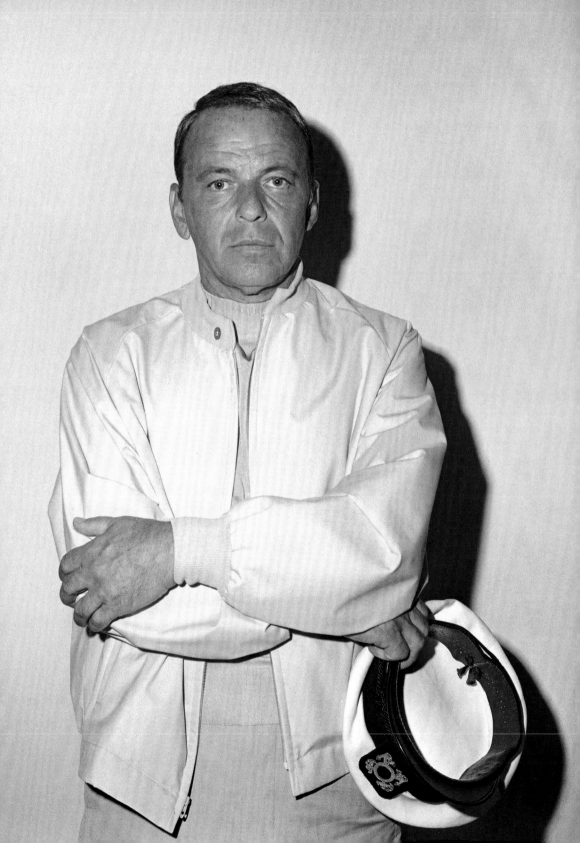

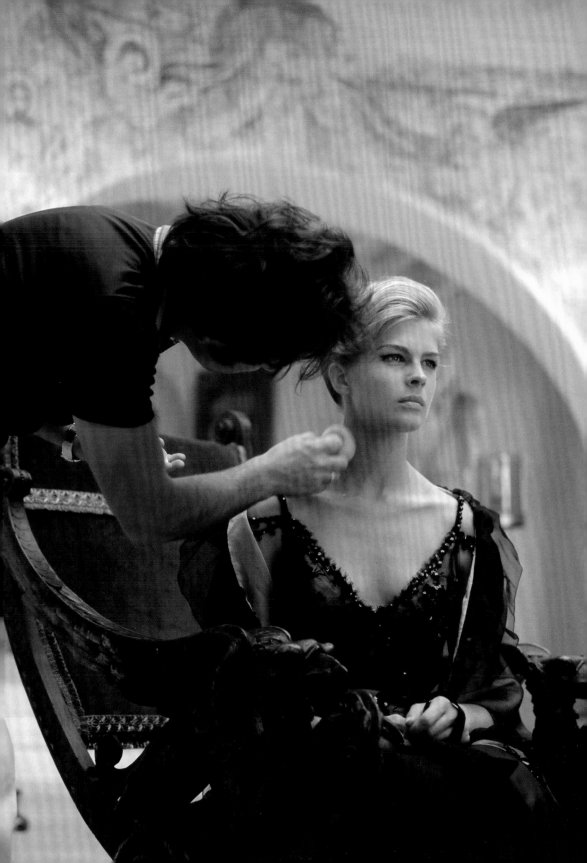

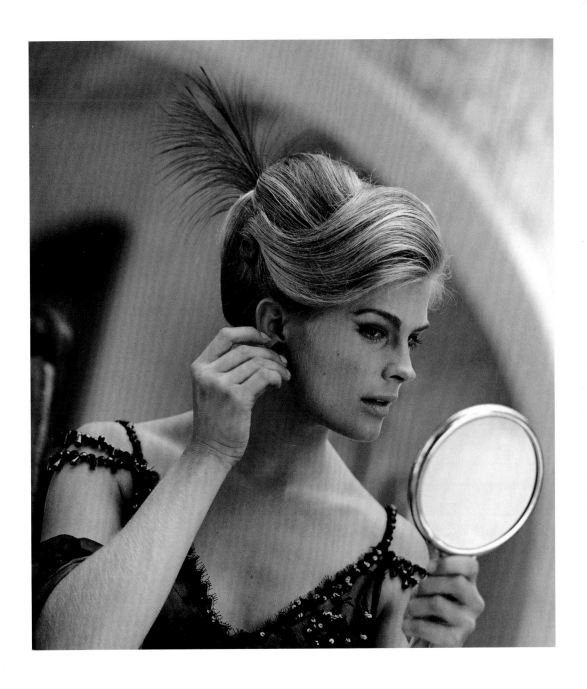

Candice Bergen, *The Magus*, 1968

Butch Cassidy and the Sundance Kid

1969

The original script was titled "The Sundance Kid and Butch Cassidy," with Steve McQueen as Sundance and Paul Newman as Butch. When McQueen dropped out, the title characters were reversed and a lesser-known Robert Redford was cast as Sundance. Released in 1969, the film was a huge hit, solidifying Newman's superstar status while Redford and Katharine Ross's chemistry catapulted them to Hollywood stardom.

Director George Roy Hill wanted to film the New York montage scenes on the *Hello, Dolly!* sets, since both films were in production at the same time. Fox refused the request, opting to keep the *Dolly* sets unique to *Hello, Dolly!*—its major release for the year. Instead, Hill simply photographed the actors on the *Dolly* set and then spliced those still images into a series of actual period photographs. The montage he created was one of the first examples of photo-effects techniques used in a movie.

Butch Cassidy and the Sundance Kid was a modestly budgeted film, with bank robbers as antiestablishment heroes representing New Hollywood values. The budget for *Butch Cassidy* was so tight that costume designer Edith Head (on loan from Universal) could only afford to design and create Katharine Ross's costumes from sketch to screen. For Newman and Redford's wardrobes, Head pulled pieces out of the Twentieth Century Fox wardrobe department, bought items, and rented others from the Western Costume Company.

Hollywood's haute couture approach to costume design for film (as represented by Katharine Ross's wardrobe) was gradually being replaced by the more economic method of acquiring pieces off the rack (Newman and Redford's garments). This practice of shopping for a film's costumes rather than the studio generating them in-house diminished the size and scope of the traditional studio wardrobe department. It provides a concrete example of how the studio system was being phased out by the New Hollywood.

Despite budgetary restrictions, *Butch Cassidy and the Sundance Kid* is still one of the most successful Twentieth Century Fox movies.

Katherine Ross and Paul Newman,
Butch Cassidy and the Sundance Kid, 1969

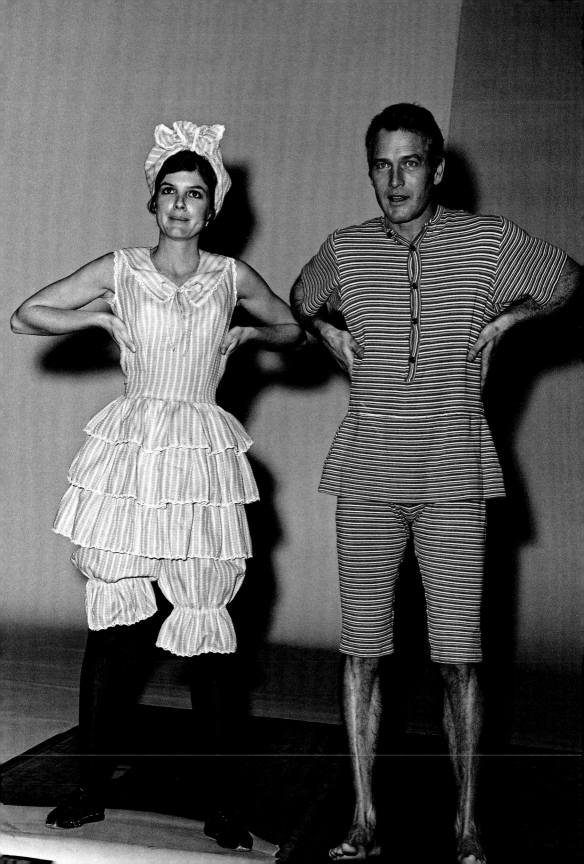

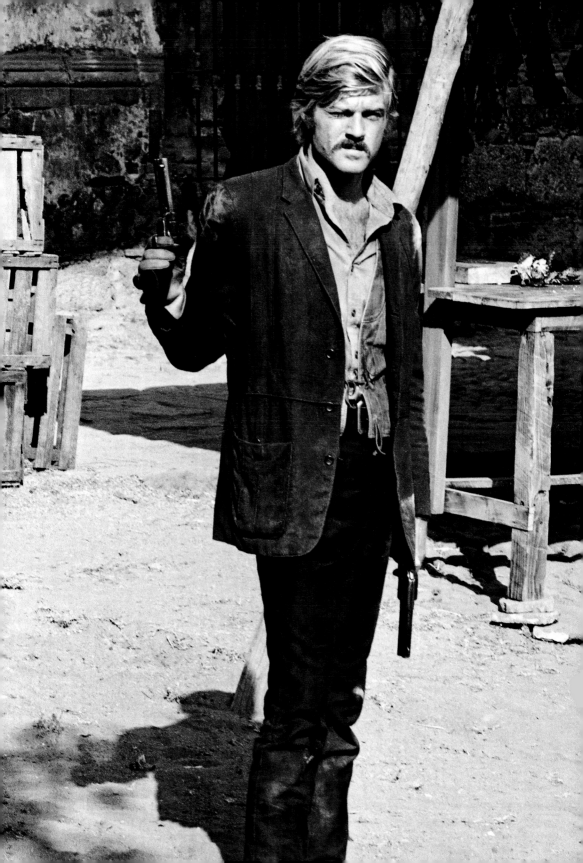

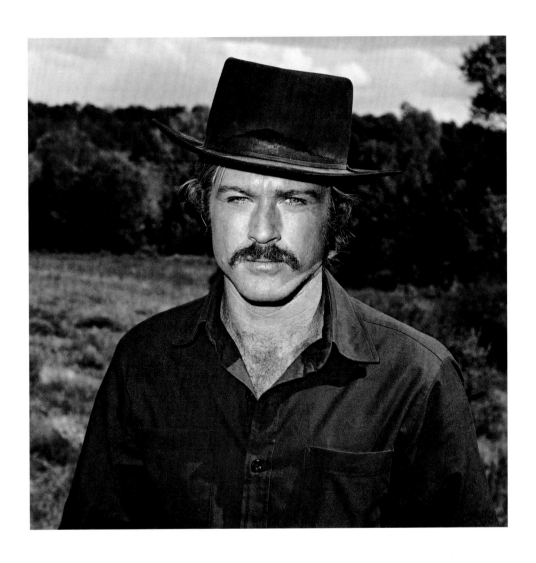

Robert Redford, *Butch Cassidy and the Sundance Kid*, 1969

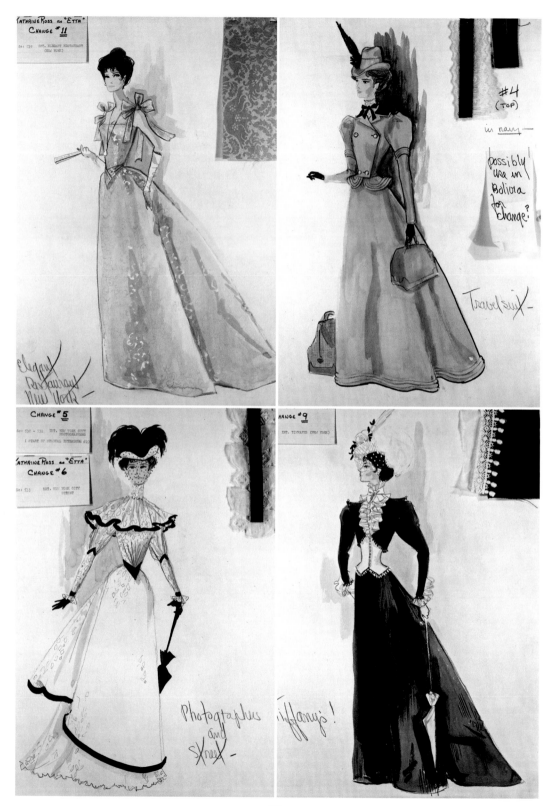

270

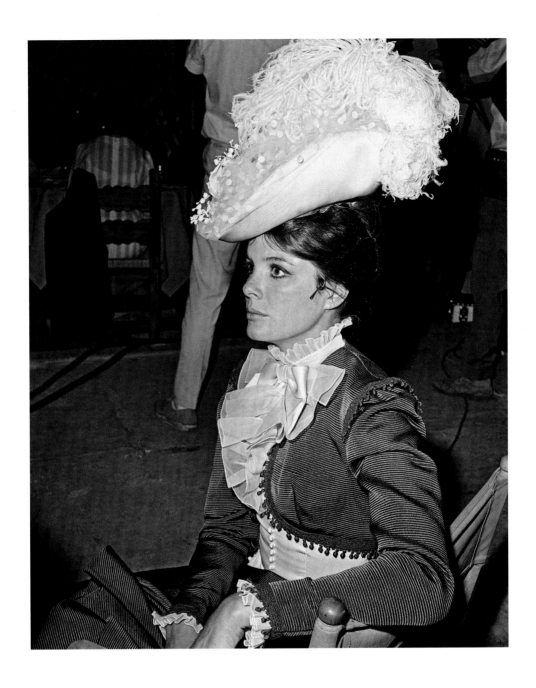

Katharine Ross, *Butch Cassidy and the Sundance Kid*, 1969

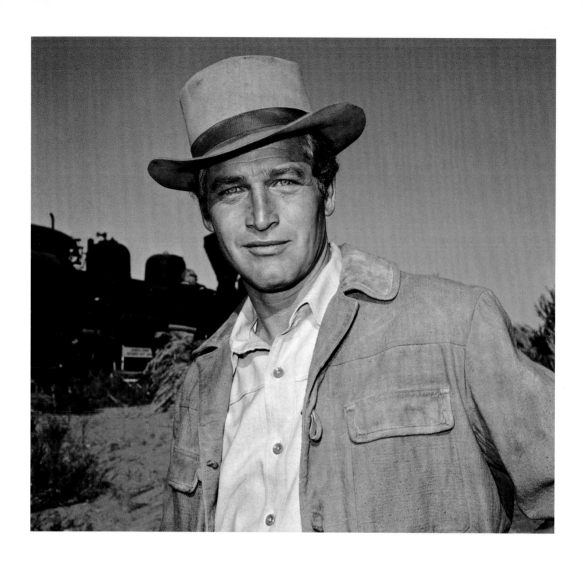

Paul Newman, *Butch Cassidy and the Sundance Kid*, 1969

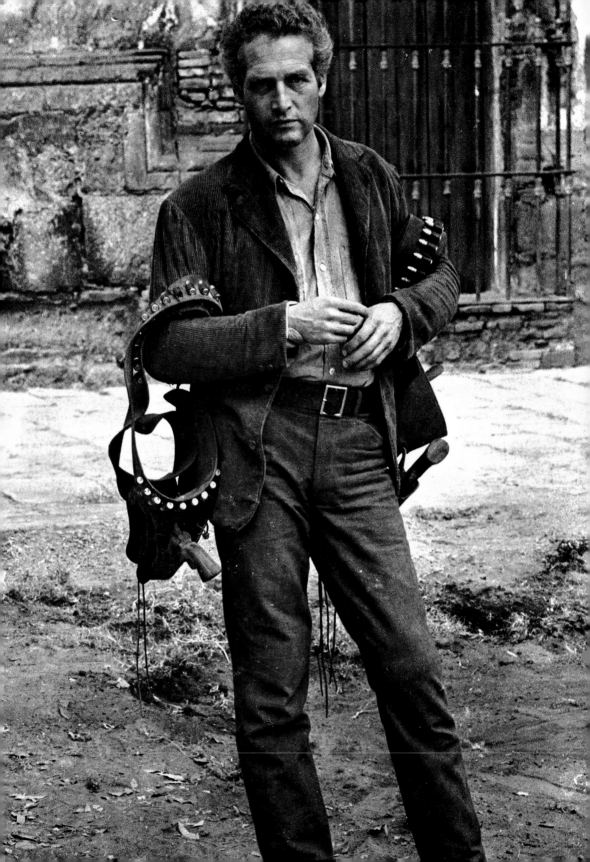

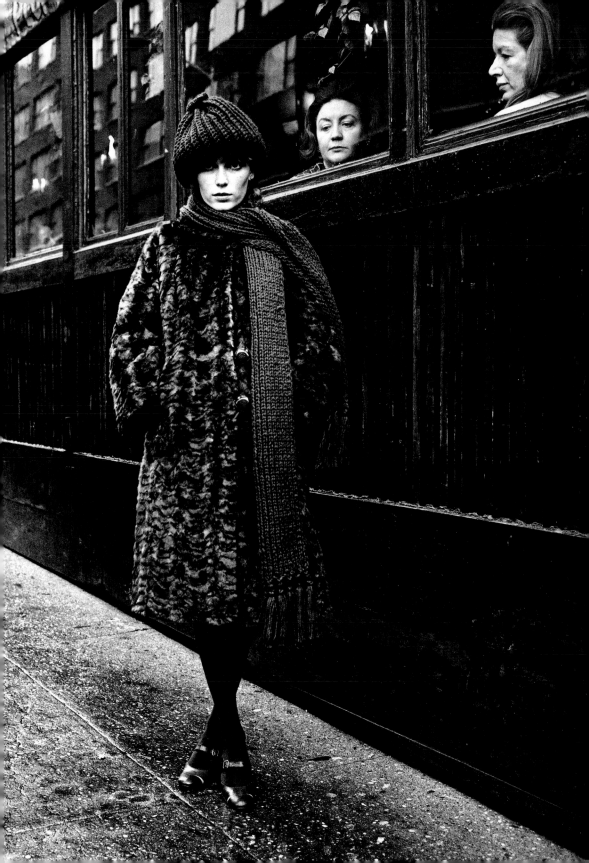

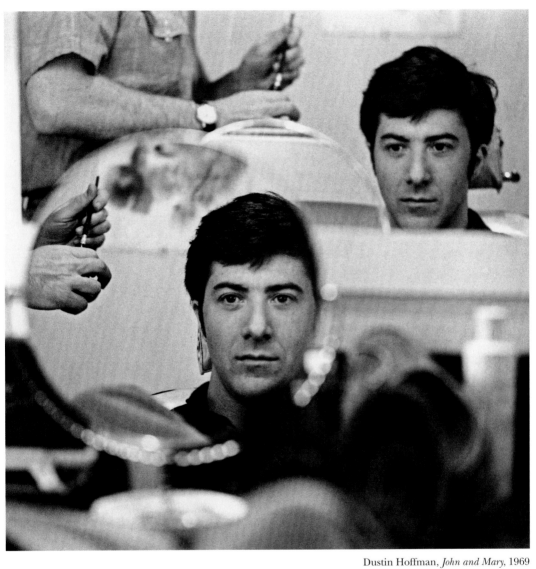

Dustin Hoffman, *John and Mary*, 1969

Mia Farrow, *John and Mary*, 1969

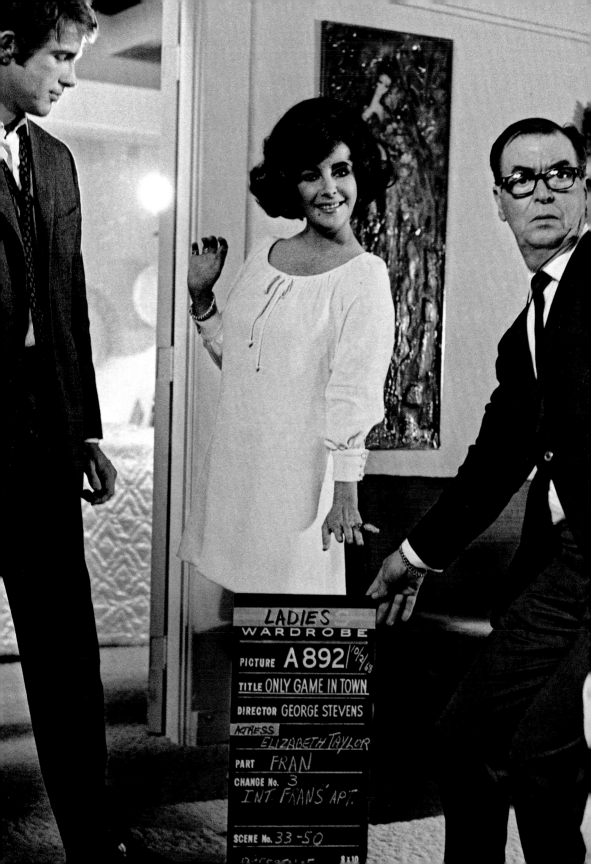

LADIES
WARDROBE
PICTURE A892 10/2/68
TITLE ONLY GAME IN TOWN
DIRECTOR GEORGE STEVENS
ACTRESS
ELIZABETH TAYLOR
PART FRAN
CHANGE No. 3
INT. FRANS' APT.

SCENE No. 33-50

8x10

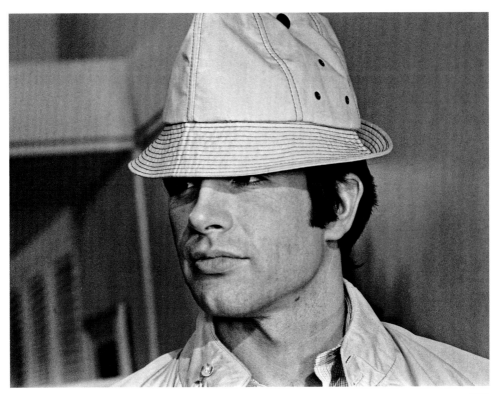

Warren Beatty, *The Only Game in Town*, 1970

Elizabeth Taylor and Warren Beatty (left), *The Only Game in Town*, 1970

Myra Breckinridge

1970

Based on the controversial novel by Gore Vidal, *Myra Breckinridge* boasted a trio of famous leading ladies: Raquel Welch, Mae West, and Farrah Fawcett. At the peak of her popularity, Raquel Welch, who had starred in a number of Fox films in the 1960s, played the title character Myra (with movie critic Rex Reed playing the male version Myron). The legendary West costarred as Leticia Van Allen, while Fawcett made her film debut as the ingenue Mary Ann Pringle, several years prior to her phenomenal success in TV's *Charlie's Angels*.

The outrageous costumes were designed by Theadora van Runkle, who was best known for the cutting-edge look of *Bonnie and Clyde* (1967). For her first film in twenty-seven years, however, West did not feel comfortable trusting her seventy-seven-year-old body to one of Hollywood's newest designers, no matter how talented. As part of her contract, West had Edith Head brought in to design her costumes. The two had worked together at Paramount during West's heyday in the 1930s, and she trusted Head to know what suited her figure.

Head created West's wardrobe entirely in black and white because the actress felt that the stark colors would draw attention to her character in the color film. The producer concurred and took it a step further, deciding that no other actor would wear either black or white when appearing in a scene with West. Unfortunately, van Runkle was not informed of this edict, resulting in Raquel Welch appearing in a black dress with a white ruffle in a scene she shared with West.

Released in 1970, the sex-change theme and adult imagery resulted in one of the MPAA's first X ratings for a major studio. A commercial and critical disappointment during its initial release, the film is now remembered by cult audiences as one of the strangest and most unusual films ever made by a major studio.

Raquel Welch, *Myra Breckinridge*, 1970

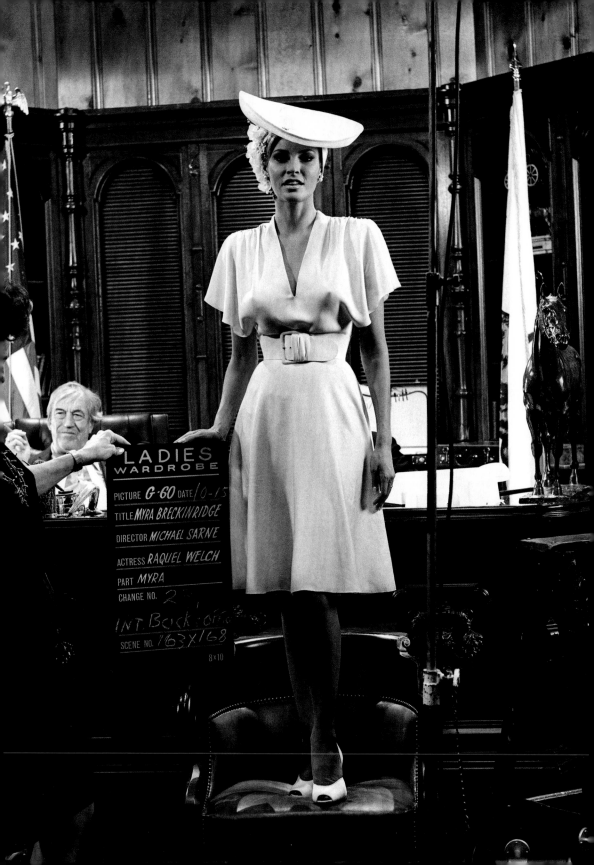

LADIES
WARDROBE

PICTURE G·60 DATE /0-15
TITLE MYRA BRECKINRIDGE
DIRECTOR MICHAEL SARNE
ACTRESS RAQUEL WELCH
PART MYRA
CHANGE NO. 2
INT. Back office
SCENE NO. 163 X 168

8×10

Farrah Fawcett, *Myra Breckinridge*, 1970

LADIES
WARDROBE
[I]TURE G·60 DATE 12-1-69
TITLE MIRA BRECKINRIDGE
DIRECTOR M. SARNE
ACTRESS FARRAH FAWCETT
PART MARY ANN
CHANGE NO. 14
INT. MYRA'S BEDROOM
SCENE NO. 169

8×10

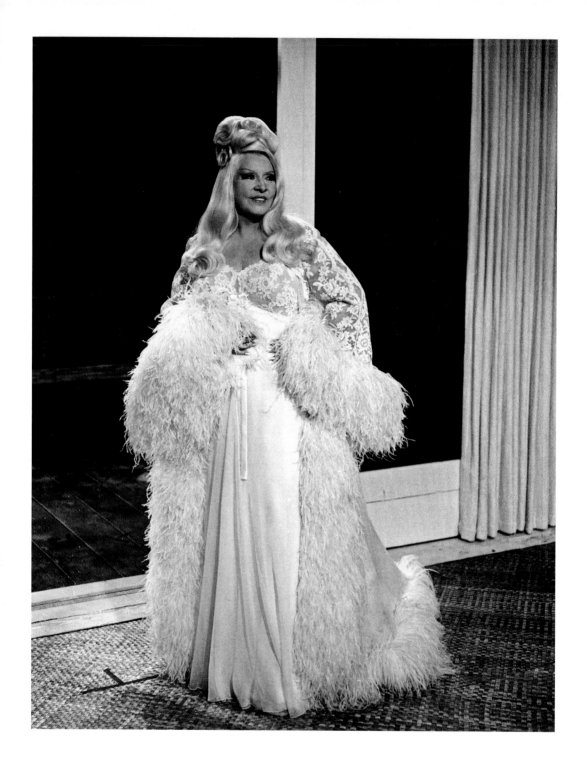

Mae West, *Myra Breckinridge*, 1970

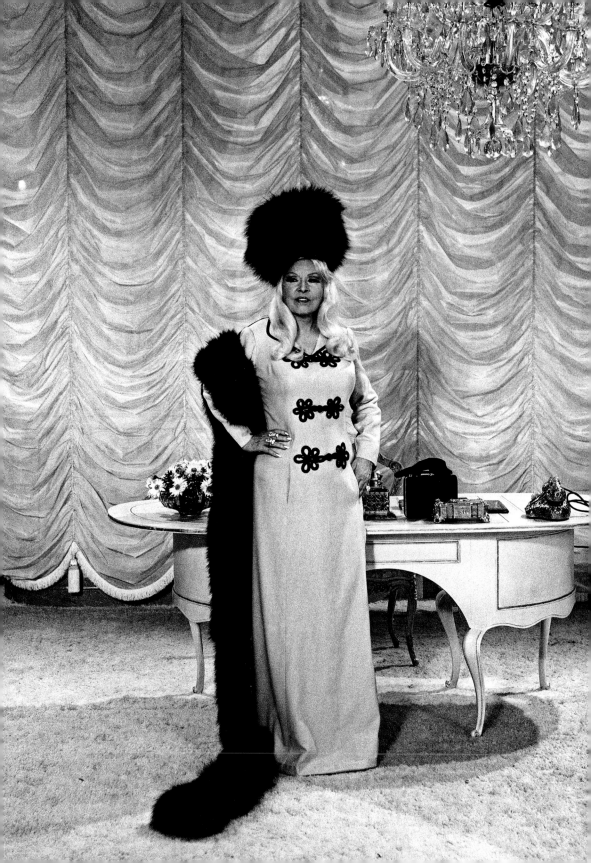

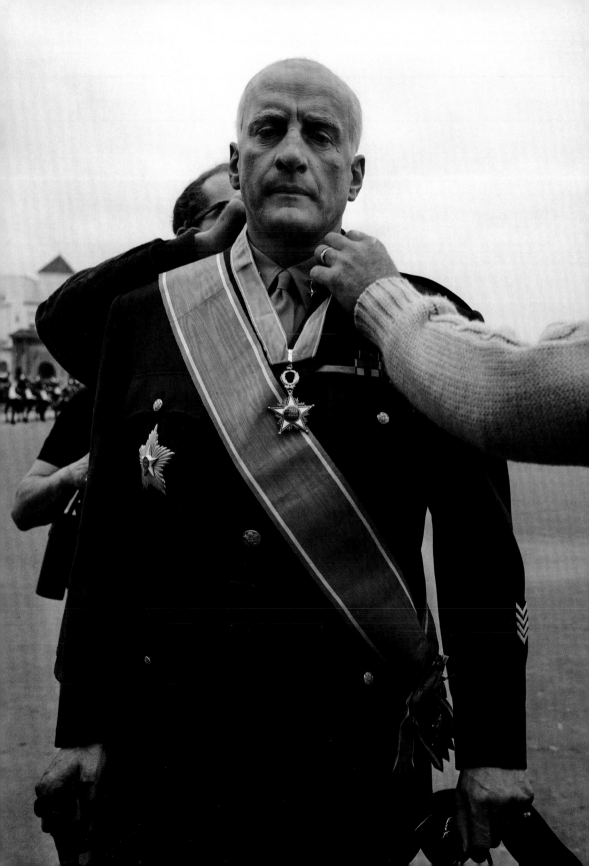

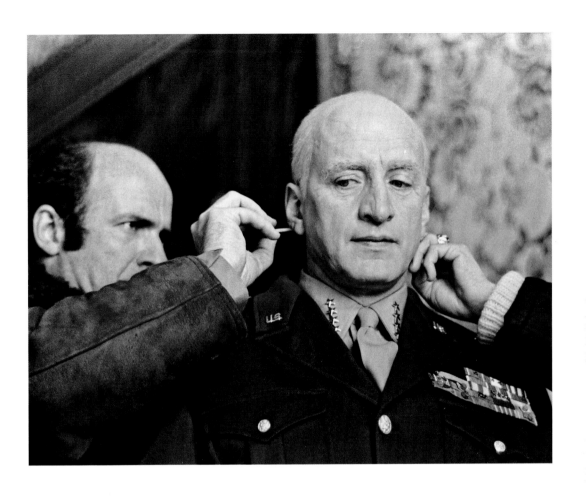

George C. Scott, *Patton*, 1970

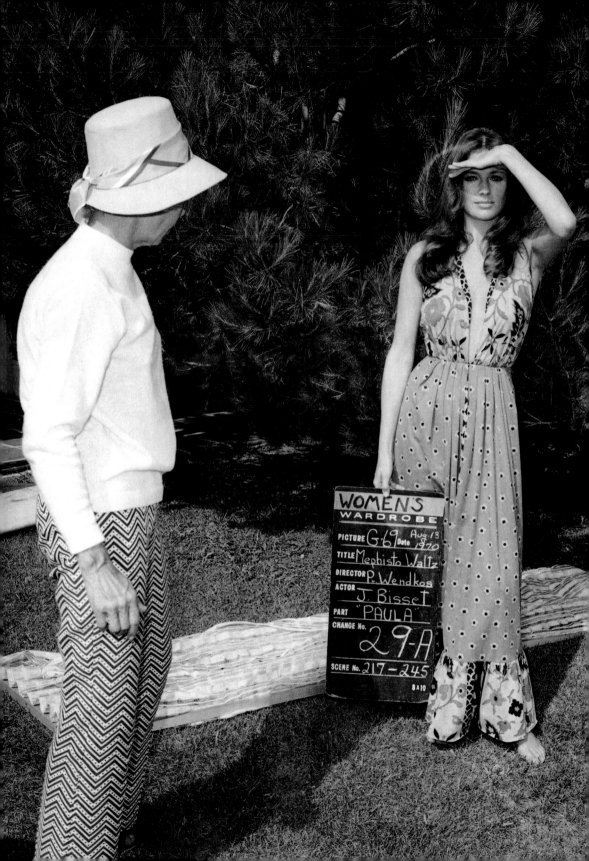

WOMEN'S
WARDROBE
PICTURE G-69 Date Aug 13 1970
TITLE Mephisto Waltz
DIRECTOR P. Wendkos
ACTOR J. Bisset
PART "PAULA"
CHANGE No. 29-A
SCENE No. 217-245
8 x 10

Jacqueline Bisset, *The Mephisto Waltz*, 1971

The Poseidon Adventure
1972

After the 1960s television successes of *Lost in Space*, *Voyage to the Bottom of the Sea*, *Land of the Giants*, and *The Time Tunnel*, producer Irwin Allen turned to the big screen in 1972 with *The Poseidon Adventure*. The film was a tremendous financial success and was the first of five feature films produced by Allen during the popular disaster-films era. The formula was simple. All-star casts pitted themselves against natural or man-made disasters, performing heroic deeds in the midst of peril—but the true stars were always the special effects. *The Poseidon Adventure* was one of the first and one of the best of the genre.

Allen, unlike former studio chief Darryl Zanuck, did believe in utilizing glamour as a selling point in his films. The gowns were designed by Paul Zastupnevich, who served as costume designer on many Irwin Allen productions, including all of his disaster films and on the television series *Lost in Space* and *Land of the Giants*.

In *The Poseidon Adventure* the ship is capsized during an elegant New Year's Eve party. Plunging necklines and tight evening gowns enticed audiences in the beginning and titillated them as the disaster ensued. How much longer could such ephemeral clothing survive the onslaught of explosions and floods?

The film was unusual in that it was shot in sequence, which should have simplified the costume department's job from a continuity standpoint. Clothes would become dirtier and more distressed each day; there would be no need to return them to a more pristine conditwion. Not so. Director Ronald Neame continually complained that his cast looked too dry and clean while climbing through the bowels of the capsized ocean liner. Modern fabrics were the culprit. The care-free synthetic fabrics were the curse of costumers. They shed water, taking dirt and grease with them, and refused to wrinkle. Wardrobe devised a creative solution by dousing the costumes with mineral oil, which not only glistened like water on-screen but also attracted oily grime. A few strategic rips and tears aided the illusion.

The film was well received critically as well, with Shelley Winters nominated for an Academy Award as Best Supporting Actress. Winters had already won a Best Supporting Actress award for Twentieth Century Fox's *Diary of Anne Frank* in 1959. The two roles were strikingly similar. Although she ultimately perishes in both films, she dies only after sacrificing for her husband and fellow victims. *The Poseidon Adventure* was one of the last films at Twentieth Century Fox employing traditional analog continuity shots.

Stella Stevens, *The Poseidon Adventure*, 1972

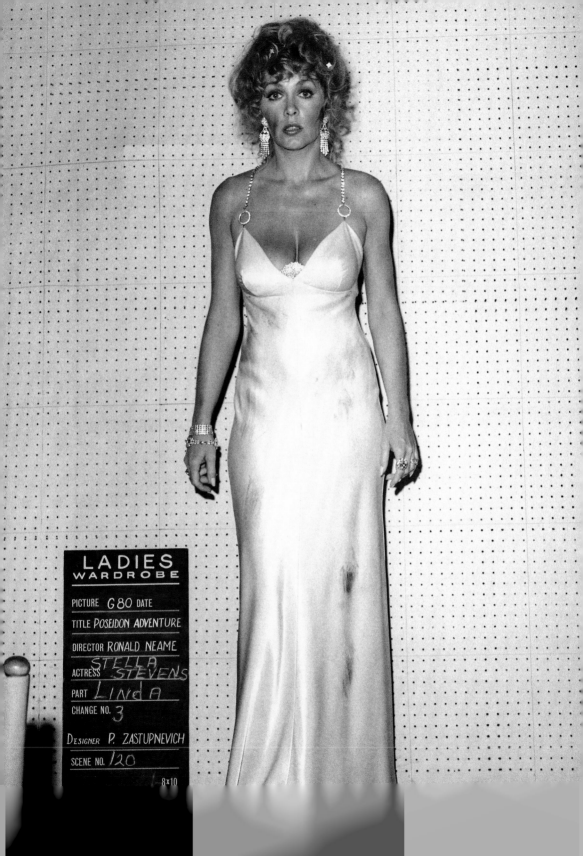

LADIES
WARDROBE

PICTURE G 80 DATE
TITLE POSEIDON ADVENTURE
DIRECTOR RONALD NEAME
ACTRESS STELLA STEVENS
PART Linda
CHANGE NO. 3
DESIGNER P. ZASTUPNEVICH
SCENE NO. 120
8x10

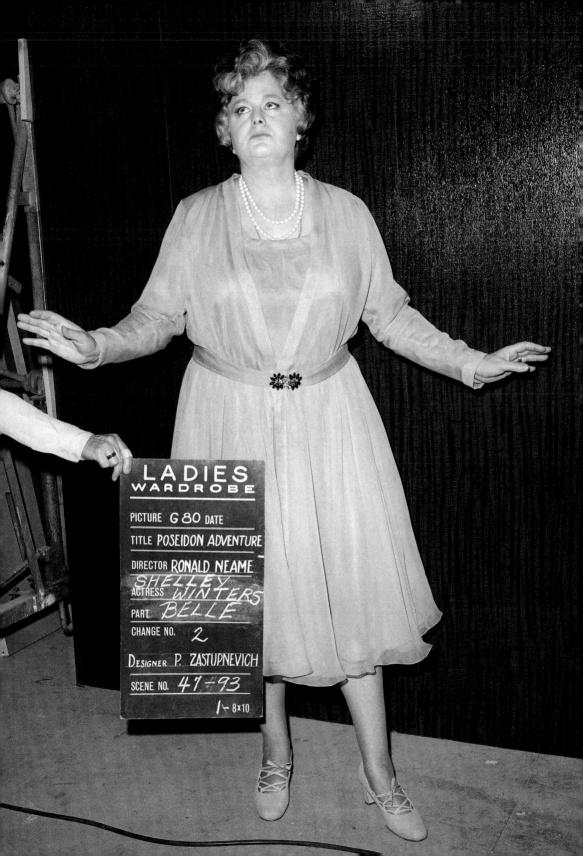

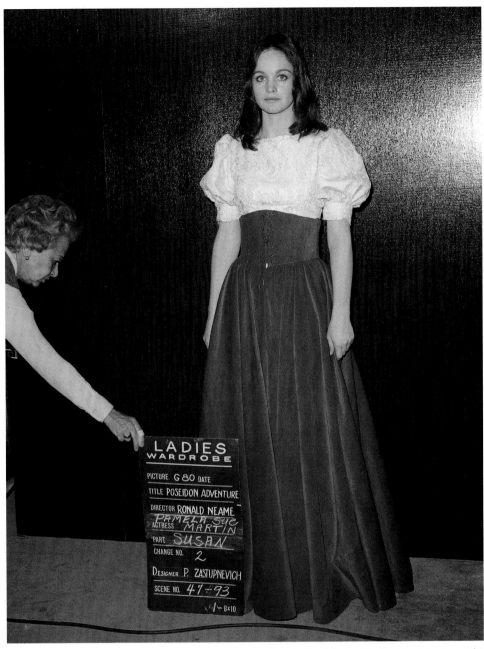

Pamela Sue Martin, *The Poseidon Adventure*, 1972

Shelley Winters, *The Poseidon Adventure*, 1972

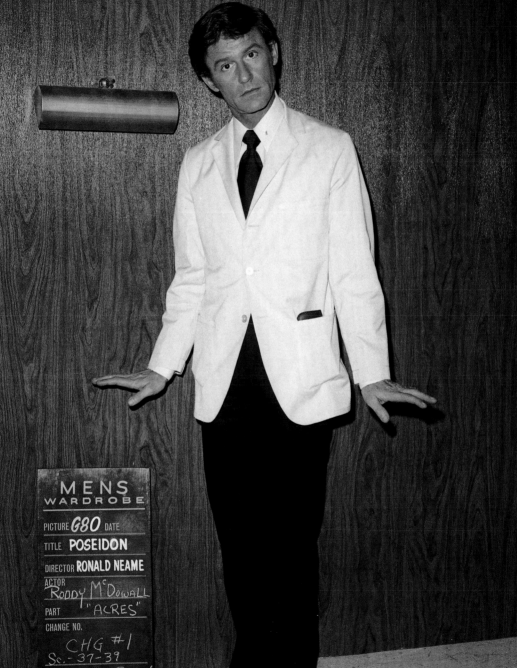

MENS
WARDROBE

PICTURE **G80** DATE

TITLE **POSEIDON**

DIRECTOR **RONALD NEAME**

ACTOR Roddy Mc Dowall

PART "ACRES"

CHANGE NO.

CHG #1
Sc.-37-39

SCENE NO. INT. SALON

DESIGNER 8x10
PAUL ZASTUPNEVICH

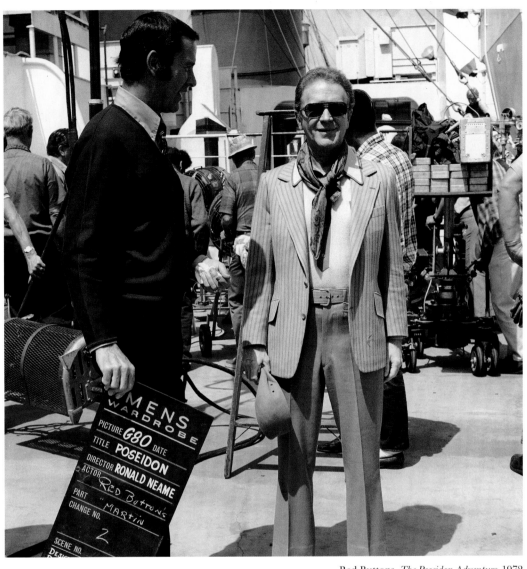

Red Buttons, *The Poseidon Adventure*, 1972

Roddy McDowall, *The Poseidon Adventure*, 1972

Susan Blakely, *The Towering Inferno*, 1974

"Hair, makeup, and wardrobe are crucial to me as an actor because they *informed* my character. I played a wealthy socialite who was trapped in a bad marriage. When I look like the character, intrinsically I *become* the character. I wanted to have an upper-class, sort of conservative look. Old money. I fought for that because Irwin Allen wanted me to have a sexier look with my hair down. He was probably right for the star appeal, but I took things like that very seriously when I was a young actress. I'd just come out from New York, studying with [Lee] Strasberg, [Sanford] Meisner, and Warren Robertson, and I wanted everything to be very realistic. I darkened my hair color and wore it in an updo, every hair in place. And the costumers had selected a perfect gown—prim and proper, yet still feminine."

—SUSAN BLAKELY

Jennifer Jones, *The Towering Inferno*, 1974

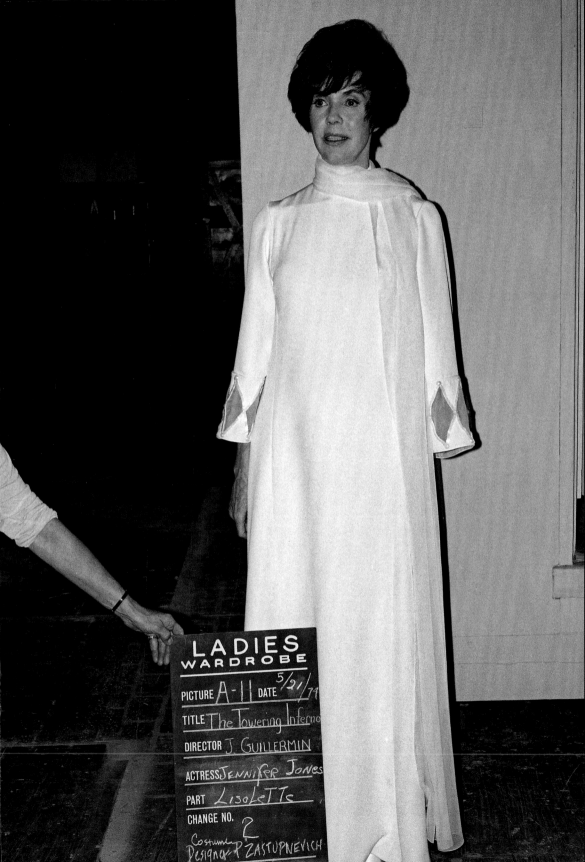

LADIES
WARDROBE
PICTURE A-11 DATE 5/21/74
TITLE The Towering Inferno
DIRECTOR J. GUILLERMIN
ACTRESS Jennifer Jones
PART Lisolette
CHANGE NO. 2
Costume
Designer P. ZASTUPNEVICH

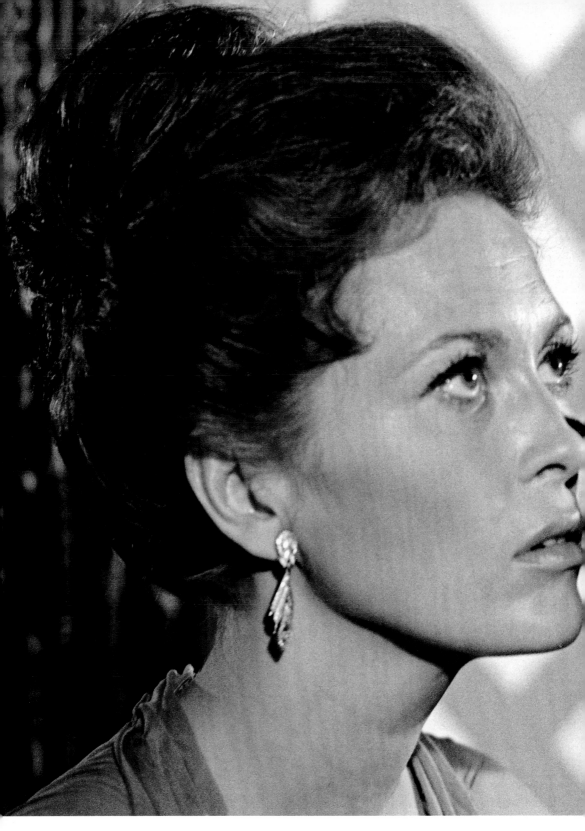

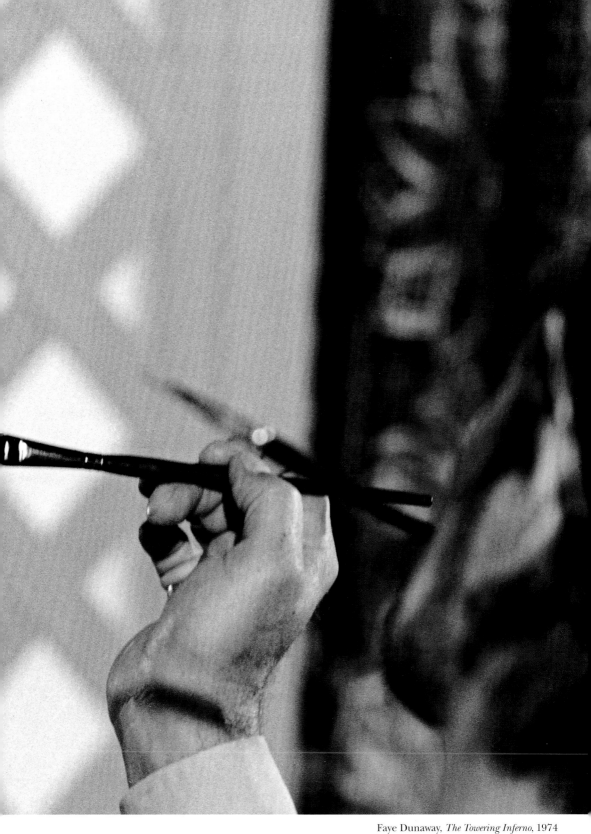

Faye Dunaway, *The Towering Inferno*, 1974

Lindsay Wagner, *The Paper Chase*, 1973.

Susan Blakely, *Capone*, 1975

ACKNOWLEDGMENTS

We would like to thank our families and loved ones for their never-ending patience and support during this two-year project. A special thanks to Michael Madden and Dustin Jones for their "Insight."

Thank you to Twentieth Century Fox Archives and Consumer Products. A great deal of gratitude to Jeffrey Thompson for his invaluable efforts and love for this project, and to Mary McLaren, without whom this book would not have happened.

The common practice of taking continuity shots by a photographer on the set with a film camera has long since become a thing of the past. Now with the digital age the wardrobe, hair, and makeup personnel take the photographs themselves and create binders with digital photos and notes on each actor for continuity reference. The placard standing beside the actor has quietly slipped into obscurity. The studio's modus operandi has quietly melted into the past confirming these are indeed rare, incomparable, unretouched, and unaltered images. That fact makes the book you are holding a fascinating journey into a bygone era of classic filmmaking and photography that we can all ponder and treasure. We pay homage to those who style and photograph the stars in the past, present, and future.

That's a wrap!

—ANGELA CARTWRIGHT AND TOM MCLAREN

OPPOSITE: Debbie the chimp, *What a Way to Go!*, 1964
FOLLOWING PAGES: Candice Bergen, *The Magus*, 1968

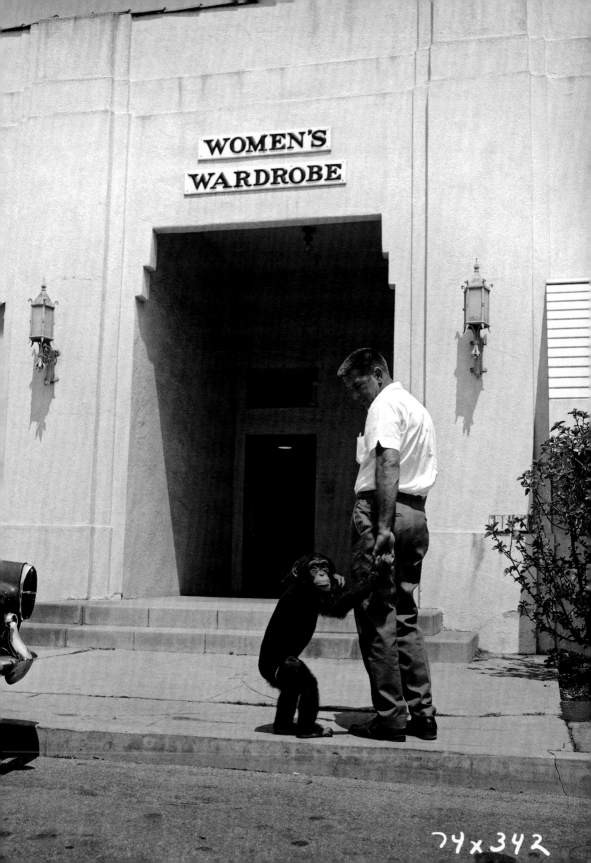

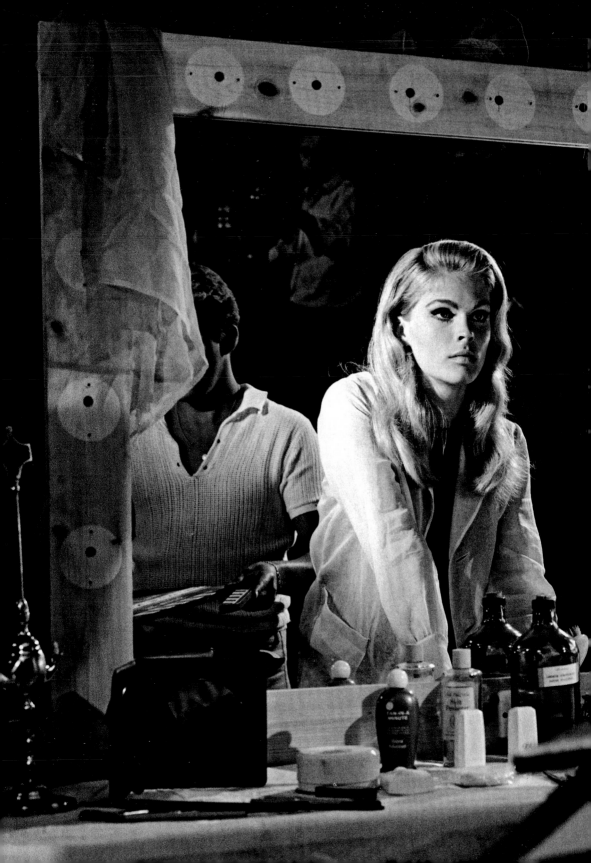